LEONARDO DA VINCI

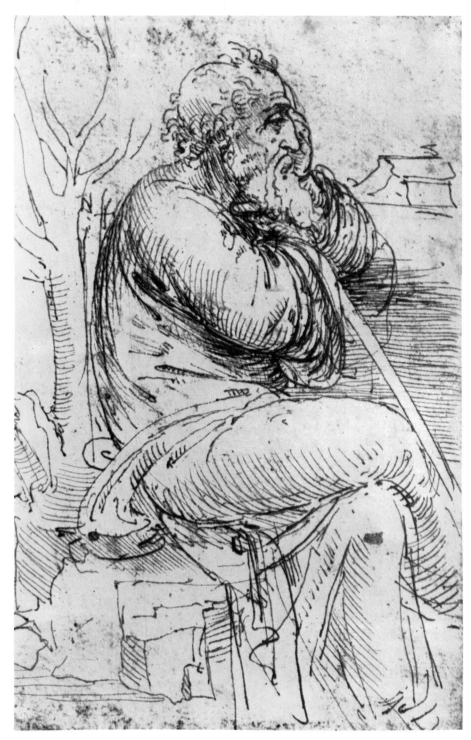

SELF-PORTRAIT OF THE ARTIST AS AN OLD MAN (detail)
Pen and ink. 15.2 x 21.3 cm.
Royal Library, Windsor

Leonardo da Vinci

PATRICE BOUSSEL

TIGER BOOKS INTERNATIONAL
LONDON

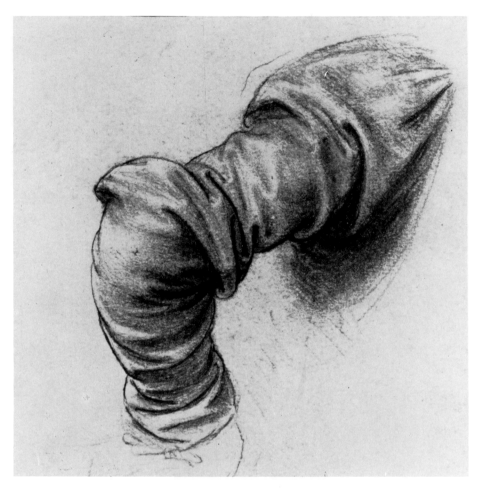

STUDY OF A SLEEVE
Black chalk heightened with white, 16.6 × 15 cm. Royal Collection, Windsor Castle.

This edition published in 1992 by
Tiger Books International PLC, London

Copyright © Nouvelles Èditions Françaises, Paris

English translation copyright © Alpine Fine Arts Collection (U.K. Ltd.)

Published by special arrangement with
William S. Konecky Associates, Inc.

ISBN: 1-85501-239-1

Printed and Bound in China

INTRODUCTION

THE few documents we have concerning the childhood of Leonardo da Vinci leave a gap that has been amply filled by gifted, imaginative biographers whose numerous accounts at least make interesting reading for people intrigued by the idiosyncrasies of biographers. Only recently have historians managed to piece together a few specific (and apparently reliable) bits of information about Leonardo's early years. While this evidence has cast doubt on a number of earlier hypotheses—usually based as much on conjecture as on fact—in no way does this mean that readers should be denied fresh interpretations that concern themselves with something other than names, places, and dates. Such data, however, cannot account for the unaccountable: the genius of Leonardo.

While sifting through documents about the artist's life, Emil Möller came across a note Leonardo's grandfather wrote in 1452. "On Saturday, April 15, at three o'clock in the morning, was born to me a grandson, the son of my son Ser Piero. He was given the name Leonardo. He was baptized by Father Piero di Bartolomeo of Vinci in the presence of Papino di Nanni Banti, Meo di Tonino, Piero di Malvolto, Nanni di Venzo, Arrigo di Giovanni da German, Monna Lisa di Domenico di Brettone, Monna Antonia di Giuliano, Monna Niccolosa del Barna, Monna Maria, daughter of Nanni di Venzo, Monna Pippa [di Nanni di Venzo, struck out] di Pervicone." (Three o'clock in the morning back then is equivalent to 10:30 p.m., twentieth-century time.)

Professor Möller determined that the house in which Leonardo was born stood in the shadow of the castle of Vinci, to the east. Leonardo's father, Ser Piero, was a notary, thus following in the footsteps of his own father—Antonio di Piero di Guido was eighty when his grandson was born—and all of his forebears as far back as the beginning of the thirteenth century. From another document, dated 1457, we learn that Leonardo's grandfather had reached the age of eighty-five, his wife Monna Lucia sixty-four, his son Piero thirty, his daughter-in-law Albiera twenty-one, and "Lionardo, illegitimate son of the aforementioned Ser Piero and Chataria, presently the wife of Achattabriga di Piero del Vacca da Vinci," five. Leonardo's mother lived with her husband on a farm in Anchiano that belonged to Ser Piero's family. In 1469, Leonardo's ninety-six-year-old grandfather died, leaving his worldly possessions to his wife, two sons (Ser Piero, then forty, and Francesco, then thirty-two), Ser Piero's second wife (twenty-year-old Francesca), Francesco's wife (twenty-six-year-old Allessandra), and "Lionardo,

age seventeen, illegitimate son of the aforementioned Ser Piero."

Since the oldest known document was from 1457, some assumed that the *figlio di Piero illegittimo* spent the first five years of his life with his mother in Anchiano and that Anchiano is where he had been born. Like Marcel Brion, one could picture a child bereft of all family affection except his mother's, a free spirit roving the rocky slopes of Monte Albano, leading "the happy, carefree life of a country boy while his mother tended house and saw to farm chores." He showed no fear when a kite swooped down and jostled him in his crib, and he formed so close a relationship with animals that "throughout his life he cherished them and attached great value to their well-being and freedom." Because of this special rapport with animals, "he never sensed any barriers between him and the outside world, nor any incompatibility that stood in the way of communion between that world and himself." "Leonardo," the French art historian concludes, "was fortunate not to have known anything about that closed, despotic world we call the family until he had learned to weather its scant affection and stern obligations without endangering that identity between himself and the boundlessness of creation." Brion adds that although Ser Piero's wife benevolently took in the little newcomer five years after their marriage, "no doubt the others—the legitimate children, the 'normal' ones—made him feel like an outsider and poked fun at the bumpkin for his animallike robustness and forthrightness, for proving so awkward at the game of social propriety."

It almost comes as a disappointment to learn that in fact Leonardo was born in the house of his grandfather Antonio, that the family took him in at once, that he was baptized with all due solemnity, and that he was brought up by his grandmother Monna Lucia and by Albiera, the sixteen-year-old his father had married the very year Leonardo was born. How could the lad have been the laughingstock of his legitimate half brothers, since it was not until 1476, when Leonardo was twenty-four, that Ser Piero's third wife finally bore him his first legitimate son?

There is much to be learned when psychiatrists called by the prosecution and the defense give testimony in criminal court, if not about the defendant, at least about psychiatrists and psychiatry. Marie Bonaparte's study of Sigmund Freud's *Leonardo da Vinci and a Memory of His Childhood* is no less enlightening. Leonardo made the following note on a leaf (*Codex Atlanticus*, f. 162 recto) while discussing the flight of birds: "Among the first recollections of my childhood it seemed to me that, as I lay in my cradle, a kite

came to me and opened my mouth with its tail and struck me several times with its tail between my lips." What we have before us, needless to say, is a "passive homosexual fantasy." Carrying his analysis further, Freud unveils the repercussions of this fantasy later on in Leonardo's life: it accounts for that strange, bewitching, enigmatic smile spreading across the lips of his female subjects. It also sheds light on the *Virgin and Child with St. Anne* in the Louvre. According to Oscar Pfister, hidden in the oddly arranged, elusive drapery are the outlines of a vulture: the head and neck in the blue cloak winding about the Madonna's hips, the tip of the bird's tail pointed toward the child's mouth. However, a number of skeptical authorities, René Huyghe among them, have reservations about this analysis and are of the opinion that "the vulture in *St. Anne* sounds more like the old game of 'Find the Hunter' than a verifiable observation."

Solmi quoted the following sentence from Leonardo's notebooks, a sentence that, according to Freud, "indicates his frigidity": "The act of procreation and everything that has any relation to it is so disgusting that human beings would soon die out if there were no pretty faces and sensuous dispositions." "This thought is noted at the top of a leaf with several anatomical studies of the hand," Marie Bonaparte points out. "From an analytical point of view, there are grounds for believing that this was not coincidental and that somewhere in Leonardo's unconscious there was a link between the undoubtedly harsh repression of his childhood masturbation and his later abhorrence of sexuality. This even may have extended to the fact that he was left-handed, or at least was partial to using his left hand when he wrote, drew, and painted. . . . It is remarkable that all of the hands that Leonardo drew on the leaf on which he expressed his loathing of sexual intercourse are *right hands.*"

Quod erat demonstrandum. No doubt we risk being accused of stubborn willfulness for pointing out that a left-handed artist would tend to study his own right hand if no other model happened to be available when he was drawing.

Vasari confined himself to psychologically superficial assertions, and Leonardo's other early biographers followed suit. Modern readers familiar with psychoanalysis find it difficult to settle for traditional accounts of the artist's boyhood: that he grew in handsomeness, wisdom, and strength; that he had a precocious mind, an insatiable thirst for knowledge, and an uneven disposition; that he was an enthusiastic student of Latin, mathematics, music, and drawing. Besides, the psychoanalytic approach can be so penetrating and fruitful that the dearth of detailed primary sources about the early years of the man who painted the *Mona Lisa* could even be considered a blessing in disguise.

Leonardo, now seventeen, was still living with his family in Vinci when his grandfather died. Three years later, in 1472, he was at work in the Florentine shop of Andrea di Cione, better known as Andrea del Verrocchio (1435–1488). Vasari tells us that Ser Piero showed the goldsmith a few of his son's drawings to see what his chances were of becoming an artist. The lad's apprenticeship probably began in 1469, when Leonardo's father and uncle, Piero and Francesco, rented a house belonging to the merchants' guild on the Via delle Prestanze (now Via del Gondi) and moved there with their respective families. The following year, Ser Piero became procurator of the monastery of the Santissima Annunziata. Florence's painters' guild, the guild of St. Luke, began keeping records in 1472. Since Leonardo's name was entered on the roll that year for payment of dues, we may assume that he had already become a member of the guild. While in Verrocchio's shop, which was both a school and a place of business, Leonardo was trained in a variety of techniques ranging from bronze casting and painting to the art of working precious metals.

The earliest dated work that can be positively attributed to Leonardo is a drawing of a landscape in the Uffizi Gallery. The inscription reads "Day of St. Mary of the Snows. August 5, 1473." The view includes a castle atop a lofty crag that looks down into a broad valley. The artist used pen and bister with some watercolor in shaded areas. The inscription reads from right to left and was written with the left hand placed in front of a mirror. Leonardo also used his left hand for several parts of the draw-

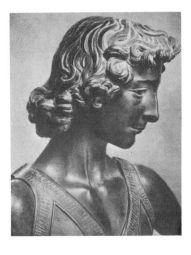

Andrea del Verrocchio:
David (detail) (possibly a likeness of Leonardo as a youth)
Bronze.

ing proper. On the reverse of the leaf Leonardo drew a bridge jutting out from a cluster of boulders, a head wearing a crown of foliage, a nude with a spear, a half-length red-chalk study of a woman, and the following sentence written with the right hand: "Zoa Morando, I am pleased with Anto."

During his stint in Verrocchio's *bottega*, Leonardo is said to have had a hand in pageants for Lorenzo de' Medici (1469) and Giuliano de' Medici (1475) as well as in court festivities to honor the visit in 1471 of Galeazzo Maria Sforza to Florence. From Vasari we learn that, while working on a *Baptism of Christ* for the church of San Salvi, Verrocchio let Leonardo paint the angel on the left. X-ray examinations revealed that the craggy landscape behind the two angels, with its broad river flowing from one pool into another, had been painted over a different scene. This, too, is now believed to be Leonardo's. One recent hypothesis holds that after a minor artist completed the groundwork of the *Baptism of Christ,* the painting found its way into Verrocchio's shop about 1469 and was entrusted first to Botticini, then to Botticelli and Leonardo. Leonardo was also supposedly asked to make a watercolor cartoon showing Adam and Eve in the Garden of Eden for a tapestry to be woven in Flanders for the king of Portugal. However, the project never reached the weaving stage, and the cartoon was kept in the house of Ottaviano de' Medici. Also attibuted to Leonardo are a *Madonna with Vase of Water* (formerly in the collection of Pope Clement VII), a *Head of Medusa,* and an *Angel* (once the property of Cosimo I de' Medici), not to mention the celebrated round shield that, according to Vasari, Ser Piero had his son make for one of his peasants. Leonardo, the story goes, had in his room a collection of lizards, snakes, newts, grasshoppers, bats, and other strange creatures. He devised a horrible monster made up of different parts of these animals and painted it on the shield. A startled and admiring Ser Piero supposedly then purchased another round panel for his peasant—one with less imaginative decoration—and sold Leonardo's to a merchant for two hundred ducats. Shortly thereafter, the merchant sold it to the duke of Milan for three hundred ducats. This anecdote, albeit amusing, is today dismissed as fiction. Two paintings of the Virgin Mary attributed to Leonardo—the *Benois Madonna* in the Hermitage (Leningrad) and the *Madonna with the Carnation* (Alte Pinakothek, Munich)—are also believed to date from his apprenticeship in Verrocchio's shop.

There was a box—the *tamburo*—outside the Palazzo Vecchio in which people could drop accusations, signed or anonymous. If witnesses came forward to testify, the charges would be investigated.

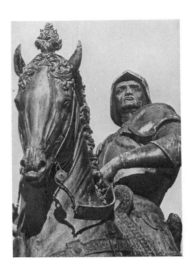

Andrea del Verrocchio: The Colleoni Monument (detail).

On April 8, 1476, someone dropped a note in the box accusing Leonardo and three other young men of engaging in homosexual acts with a seventeen-year-old artist's model named Jacopo Saltarelli. The accuser was not identified; no witnesses came forward. The matter went to court twice in two months but was not pursued. "Lionardo, son of Ser Piero da Vinci, residing in the house of Andrea Verrocchio" was acquitted "provided he never again be the object of an accusation." Not surprisingly, this episode caught the attention of Sigmund Freud, who points out the complete absence of eroticism in Leonardo's writings. Although "it is doubtful whether Leonardo ever embraced a woman in passion" and "once a master surrounded himself with handsome boys and young men who became his pupils," "we may take it as much more probable that Leonardo's affectionate relations with the young men who—as was the custom at that time—shared his existence did not extend to sexual activity."

Fred Bérence, however, seems less certain of Leonardo's innocence in the Saltarelli matter. To be sure, "accusations, acquittals, and convictions prove nothing in a case such as this," but it is equally clear that the defendants' families and Verrocchio himself—he is mentioned by name—had to intervene to obtain the acquittal. After enumerating a number of factors—young Leonardo's restlessness and overrefinement, his curiosity and the siren's song of risk ("an outgrowth of his passion for knowledge and love"), his interest in the Platonic theory of love—Bérence lets the reader draw his own conclusions about the "Saltarelli case."

While in Verrocchio's workshop, Leonardo may have devoted more time to sculpture than painting, noting in the *Trattato della Pittura* that he had "exercised [himself] no less in sculpture than in painting and doing both one and the other in the same de-

gree." Vasari mentions that Leonardo made "several clay heads of women with smiling faces," and in the second half of the sixteenth century, Lomazzo claimed that he had in his collection a little head of the Christ child. There is a story that the statue of David that Verrocchio completed in 1476 is a portrait of young Leonardo and that its haunting smile was to reappear, "slightly altered, on the lips of Leonardo's Mona Lisa, St. Anne (in *Virgin and Child with St. Anne*), and John the Baptist" (Fred Bérence). Some even believe that Leonardo had a hand in the *Colleone Monument* that Verrocchio began in 1479.

We learn in the minutes of Florence's executive council that on December 24, 1477, the priors of the Signoria commissioned Piero Pollaiuolo to make an altarpiece for the San Bernardo chapel in the Palazzo Vecchio, but that seventeen days later (January 10, 1478) the commission was transferred to Leonardo. On March 16, he received a first payment of twenty-five florins. Leonardo started work on a panel, only to abandon the project. A resolution passed on May 25, 1483, authorized Domenico Ghirlandaio to take over, but it was Filippino Lippi who completed it and dated it 1485. Any cartoon Leonardo may have made for the San Bernardo altarpiece must be presumed lost.

On April 24, 1478, Giuliano de' Medici, brother of Lorenzo the Magnificent, was stabbed to death by Francesco de' Pazzi during high mass in the cathedral of Santa Maria del Fiore. The assassin and his accomplices were arrested and summarily hanged, but one of the conspirators managed to escape to Turkey. The Signoria of Florence asked that he be arrested and extradited; the Sultan obliged. On December 29, 1479, Bernardo di Bandino Baroncelli and his wife were publicly hanged. Leonardo drew a sketch of him and added the following terse notation: "Small tan-colored cap, black satin doublet, black-lined jerkin, blue coat lined with black and white velvet stripes. Bernardo di Bandino Baroncelli. Black hose."

It is now acknowledged that the unfinished *St. Jerome* in the Vatican is indeed by Leonardo and dates from his first Florentine period. The story of the painting, if not altogether plausible, is as picturesque a tale as one could hope for. Originally in the Vatican collection, it became the property of Angelica Kaufmann. The wooden panel was then supposedly mislaid and cut in two. Joseph Cardinal Fesch recovered the lower part, which a junk dealer had been using as a table top. A few years later he found out that a shoemaker had been using the upper part as a stool. Thus, the cardinal must have known the

Sketch of the hanged Baroncelli
Musée Bonnat, Bayonne.

work through an earlier drawing. The heirs of Napoleon Bonaparte's uncle (Cardinal Fesch) sold the monochrome groundwork to Pope Pius IX for twenty-five hundred francs.

Another unfinished painting, the *Adoration of the Magi,* was commissioned in March 1481 as an altarpiece for the monastery of San Donato a Scopeto. The monks were clients of the painter's father, Ser Piero da Vinci, who drew up the contract. Leonardo agreed to complete the work in twenty-four months, thirty at the most. In exchange he would receive a third of an inheritance the monastery had come into. (The father of one of the monks had bequeathed his worldly possessions to the monastery with the proviso that his granddaughter be given a dowry of one hundred fifty florins. Leonardo would pay the dowry in installments, and the monks would reserve the right to buy back the land granted him for three hundred florins three years after completion of the painting.) Shortly after the contract was signed, the monks advanced Leonardo some money to buy paint; then in July, when one of the dowry payments fell due, he requested another advance of twenty-eight florins.

From July to September, the monks provided him with wood, wheat, and wine. He painted a sundial in the monastery, then left Florence without fulfilling his end of the bargain.

After changing hands a number of times, the *Adoration of the Magi*—which is actually an underpainting in brown ink and yellow ocher—now hangs in the Uffizi Gallery. Several preliminary drawings Leonardo did for the composition also survive. As Nello Tarchiani sees it, "from the artistic point of view, the *Adoration,* though left unfinished, can be described as complete. On close examination, it seems that even the few layers of dusky color which Leonardo applied could almost be dispensed with. The composition, which starts out spacious in the background, with its curious architecture and groups of horsemen, becomes dense and turbulent in the middle ground, then grows calm in the foreground. In this painting—and this does not come without some surprise—lie the seeds of the Master's entire *oeuvre.* By the age of thirty, Leonardo had already created and defined the almost superhuman realm that lay within his imagination."

Why did Leonardo leave Florence for Milan between the spring and summer of 1482? His "inspired restlessness" would be one easy way of accounting for it. Could it have been out of discouragement? In 1481, Pope Sixtus IV had called on the "best" Tuscan artists to decorate the Vatican and, surely after consulting with the Medici, summoned Botticelli, Ghirlandaio, Signorelli, Perugino, and Pintoricchio—but not Leonardo. Not that Lorenzo de' Medici had ignored him completely: in 1480, he had been signed on as a sculptor to do restoration work in the Magnificent's garden on the Piazza San Marco, and as far back as 1478, during one of Ludovico il Moro's brief stays in Florence, Lorenzo is believed to have recommended the artist for the monument the Duke was planning to erect in Milan to Francesco Sforza. The letter in which Leonardo offered his services as an engineer makes a passing reference to the *opera al cavallo,* as though an agreement had already been struck with the duke. Although not in his own hand and although it may have been delivered directly to the duke in Milan instead of sent from Florence, Leonardo's celebrated letter of self-recommendation is universally acknowledged to be genuine. Leonardo outlines his agenda as follows:

"Most Illustrious Lord, having now sufficiently seen and considered the proofs of all those who count themselves masters and inventors of instruments of war, and finding that their invention and use of the said instruments does not differ in any respect from those in common practice, I am emboldened without prejudice to anyone else to put myself in communication with your Excellency, in order to acquaint you with my secrets, thereafter offering myself at your pleasure effectually to demonstrate at any convenient time all those matters which are in part briefly recorded below.

1. I have plans for bridges, very light and strong and suitable for carrying very easily, with which to pursue and at times defeat the enemy; and others solid and indestructible by fire or assault, easy and convenient to carry and place in position. And plans for burning and destroying those of the enemy.

2. When a place is besieged I know how to cut off water from the trenches, and how to construct an infinite number of bridges, battering rams, scaling ladders, and other instruments which have to do with the same enterprise.

3. Also if a place cannot be reduced by the method of bombardment, either through the height of its glacis or the strength of its position, I have plans for destroying every fortress or other stronghold unless it has been founded upon rock.

4. I also have plans for making cannon, very convenient and easy of transport, with which to hurl small stones in the manner almost of hail, causing great terror to the enemy from their smoke, and great loss and confusion.

5. And if it should happen that the engagement was at sea, I have plans for constructing many engines most suitable either for attack or defense, and ships which can resist the fire of all the heaviest cannon, and powder and smoke.

6. Also I have ways of arriving at a certain fixed spot by caverns and secret winding passages, made without any noise even though it may be necessary to pass underneath trenches or a river.

7. Also I can make armored cars, safe and unassailable, which will enter the serried ranks of the enemy with their artillery, and there is no company of men at arms so

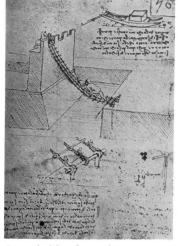

Rope ladder for scaling fortresses
Manuscript B. Institut de France, Paris.

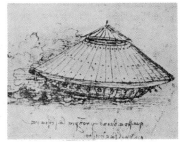

Covered tank
British Museum, London.

9

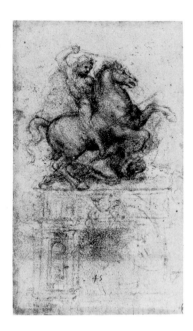

Study for the Sforza
Monument
Royal Collection, Windsor
Castle.

great that they will break it. And behind these the infantry will be able to follow quite unharmed and without any opposition.

8. Also, if need shall arise, I can make cannon, mortars, and light ordnance, of very beautiful and useful shapes, quite different from those in common use.

9. Where it is not possible to employ cannon, I can supply catapults, mangonels, *trabocchi,* and other engines of wonderful efficacy not in general use. In short, as the variety of circumstances shall necessitate, I can supply an infinite number of different engines of attack and defense.

10. In time of peace I believe that I can give you as complete satisfaction as anyone else in architecture in the construction of buildings both public and private, and in conducting water from one place to another.

Also I can execute sculpture in marble, bronze, or clay, and also painting, in which my work will stand comparison with that of anyone else whoever he may be.

Moreover, I would undertake the work of the bronze horse, which shall endue with immortal glory and eternal honor the auspicious memory of the Prince your father and of the illustrious house of Sforza.

And if any of the aforesaid things should seem impossible or impracticable to anyone, I offer myself as ready to make trial of them in your park or in whatever place shall please your Excellency, to whom I commend myself with all possible humility."

This is no run-of-the-mill petition written by a painter in search of a patron, nor is it the plea of a dispirited artist. Lorenzo the Magnificent had sent Leonardo to Ludovico il Moro with Atalante Migliorotti, "who was unsurpassed in playing the lyre," and the artist took with him a musical intrument of his own design: a silver lyre in the shape of a horse's skull. Moreover, Leonardo had a good voice, sang in

tune, composed his own words and music, and, the story goes, appeared in Milan the day of a music competition and managed to get himself called last. In light of all this, Leonardo had every reason to hope that Ludovico, a musical man himself, would find him a choice position in what was then considered one of the most glittering royal courts in Europe. No doubt Leonardo came to Milan to work on the equestrian statue of Francesco Sforza, to display his musical gifts, and live up to his reputation as a painter of note. But above all, his assignments involved engineering, specifically military engineering. In time his name was added to the list of Sforza's engineers and when summoned to Pavia in 1490 to offer advice about the completion of the cathedral, he had earned the title of *ingeniarius ducalis.*

An examination of Leonardo's notebooks reveals that his projects in the various fields mentioned in his letter to the duke were many and varied, but there appears to be no way of knowing how his plans were carried out and how much importance he actually attached to them. Quoting Lomazzo, Bertrand Gille notes that he supposedly did "for Gentile dei Borri, Ludovico's armorer, a series of sketches examining ways in which soldiers both mounted and on foot may defend themselves." His responsibilities probably included the casting of mortars and perhaps the building of canals on the outskirts of the city. After analyzing the engineering projects detailed in Leonardo's notebooks, Gille concludes that the artist's knowledge was fragmentary and did not go beyond particular problems "discussed within a very narrow framework." He proceeded like a craftsman who makes do with a set number of standard procedures. Nevertheless, there can be no denying him "a need to approach things rationally to a degree hitherto unknown among engineers. No longer were technical matters consigned to artisans, the unenlightened, and traditions of questionable validity—traditions not fully understood by the very people whose job it was to put them into practice. Leonardo attempted to arrive at truth through setbacks, mistakes, and disasters, just as physicians had only really come to know the functioning of the body through illness. . . . Leonardo was an engineer whose sole concern was efficiency and who regarded his efforts as nothing more than a way of harnessing the material world."

As one delves deeper into the life of Leonardo, it becomes apparent—much to one's delight—that the scientist, engineer, musician, and sculptor never forgot that he was also a painter. To be sure, Leonardo left posterity a number of works of undisputed genius. However, a biographer must also come to

grips with detailed, dated, incontrovertible evidence suggesting that in other respects he remains an unaccountably inscrutable figure. On April 25, 1483, three painters—Leonardo da Vinci, Evangelista da Predis and his brother Giovanni Ambrogio—signed a contract with Prior Bartolomeo Scorlione, Giovanni Antonio Sant'Angelo, and other members of the Confraternity of the Immaculate Conception, agreeing to make an altarpiece for the confraternity's chapel in the church of San Francesco Grande in Milan. In addition to three painted panels, they agreed to gild the retable and paint the parts in relief. The contract names Leonardo as *maestro* over his two assistants and mentions that, since he had no place of residence, he was staying with the da Predis brothers in their house by the Porta Ticinese (San Vincenzo in Prato parish). The fee was set at eight hundred imperial lire (two hundred ducats). An initial sum of one hundred lire would be given on May 1, 1483, the balance to be paid in monthly installments of forty lire beginning in July. The final payment would be made in January or February of 1485, and, upon completion of the altarpiece, the three painters would be entitled to a bonus to be determined by Fra Agostino Ferrari and two other members of the brotherhood to be selected by both parties. However, it was also stipulated that the project was to be finished no later than December 8, 1485, the feast of the Immaculate Conception. The subject of the central panel would be a Virgin and Child with a group of angels and two prophets. On each of the side panels would be painted four angels singing and playing musical instruments. The sculptor Giacomo del Maino had already carved the wooden retable into which the paintings would be placed. Leonardo was assigned the central panel (the future *Madonna of the Rocks*); Evangelista, the gilding, coloring, and retouching; Ambrogio, the side panels with the angels.

Leonardo and Ambrogio—Evangelista died in 1490—sent the duke an updated appeal for additional payment (probably in 1493–94), pointing out that the project assigned in the 1483 contract had been completed, but that the frame alone had taken up the entire eight-hundred-lire fee to which the artists had originally agreed. In terms of actual compensation for services rendered, they had received only one hundred of the twelve hundred lire they were asking. Consequently, they requested that the "oil painting of Our Lady" (that is, the *Madonna of the Rocks*) be withdrawn, as others had already offered to purchase it. Their petition was dismissed. Ambrogio tried again in 1503, this time with Louis XII of France, but Leonardo was no longer in Milan

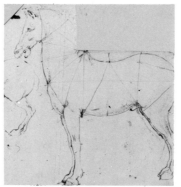

Study of a horse
Royal Collection, Windsor Castle.

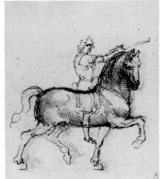

Study for the Trivulzio Monument
Royal Collection, Windsor Castle.

and the case had to be deferred yet again. A final settlement issued on April 27, 1506, judged the work unfinished and closed with the following decision: Leonardo, albeit no longer in the city, was to finish or have someone else finish the panel within two years, for which he would receive two hundred lire. Thus, there are two versions of the *Madonna of the Rocks:* the first panel that Leonardo finished but for which he received no compensation in 1506, and a second, which the artist had already begun and in fact finished within the stipulated two-year period. The first is believed to hang in the Louvre, the second in the British Museum.

Two other paintings are thought to date from Leonardo's early years in Milan (c. 1482–1483): the unfinished *Portrait of a Musician* and *Lady with an Ermine.* The first, the only portrait of a man Leonardo ever painted—if indeed he painted it—is said to be that of Franchino Gaffario, choirmaster of Milan cathedral. As for the *Lady with an Ermine,* some historians are of the opinion that the subject is Cecilia Gallerani and that only Leonardo could have painted it, but the painting remains controversial on both points.

It was also in 1483 that Leonardo probably began work on the equestrian statue of Francesco Sforza. It is believed that he was involved in the project for sixteen years. Leonardo had had a hand in planning Venice's Colleone Monument while apprenticed to Verrocchio, so the task of designing and erecting the Milanese counterpart fell to the engineer from Florence. Leonardo's notebooks reveal that he did not hold sculpture in very high regard and referred to working with stone as a "wholly mechanical exercise." This monument, however, was to be of bronze, and casting it would pose a number of challenging problems. Besides, Leonardo had a positive mania for horses and drew countless studies of

them. "Leonardo paid little attention to Francesco Sforza," Marcel Brion points out. "The human subject would come later, as an afterthought, once the horse was finished; he scarcely counted at all. If the statue had ever been completed, it would have depicted, all in all, a man borne by a god. The artist left no stone unturned when it came to bringing out the divine nature of his horses. He began by drawing one detailed anatomical study after another, then held lengthy posing sessions, as it were, in the stables of Ludovico or Sanseverino, all of which gave him deeper insight into the psychological and emotional world of the horse. . . ." At long last a full-size model was completed, and the clay horse was exhibited to admiring Milanese in the courtyard of the Palazzo Vecchio.

No doubt the engineer from Florence was just as fascinated by the technical challenges so colossal a project entailed. In his preface to *De Divina Proportione,* Luca Pacioli notes that the bronze horse would measure twelve *braccia* (over seventeen meters) from hoof to the top of the head and would weigh two hundred thousand pounds, or nearly seventy tons (one Milanese pound being roughly equivalent to a third of a kilogram). Leonardo drew up plans for four furnaces that would simultaneously cast the four sections of the animal and designed a crate for transporting the enormous clay model from the Corte Vecchia to the foundry. The project was feasible in every respect, but expenditures for war drained the ducal coffers, dashing Ludovico's dream of seeing his father immortalized in bronze. Leonardo was never remunerated for his work. The mighty clay model crumbled into ruins after French archers used it for target practice.

In April 1485, the duke may have commissioned Leonardo to paint a Madonna for presentation to Matthias Corvinus, king of Hungary, assuming that Leonardo was in fact the "unsurpassed painter" mentioned in a letter from A. Terzaghi to Malfeo di Treviglio, the Grand Duke's ambassador to Buda.

In 1487–88, Leonardo and Bernardino di Madiis or di Abbiate received fees for models of the central cupola planned for the dome of Milan cathedral. Leonardo proved equally brilliant when it came to planning masquerades and entertainments for the court, or devising strange machines for special occasions. For the wedding of Gian Galeazzo Sforza and Isabella of Aragon, scheduled for early 1489, he designed the framework of a portico that was to be set up in the Castello Sforzesco and covered with greenery. Work came to a temporary halt when the mother of the bride-to-be died. The ceremony finally took place in January 1490, and in honor of the occasion Leonardo staged the so-called Masque of the Paradiso. A mountain, complete with several tiers of crags and crowned with a gigantic egg, was built in a hall of the duke's palace. First appeared characters representing mankind as far back as the age of "wild men," singing the praises of the Sforza family. Then the egg spun around and opened, revealing personifications of the seven planets and the twelve signs of the zodiac. This was followed by ballets of the Graces and the Virtues, choruses of Nymphs, and dances by Mercury, Apollo, and Jupiter. Extravaganzas of this sort were much in vogue at the time and were considered well within the painter's ambit. Clearly Leonardo had a flair for planning lavish productions for royal audiences.

In June 1490, Ludovico sent Leonardo da Vinci and a Sienese engineer, Francesco di Giorgio Martini, to Pavia when the church council there requested consultants for completion of the cathedral.

When Ludovico Sforza married Beatrice d'Este in January of the following year, Leonardo staged a pageant sponsored by Galeazzo di Sanseverino, the duke's son-in-law and captain-in-chief of his armies. He designed the costumes, included a repeat performance of his "wild men" display, brought out a mounted warrior bedecked in golden scale armor and peacock feathers, and followed up with Scythians and Tartars. Meanwhile, in the wings, Gian Giacomo Caprotti da Oreno—nicknamed Salai, or "little Satan"—was once again giving proof of his waywardness. Leonardo had taken him in the year before. No sooner had the ten-year-old tatterdemalion met the painter than he stole the money Leonardo had set aside to pay for two shirts, a pair of shoes, and a doublet he had just ordered for his new protégé. The lad was, by Leonardo's own admission, "thievish, lying, obstinate, greedy." But he was also handsome and quick-witted and may have shown some promise as an artist. Leonardo kept a running account of his misdeeds: gluttony, bad manners in public, pilfering, etc., and kept him close by. That was where he stayed to Leonardo's dying day. "On the 26th of January following," Leonardo wrote in 1491, "I, being in the house of my lord Galeazzo da San Severino, was arranging the festival for his jousting, and certain footmen having undressed to try on some costumes of wild men for the said festival, Giacomo went to the purse of one of them which lay on the bed with other clothes [2 lire 4 s] and took out such money as was in it." A while later, Giacomo filched a fine piece of Turkish hide out of which Leonardo intended to have some boots made. Salai sold it to a cobbler and confessed to spending the money on anise candy. The thefts continued unabated, and so did Leonardo's

Study for Judas (*Last Supper*) Royal Collection, Windsor Castle.

kindnesses. Not content with supporting Salai and providing him with splendid clothing, the artist later loaned him money for his sister's dowry and bequethed to him a tidy sum "for [his] good and kind services." In his biography of Leonardo, Vasari simple noted, "It was in Milan that Leonardo took for his servant a Milanese called Salai, a very attractive youth of unusual grace and looks, with very beautiful hair which he wore curled in ringlets and which delighted his master. Leonardo taught Salai a great deal about painting, and some of the works in Milan which are attributed to him were retouched by Leonardo."

Sigmund Freud, who could not help finding Leonardo's handsome pupils intriguing, believed that Giacomo and Salai were in fact two different individuals and points out that since neither of them became a painter of note, the artist had chosen them for their looks, not for their talent. He then turns his attention to Leonardo's reckonings of petty expenses of his pupils, "notes recorded with a minute exactness, as if they were made by a pedantically strict and parsimonious head of a household," concluding that "as it is impossible to believe that his motive was that of letting proofs of his good nature fall into our hands, we must assume that it was another motive, an affective one, which led him to write these notes down." This motive, Freud goes on, manifests itself in Leonardo's list of "expenses for the interment of Caterina." Who was this Caterina? "Caterina came on the 16th day of July," Leonardo notes elsewhere; an entry dated January 29, 1494, reads "To Caterina 10 S[oldi]." Another note, though no name is mentioned, refers to "The cistern . . . at the Hospital,—2 ducats,—beans,—white maize,—red maize,—millet,—buckwheat,—kidney beans,—beans, —peas." Some biographers believe that this alludes to a period during which Caterina was in the hospital. Then, probably in 1495, we find the burial ex-

penses. Was Caterina just one of Leonardo's servants? Or was she his mother, the peasant girl "Chataria" who later became the wife of Achattabriga di Piero del Vacca da Vinci? Comparing the cost of her funeral with those of prominent people at the time, Luca Beltrami concludes that Leonardo spent "not an inconsiderable" sum on this individual. This would lend weight to the second hypothesis, except that there is ample evidence of Leonardo's natural munificence toward humble folk. Likewise assuming that Caterina was Leonardo's mother, Freud suggests a psychoanalytic explanation. "What we have before us in the account of the costs of the funeral is the expression—distorted out of all recognition—of his mourning for his mother." Leonardo was the victim of an "obsessional neurosis." "In his unconscious," Freud continues, "he was still tied to her by erotically colored feelings, as he had been in childhood. The opposition that came from the subsequent repression of this childhood love did not allow him to set up a different and worthier memorial to her in his diary. But what emerged as a compromise from this neurotic conflict had to be carried out; and thus it was that the account was entered in the diary, and has come to the knowledge of posterity as something unintelligible." Freud uses the same line of reasoning to explain Leonardo's reckonings of his outlays for pupils. "His mother and his pupils, the likenesses of his own boyish beauty, had been his sexual objects—so far as the sexual repression which dominated his nature allows us so to describe them—and the compulsion to note in laborious detail the sums he spent on them betrayed in this strange way his rudimentary conflicts."

In 1493, more than ten years after the Holy Roman Emperor had lost his wife, Marie de Bourgogne, Maximilian I married Maria Bianca Sforza, niece of Ludovico il Moro and sister of Jean Galéas. Her dowry came to four hundred thousand florins, and the emperor reciprocated by investing Ludovico with the duchy of Milan. Guests at the wedding celebration—so splendid that it inspired poetry—marveled at Leonardo's model of the colossal statue, which at the time was surmounted by a triumphal arch. That year Leonardo visited Lake Como, Valtellina, and the valley of Chiavenna, probably while traveling with the new empress's escort during part of its trip to Germany. The following year, Leonardo's engineering skill was pressed into service to restore the ducal farming estate near Vigevano, and in 1495 he began decorating rooms in the Castello Sforzesco in Milan. He probably also studied the feasibility of channeling water into the moats surrounding the castle. About this time, probably at the request of Ludovico il

Moro, Leonardo began preliminary studies for the *Last Supper,* a fresco planned for the refectory of the monastery of Santa Maria delle Grazie in Milan. A letter from the duke, dated June 29, 1497, instructs Marchesino Stampa to "urge Leonardo the Florentine to finish the work begun in the refectory of [Santa Maria] delle Grazie, and after that to see to the other wall of the refectory, and to sign instruments which oblige him to complete the work within a period of time to be agreed upon with him." In the dedication of *De Divina Proportione,* dated February 8, 1498, Luca Pacioli implies that the *Last Supper* had been completed. The process of deterioration is known to have begun twenty years later. After fifty years, Vasari saw nothing more than "a muddle of blots." By the middle of the seventeenth century, dampness, corrosive salts, and mildew had caused the paint to flake away from the wall, and visitors at the time had to take it on faith that the *Last Supper* had been a marvel back when Leonardo painted it. Remodeling of the refectory (a door was enlarged), restorations in the eighteenth century, and the French occupation in 1796—the refectory was converted into a stable—aggravated the ravages of time. "In all of painting there is no work so celebrated, yet so little known," wrote Gabriel Séailles in 1892. "Commentaries have been written about it, and there have been commentaries on the commentaries. No sooner had the master finished it than his disciples copied it. . . . Engravings exposed it to a still wider audience. . . ."

Because of Ludovico's letter regarding the completion of the refectory decoration, it was long believed that on the wall opposite the *Last Supper* Leonardo painted portraits of Ludovico with his eldest son Massimiliano and of Beatrice d'Este with her son Francesco. (They are seen in the left and right foreground of a fresco of the Crucifixion that Giovanni Donato di Montorfano painted and signed in 1495.) Vasari's and Lomazzo's accounts notwithstanding, Angela Ottino della Chiesa notes, "After the aerial bombardment of the monastery in 1943 blew off what remained of the original color, re-

paintings, and surface layers, the groundwork of the fresco reappeared, and this preliminary design tells us that the painting absolutely could not have been by Leonardo."

According to Alessandro Visconti, Leonardo "surpassed all of his contemporaries in his art of modeling and the breath of transcendent life which surrounds his portraits." "Henceforth there can be no doubt," the historian adds, "that the portraits of Ludovico il Moro's two mistresses—Lucrezia Crivelli (*La Belle Ferronnière* in the Louvre) and Cecilia Gallerani—should be attributed to Leonardo and that they are among the first paintings he did in Milan." However, not all historians are so confident. Is, in fact, the *Lady with an Ermine* (or weasel) a portrait of Cecilia Gallerani? Should we attribute it to Leonardo, or is it a Leonardesque painting by a Lombard artist? And what about *La Belle Ferronnière,* so dubbed because of the headband worn over the forehead to hold the hair in place (and which was mislabeled due to a confusion with the surname of the mistress of Francis I of France)? Is it indeed a portrait of Lucrezia Crivelli? The close resemblance between the two subjects only adds to the mystery. Is the painting in the Louvre a genuine Leonardo, or should it simply be classified as a fifteenth-century work of the Milanese school?

When the church council of Piacenza decided to have bronze doors cast for the cathedral, Leonardo, whose name appeared in 1498 on the list of the duke's engineers, brought his experience as a founder to the council's attention.

Leonardo's last years in Milan remain hazy on a number of points. He had become the owner of a vineyard on the outskirts of Milan, and it is said that he wanted to have a house built there, which would have made it easier for him to be granted freedom of the city. But where did he live prior to this? The vineyard had been a gift from the duke. What scandal estranged the artist from Ludovico il Moro just as he was starting to decorate rooms in the Castello Sforzesco? Financially speaking, Leonardo must have been secure, for he deposited six hundred gold florins with the treasurer of Santa Maria Nuova in Florence. However, we do not know what work or works this was in payment for. Was Leonardo squirreling away money for the dark days that lay ahead?

French troops descended on Milan in the summer of 1499. On September 2, Ludovico fled to the Tyrol to join Emperor Maximilian I. On September 28, the French entered Milan; Leonardo and Pacioli had already left the city. After spending some time at Melzi's home in Vaprio, Leonardo moved on to Mantua. There he did a preliminary drawing for a portrait of Isabella d'Este: a black chalk cartoon

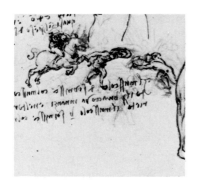

Sketches of men fighting.

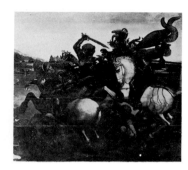

Copy of the *Battle of Anghiari*.

heightened with red chalk for her hair and skin, and yellow pastel for her dress. The artist left Mantua and was in Venice by March 1500. On February 5, Ludovico had recaptured Milan, but in April the French once again crossed the Alps. The duke was taken prisoner and brought to Loches, where he died ten years later. Leonardo tersely stated in his notebooks, "The Duke has lost his state and his possessions and his liberty, and has seen none of his works finished."

After an eighteen-year absence, Leonardo was back in Florence in April 1500. He was probably planning to proceed to Naples with Louis de Luxembourg, count of Lagny; but when the count promptly gave up his claims and returned to France, Leonardo stayed on in Florence. The Servite monks of the Santissima Annunziata had commissioned Filippino Lippi to complete two paintings for the high altar of their church. Leonardo persuaded them to transfer the commission to him. "Then the friars, to secure Leonardo's services, took him into their house and met all his expenses and those of his household. He kept them waiting a long time without even starting anything. . . ." (Vasari). On September 15, a Servite monk, Fra Saccaria, called on Baccio d'Agnolo to make a frame. Leonardo was hard at work—but not on the altarpiece. He completed a first cartoon (now lost) of the *Virgin and Child with St. Anne*. However, not only would it not have fit the frame the sculptor had carved, but its subject would not have been in keeping with the theme (the Descent from the Cross) planned for the altar. He retouched a number of his pupils' paintings. He did a small panel—perhaps the *Virgin with the Yarn Winder*—for Florimond Robert, Louis XII's secretary of state. Three variations on this theme are known to exist, but none is by Leonardo: the artist did not leave a single sketch of this painting. He spent most of his time on mathematical problems, for, as Fra Pietro da Novellara put it, "the sight of a brush [put] him out of temper."

During the first part of May 1502, Leonardo, presumably still in Florence, was asked to appraise

four valuable vases that once belonged to Lorenzo de' Medici and that were being offered to the marchioness Isabella. By the end of the month he was in Piombino, studying the feasibility of swamp reclamation projects. A captain in the army of Cesare Borgia, the duke of Valentinois (by the grace of Louis XII), approached Leonardo and invited him to enter his commander's service. The artist accompanied the captain, one Vitellozo Vitelli, to Siena (where Leonardo examined the mechanism of the clock in the Mangia Tower), Foligno, and finally Arezzo, a town that Vitelli besieged. After the stronghold surrendered on June 18, Leonardo proceeded to Urbino to join Borgia, who made him his "architect and engineer-in-chief." Now inspector of fortresses, Leonardo took part in Borgia's campaign in the Romagna, drew maps and surveys, studied anything that piqued his curiosity, and returned to Florence. There, Vasari tells us, between March and June of 1503, he began work on the *Mona Lisa* and *Leda and the Swan*. Eight years earlier, Pisa had declared its independence. As the Florentines prepared to lay siege to the renegade city, Leonardo came up with a scheme to make the Arno navigable from Florence to Pisa. He spent July 24–26 in the Florentine camp, where plans were being made to divert the Arno, cut off Pisa's link to the sea, and bring the city to its knees. Leonardo approved the project and submitted an expense memorandum.

The Signoria called on Leonardo (now back in Florence) and Michelangelo to decorate the Sala del Consiglio (council chamber). Michelangelo chose as his subject an episode from the war between Pisa and Florence: the Florentines, surprised by Pisan troops while bathing, make a dash for the weapons they had left on the riverbank. Leonardo decided to depict a battle that took place when the Florentines clashed with mercenaries of the duke of Milan at Anghiari on June 29, 1440. On October 18, 1503, Leonardo was reinstated in the guild of St. Luke, Florence's painters' guild. In February 1505, both Leonardo and Michelangelo finished their cartoons, which were put on display to admiring Florentines. The contract stipulated that Leonardo would receive fifteen florins a month beginning April 20, 1504, but that if the cartoon were not finished by February 1505, he would have to return all monies paid to him and forfeit the cartoon to the Signoria. Little wonder that Leonardo met his deadline and even started the painting proper. Unfortunately, nothing, or virtually nothing, remains of the *Battle of Anghiari* except for a minutely detailed record of the project. The colors Leonardo applied to the wall were a failure, the cartoon vanished, and the only surviving

copies show nothing but the central portion of the original composition.

"On the 9th of July, Wednesday at 7 o'clock," Leonardo noted, "died Ser Piero da Vinci, notary at the palace of the *Podestà,* my father, at 7 o'clock. He was 80 years old, left ten sons and two daughters." Actually Ser Piero died at the age of seventy-seven.

Not only did the formula Leonardo had come across in Pliny prove unsuccessful when he began painting the *Battle of Anghiari* in the council chamber of the Signoria, but work on diverting the Arno— two thousand laborers notwithstanding—had come to naught, probably due to a miscalculation on his part. This did not exactly endear him to his employer, the *gonfaloniere* Soderini. Consequently, he decided to go to Milan at the request of Charles d'Amboise, Lord of Chaumont-sur-Loire, who governed the city in the name of Louis XII. The artist stayed there until the fall of 1507, returning to Florence only briefly to do legal battle with his brothers over an inheritance from their mutual uncle. In the summer of 1508, he went back to Milan, where he remained until 1513.

In September 1513, Guiliano de' Medici (and Giovanni de' Medici, who had become Pope Leo X) invited Leonardo to live in the Belvedere Palace of the Vatican. During this stint in Rome, which lasted until 1516, he delved into a number of scientific problems.

Louis XII had once tried to persuade Leonardo to come to France, to no avail. But when Francis I offered him a pension of seven thousand gold crowns and "a palace of your choosing in the loveliest part of France," the aged artist accepted. Leonardo would serve as the king's painter, sculptor, engineer, architect, hydraulics expert, in short, "master of all arts and sciences." When he met Louise of Savoy on the road to Provence, the queen offered him her manor house at Cloux, near Blois. Included in the artist's baggage were a few of his paintings. On October 10, 1517, Cardinal Louis of Aragon and his secretary, Don Antonio de Béatis, paid a visit to the "graybeard" of Cloux. Don Antonio noted in his diary that Leonardo had shown them "three pictures, one of a certain Florentine lady done from life at the instance of the late Magnificent, Giuliano de' Medici, another of St. John the Baptist as a youth, and one of the Madonna and Child in the lap of St. Anne, all most perfect. . . ."

Though crippled with rheumatism and no longer able to paint, the guest at Cloux was involved in the staging of pageants along the banks of the Loire. In September 1517, he devised a mechanical lion, which, when struck on the chest, opened to reveal a

Frescoes in the chapel of Clos Lucé (inspired by Leonardo).

cluster of French lilies for Marguerite d'Angoulême, who was holding a celebration at Argentan. In May 1518, a mock battle was held at Amboise in honor of the marriage of Lorenzo de' Medici, Leo X's nephew, and Madeleine de la Tour d'Auvergne, niece of Francis I. A triumphal arch was erected in the main square, and galleries for spectators were built all around. From atop a makeshift fortress wooden cannon bound in iron fired balloons— "huge air-filled balls as big as casks"—which burst harmlessly on the castle walls. On June 17, 1518, Leonardo staged a pantomime at the castle of Cloux for Francis I and the royal court. "The paved courtyard was covered with a sky blue cloth," observed Galeazzo Visconti. "Then there appeared the principal planets, the sun on one side, the moon on the other, all of which made a wondrous sight."

"I shall go on," was Leonardo's terse entry on June 24, 1518. He did not fear death in the least. "As a day well spent procures a happy sleep," he wrote, "so a life well employed procures a happy death." On April 23, 1519, he dictated his last will and testament to "the royal notary in the court of the bailiwick of Amboise." To Francesco Melzi he bequeathed his books, instruments, drawings, the remainder of his pension, and "the sums of money which are owing to him from the past time till the day of his death." To his servant Battista de Vilanis he left half of his vineyard outside Milan; the other half went to Salai. To another servant, Maturina, he bequeathed "a cloak of good black cloth lined with fur, a piece of cloth, and two ducats." He even included his *fratelli carnali,* who received "the sum of four hundred scudi del Sole which he has deposited in the hands of the treasurer of Santa Maria Nuova." Leonardo also bequeathed "to the poor of the Hôtel-Dieu and to the poor of Saint Lazare d'Amboise . . . the sum of seventy soldi of Tours" and requested that "at his funeral sixty

tapers shall be carried which shall be borne by sixty poor men, to whom shall be given money for carrying them, at the discretion of the said Melzi. . . ." Our only copy of Leonardo's will is an Italian translation someone made in 1779 of a now lost original. Although, as Fred Bérence points out, "it shows all the signs of authenticity, his will nevertheless reveals the influence of French clergymen—Leonardo commends his soul to St. Michael, patron saint of France—and omits the Fiesole property that he bequeathed to his brothers. Leonardo da Vinci died on May 2, 1519. He was buried on August 12 in the monastery of Saint-Florentin in Amboise, but his remains were scattered during the Wars of Religion.

Vasari tells us that Francis I was present while Leonardo lay on his deathbed—the king was actually with the royal court at Saint-Germain-en-Laye celebrating the birth of his second son—and speaks of the artist's return to the Christian faith. In the first edition of *The Lives of the Painters* (1550) we read, "Leonardo was of such a heretical frame of mind that he did not adhere to any kind of religion, believing that it is perhaps better to be a philosopher than a Christian." This sentence was omitted in the second edition (1569), and the old man's death was turned into an exemplum: "He desired to occupy himself with the truths of the Catholic faith and the holy Christian religion. Then having confessed and shown his penitence with much lamentation, he devoutly took the sacrament."

BIOGRAPHY

1452 April 15: An illegitimate son, Leonardo, is born to Caterina and Ser Piero da Vinci, in Vinci. Ser Piero, like all of his forebears since the 13th century, is a notary. That year Ser Piero marries Albiera di Giovanni Amadori (born 1436). Shortly thereafter Caterina marries Achattabriga di Piero del Vacca, who lives in Anchiano, not far from Vinci.

1457 Tax records for 1457 state that Leonardo is living with his grandparents, his father, and his stepmother.

1464 Albiera dies in Florence.

1465 Ser Piero marries Francesca di Ser Giuliano Lanfredini.

1469 Leonardo's grandfather dies. The Signoria of Florence takes on Ser Piero as a notary.
Beginning of Leonardo's apprenticeship in Verrocchio's shop.

1472 Leonardo's name appears as a member of the Guild of St. Luke's.

1473 Death of Francesca. First drawing signed by Leonardo: a landscape dated August 5.
Leonardo paints the head of one of the angels in Verrocchio's *Baptism of Christ*.

1475 Ser Piero marries Margherita di Francesco di Jacopo di Guglielmo (born 1458).

1472–76 During this period Leonardo is believed to have done a cartoon for a tapestry depicting Adam and Eve in the Garden of Eden, a *Madonna with Vase of Water*, a *Head of Medusa*, and an *Angel*. Less doubtful attributions include the *Madonna with the Carnation*, the *Benois Madonna*, and two *Annunciations*.
April 9, 1476: Leonardo is accused of homosexual relations. On June 7 the case is closed.

1478 January 10: Leonardo is commissioned to paint an altarpiece for the San Bernardo chapel in the Signoria.
Leonardo begins the portrait of Ginevra de' Benci.

1479 December 29: Leonardo sketches the corpse of Bernardo di Bandino Baroncelli, publicly hanged for killing Giuliano de' Medici.

1480 Leonardo helps restore Lorenzo de' Medici's garden on the Piazza San Marco in Florence, possibly also does some sculpture.
Commissioned to paint an altarpiece for the church of San Donato a Scopeto: the *Adoration of the Magi*.

1482 Leonardo offers his services in a letter to Ludovico il Moro.
Leaves the *Adoration of the Magi* unfinished and moves to Milan. Paints at this time (?) the *Portrait of a Musician* and *Lady with an Ermine*.

1483 April 25: Leonardo signs a contract in Milan for the *Madonna of the Rocks*.
Ser Piero marries Lucrezia di Guglielmo Cortigiani (born 1464).
Leonardo probably does his first studies for the equestrian statue of Francesco Sforza.

1484–89 In addition to completing commissions, Leonardo broadens the scope of his work on architecture (plans for a domed church, stables, etc.), military engineering and war machines (various types of armored cars equipped with scythes, scourges, etc.), and even flying machines. From Leonardo's notebooks: "On the second day of April 1489 the book entitled 'Of the Human Figure.' "

1490 January 13: Leonardo's court festivities for the Sforza-Aragon wedding.
Leonardo resumes work on the equestrian statue of Francesco Sforza. From the notebooks: "On the twenty-third day of April 1490 I commenced this book and recommenced the horse."

1491 July: Leonardo takes in ten-year-old Gian Giacomo Caprotti da Oreno, nicknamed Salai.

1492 April 9: Death of Lorenzo de' Medici.
August 11: Rodrigo Borgia elected Pope Alexander VI.

1493 Leonardo's colossal clay model of *Il Cavallo* is put on display.
Leonardo travels to Lake Como, Valtellina, and the valley of Chiavenna.

July 13: A certain Caterina, possibly Leonardo's mother, visits the artist in Milan.

1494 Leonardo works at the ducal farming estate near Vigevano.
Preliminary studies for the *Last Supper*.

1495 Leonardo begins the *Last Supper* and decoration of rooms in the Castello Sforzesco.
Death and burial of Caterina, possibly Leonardo's mother.

1496 Portrait of Lucrezia Crivelli.

1497 June 29: Memorandum from Ludovico il Moro to Marchesino Stampa instructing Leonardo to finish the *Last Supper*.
Leonardo finishes the *Last Supper*.
Decoration of the Sala delle Asse in the Castello Sforzesco.

1498 Luca Pacioli publishes *De Divina Proportione* with figures by Leonardo.
April 26: Letter from Isabella d'Este. Leonardo named engineer to the duke.
October 2: Ludovico il Moro issues a notarized deed granting Leonardo a vineyard.

1499 Louis XII having invaded Lombardy, Leonardo left Milan for Mantua where he executed two portraits of Isabella d'Este and returned to Venice.

1500 March: after a brief stay in Venice, Leonardo returns to Florence.

1501 First cartoon for *Virgin and Child with St. Anne* exhibited in Florence.

1502 Leonardo plans to leave for Turkey. Enters the service of Cesare Borgia, serves as architect and engineer-in-chief during the Romagna campaign. Named inspector of Borgia's fortresses.

1503 Leonardo returns to Florence. In April he is commissioned to paint the *Battle of Anghiari*.
October 18: Leonardo is reinstated in the Guild of St. Luke.
Leonardo begins the *Mona Lisa* and *Leda and the Swan* (according to Vasari).

1504 January: Leonardo a member of the committee appointed to determine a site for Michelangelo's *David*.
May: Leonardo receives a letter from Isabella d'Este requesting him to paint her portrait.
July 9: Death of Leonardo's father, Ser Piero.

1505 Leonardo stops work on the *Battle of Anghiari*. From the notebooks: "Begun by me, Leonardo da Vinci, on the twelfth day of July 1505. Book entitled 'Of Transformation,' that is, of one body into another without diminution or increase of substance."

1506 March 22: Leonardo begins a collection of notes on mathematics and physics in the house of Piero di Braccio Martelli.

June: Leonardo leaves Florence for Milan at the request of Charles d'Amboise.
Finishes the second *Madonna of the Rocks*. Continues work on *Virgin and Child with St. Anne*.

1507 Through the Signoria, Louis XII asks Leonardo to remain in Milan. Legal battle between Leonardo and his younger brothers.

1508 From the notebooks: "Begun at Florence in the house of Piero di Braccia Martelli, on the 22nd day of March 1508. And this is to be a collection without order, taken from many papers . . ."
September: Leonardo returns to Milan.

1509 Leonardo draws maps and geological surveys of Lombardy and Lake Isea.

1510 From the notebooks: "This winter of the year 1510 I look to finish all this anatomy." "The Book of the science of Mechanics must precede the Book of useful inventions.—Have your books on anatomy bound!"
"My treatise *On Voices* in the hands of my Lord Battista dall'Aquilo, the Pope's private chamberlain." Drawings of Apocalyptic Visions.

1513 March 25: Leonardo in Milan.
September 24: Leonardo leaves Milan with Melzi, Salai, and two servants. Enters the service of Giuliano de' Medici, brother of Pope Leo X, and resides in the Belvedere Palace of the Vatican.

1514 From the notebooks, after a demonstration of geometry: "Finished on the seventh day of July, at the twenty-third hour, in the Belvedere, in the study made for me by the Magnifico, 1514."
September: Leonardo travels to Parma, Sant'Angelo, Bologna, and Florence.

1515 January 9: Leonardo notes the death of Louis XII. Paints *St. John the Baptist* (c. 1515).
October 11: Francis I of France enters Milan.

1516 March 17: Death of Leonardo's patron, Giuliano de' Medici.
Leonardo leaves for France in the fall.

1517 Leonardo arrives at Amboise in April and settles in the manor house at Cloux in May. Cardinal Louis of Aragon pays Leonardo a visit. He is still able to draw, although his right hand is partially paralyzed.

1518 Leonardo probably involved in the staging of royal pageants.
May: Festivities in honor of the Dauphin's baptism and the marriage of Lorenzo de' Medici and Francis I's niece (both at Amboise). Court entertainments at Cloux in honor of Francis I.
Leonardo does hydrographic studies for possible canalization of the Loire and the Saône.

1519 April 23: Leonardo dictates his last will and testament.
May 2: Death of Leonardo. Buried at Amboise, but his remains are scattered during the Wars of Religion.

I LEONARDO ON PAINTING:
The *Trattato della Pittura*

LEONARDO da Vinci's principal, possibly his only, weakness was knowing that he was Leonardo da Vinci (not counting the fact that Leonardo da Vinci was mortal). Inquisitive about everything, confident of equaling and surpassing anyone, regardless of subject, capable of captivating everyone, yet refusing ever to be wholly dependent on a patron or employer, all his life Leonardo worked with tremendous intensity to develop his mind, enrich his personality, and hone his skills. But when the effort involved giving others satisfaction, he was not so liberal with his talent. So multifarious were his projects, so diverse his interests, that biographers invariably find themselves thrown off course every step of the way. Anyone trying to categorize Leonardo's observations and insights by subject and type of endeavor, relegating chronology to a secondary consideration, ends up torn between keen admiration and justifiable vexation. Why did not Leonardo explain himself more fully, delve deeper, produce more? Obviously, it is no easy thing to admit that Leonardo worked above all for Leonardo, and that even as a painter, if he seemed to consider some of his works finished, perhaps it was really because outside circumstances left him no alternative, or because he deemed it necessary to let some time pass before returning to the subject.

That Leonardo produced so few paintings comes as a surprise, but, as André Chastel points out, equally astonishing is the fact that there were "so very many copies and imitations so early on, which points to a scanty output, to be sure, but one which artists continually scrutinized and exploited with unsettling enthusiasm." Over and above Leonardo the painter, however, there was Leonardo the man, forging his own legend in turbulent Renaissance Italy, a time and place brimming with brilliant, colorful personalities and knowledge-hungry minds. Although it took four centuries for the legend to come

to full flower, it had already taken root while the artist was still alive. Not only did Leonardo consider his self-appraisal to Ludovico Sforza to be accurate, he managed to convince others it was, too. Nothing lay beyond the grasp of his intellect, the legend went. His technical expertise enabled him to solve highly complex problems involving hydraulics, ballistics, and architecture; his intuition guided him to bold schemes far ahead of his time; and to top it all off, he could paint better than any other artist of his day.

An effusive Giorgio Vasari wrote of a Leonardo, "marvelously endowed by heaven with beauty, grace, and talent in such abundance that he leaves other men far behind, all his actions seem inspired, and indeed everything he does clearly comes from God rather than from human art." Capable of effortlessly overcoming all obstacles, Vasari continues, Leonardo would have pushed his quest for knowledge still further had he not been "so volatile and unstable," if he had not been given to "setting himself to learn many things only to abandon them almost immediately." Later on, biographers, after an examination of the thousands of notes and sketches Leonardo left behind—coupled with the certainty that a great many more texts and drawings did not survive—rejected Vasari's assertion that the artist was flighty and temperamental. A bit more time, they held, and he would have completed the many treatises for which he had already laid the groundwork. Already hailed as the greatest artist of the Renaissance, Leonardo became the prophet of modern times, the genius of science.

Along came another generation of historians who virtually turned their back on the painter they must have thought all too easy to admire. They threw together what Leonardo hoped to finish and what he actually did, and—unaware of (or choosing not to acknowledge) the contributions of those who had come before him as well as the technical advances made by his contemporaries—they turned their attention to the universal superman, the inspired precursor. Once again Leonardo had been done an injustice.

However, making Leonardo out to be a "prophet" or "seer," saying that he was far ahead of his time, that he drew up blueprints of what the nineteenth and twentieth centuries were to turn into reality, also implies that those who came after were superior, or at least that Leonardo had somehow fallen short of the mark. Now that we have a clearer picture of the intellectual history of the Middle Ages and can give the contributions of fifteenth-century engineers their due, we are in a po-

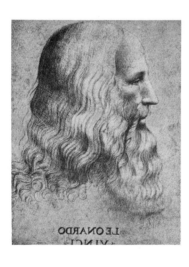

Presumed portrait of Leonardo da Vinci
Pinacoteca Ambrosiana, Milan.

sition to restore Leonardo to his era, appreciate the positive aspects of his output as a whole, and concentrate on how certain of his ideas were fruitful for *his* time, not on what prevented them from being of ours.

Of the treatises Leonardo was planning to compile, the one on which he seems to have made the most headway is without question the *Trattato della Pittura*. He completed an outline of it about 1490 and continued accumulating notes, observations, sketches, and amplifications. If he did not live to see the *Trattato* in a structured form, certainly it was not for lack of material. After Leonardo's death, Francesco Melzi took the master's papers to his family home at Vaprio d'Adda, let people consult and copy them, and readied his own anthology that would bear the title *Trattato della Pittura*. This project, however, was left unfinished. The papers changed hands a number of times and ended up in the Vatican, where they were collectively dubbed the *Codex Urbinas Latinus 1270*. More than fifty manuscript copies were derived from this material, all "not as complete and at times undisguisedly simplified." The one in the Biblioteca Ambrosiana (Ms. H. 228) was the basis for R. du Fresne's edition of 1651. (A French translation by Fréart de Chambray was published the same year.) Subsequent editions in Italian, French, English, German, and Spanish, right up to the nineteenth century, did nothing but repeat the du Fresne edition.

In 1960, André Chastel edited a French version of the *Treatise on Painting,* "for the first time translated and restructured from all of [Leonardo's] manuscripts." "The *Trattato* is doubly significant," Chastel writes. "Transmitted to us through R. du Fresne's edition of 1651 (based on the *Cod. Urb. 1270),* it was the only set of Leonardo's writings we knew of until his manuscripts were methodically edited in the late nineteenth century. Secondly, this undisputedly remarkable selection from Leonardo's writings provides us with a great many insights we would not have gotten from surviving autograph manuscripts."

In his edition of the *Trattato*—a mingling of "serviceable pages from Melzi's *Trattato*" and excerpts from published manuscripts—Chastel preserves the original combinations of text and drawing while conceding the "fragmentary and discontinuous" nature of Leonardo's writings as a whole. He worked out the following scheme:

1. The *Paragone:* painting's place among intellectual endeavors
2. The universal agenda: the painter and reality
3. Problems confronting the painter: theory and practice
4. The painter's studio: precepts and tricks of the trade

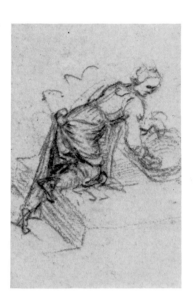

Woman washing clothes
Royal Collection, Windsor Castle.

5. The painter at work: his life and inner dignity

The editor justifies this blueprint on two grounds. Firstly, "it mirrors the successive categories through which painting moves as an intellectual and human endeavor," and thus works for any painter, regardless of when he lived. Secondly, since reproducing Leonardo's writings in their entirety was out of the question and given the fact that "less than pithy notes and overlapping remarks" were excluded, Chastel's criterion for inclusion boiled down to his system of classification and his attempt to restore "ramifications and internal logic." "In this manner," he notes, "the progression of fine points becomes as interesting to follow as the solemn development of the whole." It should be added, however, that certain chapters of the *Trattato* have not survived (if in fact they were ever written), and that Chastel felt it necessary to fill in these supposed lacunae with texts "obviously quite different from what would have been included in a *trattato* in the strict sense of the word."

In a kind of preface entitled "Les Projets," the editor of this "reconstructed" *Treatise on Painting* quotes Leonardo's diatribe against "abbreviators" who compile manuals and anthologies. "Abbreviators," he writes, "do harm to knowledge and to love, seeing that the love of anything is the offspring of this knowledge, the love being the more fervent in proportion as the knowledge is more certain. And this certainty is born of a complete knowledge of all the parts which, when combined, compose the totality of the thing which ought to be loved. Of what use then is he who abridges the details of those matters of which he professes to give thorough information, while he leaves behind

the chief part of the things of which the whole is composed?"

Granted, Leonardo did not complete any of his treatises, not even the one on painting. But does this mean that people intrigued by Leonardo's thoughts should shun those notes he had planned to include in treatises, but of which only fragments survive, and that they should be even more wary of the anthologies a few of his admirers have compiled? Must we hold it against them that they have suggested some kind of scheme or master plan? Or perhaps we should distinguish between good and bad "abbreviators" and, before tackling those "reconstructions," simply bear in mind that we are dealing with interpretations whose faithfulness to the original is still subject to evaluation.

Common sense dictates that Leonardo's sincere admirers should read and reread the *Trattato,* even if something they read elsewhere casts doubts on the validity of an editor's suggested order or grouping of texts. A person who confidently praises the beauty of an ancient masterpiece because it is famous marvels at his own good taste. When he learns that this part vanished, that part was restored, another part appended later on, he loses all enthusiasm and fears he is compromising himself. He is willing to love a work of art, but only if it is a sure thing. Since many art lovers seem less concerned about distinguishing between the authentic and the not-so-authentic than about their anxiety over not showing enough critical acumen, love of art is quite often reduced to temporary commitments. The painting business provides us with distressing examples of this, while museum-goers, for all their wide-eyed curiosity, remain oddly receptive to attributions suggested by curators.

For many reasons that have nothing to do with simple demographics, the number of art enthusiasts (or those claiming to be) as the twentieth century draws to a close is out of all proportion to what it must have been in the early sixteenth century. It would be pointless to try and determine which of the two eras had surer and more refined taste. What is certain is that a single phenomenon—photography—brought about a fundamental change in the way people looked at things. Before photography, art lovers not only regularly went to see works of art, but turned to books, periodicals, and other printed media for information and ideas that could supplement their visual experience. True, there were engravings "after" paintings, but all they did was refresh the memory; the same was true of copies, even those signed by the very best artists. With the advent of collections both public and private, the more celebrated a painter, the more difficult it became to see

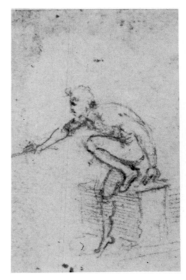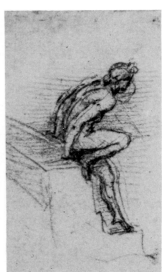

Male Figure
Royal Collection, Windsor
Castle.

the fruit of an entire career that was now scattered throughout the world. Except for an occasional exhibition, it remained impossible to compare a lifetime of painting in a single time and place. Now, thanks to photography, books, newspapers, films, and television, the opposite is true: the more famous an artist, the better known his entire *oeuvre.* Before going to a museum or private collection to view a painting by a certain artist, one feels as though one is about to pay a visit to an old friend, because it—indeed, the artist's entire output—is *déjà vu,* and many times over at that. Similarities and omissions take on a different meaning. Another possibility: Might not a well-known contemporary artist modify the way he works, knowing that a painting is no sooner finished than it is reproduced and published, over and over again?

"The mind of a painter," Leonardo writes in the *Trattato della Pittura,* "must resemble a mirror which always takes the color of the object it reflects and is completely occupied by the images of as many objects as are in front of it. Therefore you must know, O Painter, that you cannot be a good one if you are not the universal master of representing by your art every kind of form produced by nature." Elsewhere, however, he observes that "the painter who draws merely by practice and by eye, without any reason, is like a mirror which copies every thing placed in front of it without being conscious of their existence." In another note we read, "Necessity obliges the mind of the painter to take the place of the very soul of nature and to become the interpreter between nature and art; he resorts to the latter as a way of

elucidating its inner workings and processes." There seems to be a gradual shift in thinking from one passage to the next. In fact, the last statement virtually contradicts the first. No longer does the painter merely reflect the world like a mirror. He must know the world, the better to become "an interpreter between nature and art." What matters now is *knowing*.

Thus, the painter becomes a philosopher. "Painting was Leonardo's philosophy," wrote Paul Valéry. "Painting for Leonardo was a process that called on all branches of knowledge and virtually the entire gamut of techniques. Geometry, dynamics, geology, physiology. Depicting a battle implied having to study clouds of dust and whirlwinds; he would represent them only after observing them with eyes that were well informed, imbued with a knowledge of the laws governing them. A human figure was a fusing of disciplines ranging from dissection to psychology. He noted with exquisite precision how differences in age and sex should be depicted; elsewhere he studied workers as they plied their sundry trades. Everything was grist for his mill, for his desire to get at and grasp forms through their causes. His starting point was the appearances of things. He then boiled down, or tried to boil down, their morphological traits to systems of forces. Once these systems had been grasped, experienced, and studied, he completed—or more precisely, reactivated—the process by producing a drawing or painting in which he reaped the fruit of all the strain he had put himself through. In this way he re-created the way phenomena appear or project themselves, through in-depth analysis of their every conceivable characteristic."

Thus, Leonardo found in painting all the problems arising from an attempt to map out an all-embracing view of nature. However, as Valéry points out, "if philosophy is inseparable from expression (through language), and if that expression is the aim of every philosopher, then Leonardo, whose aim was painting, was not a philosopher, although he has all the earmarks of one." Probably. But "language, organic and vital though it may be, can bring *nothing* in the realm of thought to a conclusion; its very transience precludes its ever being pinned down. The very act of focusing our attention creates a gap between it and us. Both the rigor of logic and the heat of emotion set us at odds with it." "Philosophy can be thought of as an attitude, an anticipation, a restraint through which an individual now and again thinks his life through, or lives his thinking, in a kind of equivalence or reversible state between *being* and *knowing*. Attempting to hold all conventional expression in abeyance, he senses that a particular combination of thoughts—one far more precious than any other—is coalescing and becoming better defined, one which meshes reality as he feels it within and reality such as it makes itself felt on him."

In other words, the endeavor is doomed to failure by the nature of language itself, and the only way someone reading a philosopher's writings can make them come alive is through a sort of personal act of creation. This is why the idea of two entirely consistent philosophers—with a single, unchanging interpetation of the universe—is inconceivable. Since philosophy, like poetry, can have no real existence except through this act of creation on the part of the reader—"The soul we have this evening shall never be ours again," to quote the Comtesse de Noailles—having painting as one's philosophy may seem a reckless venture bordering on the irrational. However, the hold that Leonardo da Vinci's paintings have had on humankind for almost four centuries leads us to believe that the effort is worthwhile.

Having set as his goal a treatise on painting—that is, a treatise on appearances—Leonardo owed it to his future readers, and above all himself, to amass technical notes and useful bits of advice that might help painters render those appearances. At times the surprised reader will find these notes, albeit seminal reading for anyone wishing to understand better Leonardo's paintings, disconcertingly ingenuous.

Some of his advice is of a purely practical sort: how to prepare colors and supports; how to render the perspective of color with the help of a plate of glass; how to draw with a plumb line or grid; how to use a frame to draw shadows. Other fragments focus on various kinds of perspective, color, light—everything that has anything to do with the observation of man and nature.

Some psychoanalysts believe that one of their best-known tools, the Rorschach test, yields an accurate "psychodiagnosis." What does the patient see in an ink blot? Armed with the patient's responses, the analyst ferrets out—or thinks he is ferreting out, which amounts to the same thing when it comes time to pay his fee—what is hidden in the patient's unconscious and what he has hitherto repressed. Without giving any thought to its possible therapeutic value, Leonardo had already observed how easily the mind fabricates anything out of anything set before it: a cloud, some mildew, a shadow, some tangled threads. True, this is something we all notice, some of us as far back as childhood. But Leonardo hit upon its potential for artists. "When you look at a wall spotted with stains, or with a mixture of stones, if you have to devise some scene, you may

discover a resemblance to various landscapes, beautified with mountains, rivers, rocks, trees, plains, wide valleys, and hills in varied arrangement; or again you may see battles and figures in action; or strange faces and costumes, and an endless variety of objects, which you could reduce to complete and well-drawn forms."

This "deception"—Leonardo's own word to denote a fleeting aberration of our senses prompted by our own imagination, not the exploitation of this aberration by others—helps the modern psychoanalyst to pinpoint the manner in which the ego interacts with various aspects of a patient's personality. "The ego," writes M. R. Eissler, "must constantly hold out against pressure from things that are repressed. It dares not give them free rein, these free-floating fantasies which spring directly from the unconscious like so many offshoots of suppressed desire. The way to get around this is to use perceptions that are securely anchored in neutral external objects. Within this framework, the imagery projected by the mind is less likely to break loose from the bounds which hold it back. Thus, artistic inspiration may tap the creative potential of unconscious imagery without running the risk of triggering undue excitement or anxiety."

Not only does the creative potential of unconscious imagery pose no threat to artists in general; apparently it is what enabled Leonardo to create some of his most inspired visions. It is an eerie world that is his and his alone: age-old mountains, weathered crags, and bluish glaciers in a rarified atmosphere; gloomy caves of impenetrable stone; mysteriously barren landscapes; *chiaroscuro* that casts a veil of vagueness over everything it touches. René Huyghe notes an "obsession with secrecy" in Leonardo's work, an obsession that manifests itself in "unfathomable souls locked away behind inscrutable faces with fleeting, deceptive smiles that make them that much more elusive and baffling."

II RELIGIOUS PAINTINGS

AFICIONADOS of painting are always uneasy when it comes to simply admiring a work of art, and for them Leonardo's admittedly small *oeuvre* remains a special source of anxiety. The painter's reputation has been irreproachable for more than a century; everything he produced has been hailed as a manifestation of profound genius. But do we really know what he produced? How easy everything would be if there were a reliable chronological list of his works! Over the past century, a number of new works have been added to the list; others have been deleted. Historians have stepped into the picture; art critics have formed their opinions. Virtually every painting presents a problem of one kind or another.

Among the handful of paintings about which there is no doubt, religious subjects predominate: the *Annunciation,* the *Adoration of the Magi,* the *Benois Madonna, St. John the Baptist,* the *Last Supper,* and *St. Jerome.* Though few in number, they are known the world over. Only the *Mona Lisa* is rooted more securely in people's memories. Leonardo's Virgins and angels, the head of Christ in the *Last Supper,* St. John the Baptist, and even St. Jerome have enjoyed—and continue to enjoy—astounding "press," so to speak, thanks to religious iconography and pictures of the kind seen at first communions. Countless crowds pause in front of the *Mona Lisa,* whether in the Louvre or during one of its stints in New York or Tokyo. More often than not, reproductions have already familiarized them with the painting. A twofold "museum without walls" has taken shape in the minds of twentieth-century man, one in which Leonardo probably occupies a place of choice.

Anyone looking at an actual work of art for the first time becomes aware of both the inadequacy of reproduction and the tricks his own memory can play on him. This double screen turns that first physical encounter into a ticklish situation, making it hard for him to fathom the emotional response of those who, in bygone days, saw only the work before them, not the work superimposed on a previously seen facsimile. Drawing on a highly sophisticated arsenal of techniques, armed with history and X-ray photography, experts do everything in their power to look at paintings as though they were seeing them for the first time. This accounts not only for their enthusiasm and diverse opinions, but for the trouble readers often have in grasping their arguments.

History tells us that about 1475, in Florence, Verrocchio painted a *Baptism of Christ* for the brothers Di Vallombrosa, a work that has hung in the Uffizi Gallery since 1914. (Florence has always been its home, although it was moved from the monastery of San Salvi to Santa Verdiana and again in 1810 to the Academy of Fine Arts before its final transfer to the Uffizi.) Two angels kneel to the left of Christ, the central figure, as John performs the baptism. Verrocchio had Leonardo, then one of his pupils, paint the angel at far left and perhaps also the landscape behind the pair of angels. According to Siren (1928), Leonardo added his angel some time after the entire painting had been finished. While there is some doubt as to whether this was actually Leonardo's first attempt at painting, all historians allude to Vasari's anecdote about how Verrocchio "would never touch colors again, he was so ashamed that a boy should know more of their art than he did."

Our aim is not to debate the merits of this old and widely accepted account. We will simply point out that this *Baptism* is in fact Verrocchio's last known painting and that Leonardo showed his genius for painting while still a youth. It should also be added that Verrocchio was above all a sculptor and goldsmith and, as Walter Pater points out, ". . . painting had always been the art by which Verrocchio set least store." Leonardo, for his part, thought of himself primarily as an engineer. In any event, the question of who painted the angel in the *Baptism of Christ* is no longer a subject of controversy.

Both the Uffizi Gallery (Florence) and the Louvre (Paris) claim an *Annunciation* by Leonardo, but at first they were attributed to Domenico Ghirlandaio. The one in the Uffizi was painted for the church of the monastery of San Bartolomeo di Monte Oliveto, near Florence; the one in the Louvre was part of a predella. The Uffizi catalogue did not list the first *Annunciation* as a Leonardo until 1869, two years after it had been transferred to the museum. The Louvre *Annunciation,* acquired in 1861 as part of the Campana collection, was pronounced a Leonardo in 1875 by Giovanni Morelli. Both gave rise to protracted wrangling among experts. The majority of them are of the opinion that Leonardo had at least a hand in the Uffizi version and considerably more than a hand in the Louvre version. However, some feel that these attributions are mutually exclusive. Ruskin considered the Uffizi painting undoubtedly an authentic da Vinci and scorned those scholars who did not see it as such. "In terms of detail," writes Angela Ottino della Chiesa, "the little panel in the Louvre, which was painted after the Florentine *Annunciation,* is coherent, personal, vibrant," and could not have been done by anyone except Leonardo. This much is certain: both are worthy of our admiration.

Everyone is familiar with the splendid drapery studies Leonardo drew, or those attributed to him.

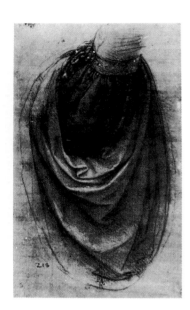

Study of a sleeve
Royal Collection, Windsor
Castle.

"Sometimes he made clay models," notes Vasari while describing the painter's youth in Florence, "draping the figures with soft worn linen dipped in plaster and then drawing them painstakingly on fine Rheims cloth or prepared linen . . . drawings done in black and white with the point of the brush." Perhaps the few surviving studies on prepared cloth surfaces traditionally attributed to Leonardo are the ones Vasari alludes to, but some experts have their doubts. This must have been a widespread practice, not only in Verrocchio's shop but among other painters as well. However, as A. E. Popham points out, "the medium is an impersonal one and the artist's individual outlook is apparent rather in the arrangement of the draperies on the model than in the actual handling."

Probably the best known and most widely accepted of these studies is in the Louvre: a drawing of clay-dipped drapery for a seated figure. The curious thing about it—though less curious than for other painters—is that only this drawing was used for a painting and that the painting in question is not by Leonardo, but by Domenico Ghirlandaio: the *Madonna and Child with Saints and Angels* in the Uffizi. At the time Ghirlandaio painted it, he did not depict drapery this way, which is more akin to Verrocchio's approach to drapery. Moreover, the drawing in the Louvre immediately brings to mind the drapery of the angels in the *Baptism of Christ* or that of the Madonna in the Uffizi *Annunciation*.

Three other drapery studies—one in the Louvre, another in the Uffizi, the third in the collection of the Comtesse de Béhague—are quite similar, but none can be matched exactly with the drapery in the Uffizi *Annunciation*. Fortunately, a preliminary drawing Leonardo did for this painting survives: a pen-and-ink study for the sleeve of the angel (Christ Church Library, Oxford).

A. E. Popham mentions a drawing "which though its purpose is equally uncertain, is indubitably by Leonardo himself. It is the beautiful silverpoint study on a brilliant wine-red surface of the kneeling Virgin. The drapery is a marvel of precise and sensitive draughtsmanship. It has the extreme delicacy of Lorenzo di Credi without his niggling quality and shows in fact that artist's *point de départ* in the fellow-pupil who influenced him so strongly. And apart from its infinite superiority it is drawn by a left-handed artist. It has been claimed to be a combined study for the Madonna and the angel in the small Louvre *Annunciation*—the upper part of the figure being that of a Madonna while the drapery is very close indeed to that of the angel in reverse. But if the small *Annunciation* is in fact by Credi, such a subtle piece of plagiarism would be quite consistent with his character. Indeed a comparison between the so similar drapery of the angel in the picture and the drawing emphasizes the Credi-like quality of the former."

Ordinary art lovers will find the going just as rough if they try to follow the experts who attribute to Leonardo the *Madonna with the Pomegranate* in Washington's National Gallery and the *Madonna with the Cat* in the Noya collection (Savona).

Two other paintings are widely considered to be authentic Leonardos: the *Madonna with the Carnation* in the Alte Pinakothek (Munich) and the *Benois Madonna* in the Hermitage (Leningrad). The arguments that have been put forward to justify these attributions bring out a number of crucial elements that those who are put off by these works may find welcome. Of the *Madonna with the Carnation,* Berenson writes: "With its young, beaming mother and vacant child still unable to direct his movements, the intricate hairstyle and labyrinthine drapery, over-elaborate flowers and Dolomite landscape, this painting is already full of the contradictions and unsettling strangeness which rather spoil for us the magic and magnificence of Leonardo." Berenson also went to see the *Benois Madonna,* named for the man who sold it to the Hermitage at the beginning of the century. "One unhappy day," he writes, "I was called upon to see the 'Benois Madonna,' a picture that had turned up in Russia some few years ago, and has since been acquired by the Hermitage. I found myself confronted by a young woman with a bald forehead and puffed cheeks, a toothless smile, blear eyes, and furrowed throat. The uncanny, anile apparition plays with a child who looks like a hollow mask fixed on inflated body and limbs. The hands are wretched, the folds purposeless and fussy,

the color like whey. And yet I had to acknowledge that this painful affair was the work of Leonardo da Vinci. It was hard, but the effort freed me, and the indignation I felt gave me the resolution to proclaim my freedom."

A note Leonardo made in a corner of a drawing in the Uffizi Gallery suggests that the *Benois Madonna* may have been one of the two Virgins the artist began in the final months of 1478. The other may be the now lost *Madonna with Vase of Water,* whose flowers, Vasari notes, "had on them dewdrops that looked more convincing than the real thing."

In the Cabinet des Dessins of the Louvre there is a pen-and-ink over silverpoint of the *Madonna and Child with a Plate of Fruit.* In this semiprofile, half-length portrait, the seated Mary holds the Christ child in her lap, offering him a bowl of fruit with her right hand. The child thrusts his left hand in the bowl while raising his other hand toward his mother's face, which is tilted forward. The study was once attributed to Raphael, but Both de Tauzia restored it to Leonardo. Could it be a first sketch for the *Benois Madonna* in the Hermitage? The face of the Virgin is similar to the one in the *Adoration of the Magi,* which Leonardo worked on about the same time as this drawing.

One way Leonardo prepared for paintings that included the Christ child, the infant St. John the Baptist, or angels (usually depicted as older children) was to draw countless studies of little children, many of which are marvels of draftsmanship in their own right. By and large these children range between nine and eighteen months of age, are shown nude, and so closely resemble one another that one is tempted to think that Leonardo used only one model for all of them, or rather that he came up with an ideal child-type he felt was appropriate to his religious paintings: the *putto.* Little nude children—no doubt the Eros of Hellenistic times come back to life—had resurfaced in Italy almost a century earlier. Highly favored in works of art both religious and profane, the *putto* became the model even for the Christ child and other sacred child subjects. "There is an unmistakable link between this predilection for child nudity and the prevailing taste for nudity in the ancient style, which overtook even portraiture," notes Philippe Ariès. "However, it lasted much longer and permeated every sphere of decoration. . . ." "Like the medieval child—which was depicted either as a holy child or an allegory of the soul or some sort of angelic creature—the *putto* of the fifteenth and sixteenth centuries was not a flesh-and-blood child in historical time. This is all the more remarkable in that the *putto* came

into its own at the same time as child portraiture. However, children in fifteenth-century portraits are never, or almost never, depicted in the nude. Either they are swaddled (even when in a kneeling position) or else they wear cloths befitting their age and social status. People simply could not conceive of the historical child, however tiny, in terms of the mythological or ornamental—that is, nude—child, and this distinction persisted for a long time."

Perhaps all the more staggering for its never having been finished, Leonardo's painting of *St. Jerome* (Vatican, Rome) was probably begun in 1481. Even though we do not know for whom it was painted or the circumstances surrounding it, there can be no mistaking its deeply felt anguish. A passage in the *Trattato della Pittura* may shed some light on the stage at which the artist stopped work on the painting. "Affix the canvas to a stretcher, rub with a thin layer of size, and let dry. Make your drawing, using silk brushes for flesh tints, and straightway you will obtain a suitable *sfumato* effect. Use white, lake, and massicot for flesh tints; black, massicot, and some lake, or even black chalk, for shadows. Let this groundwork dry. Then retouch with a mixture of lake and gum solution; allow the lake to sit in the gum solution for a long time, for then it will leave no gloss when used. In order to darken shaded areas, take some of the lake I have just mentioned, dilute with gummed ink, and with this tint you will obtain several colors, for this tint is transparent and will be useful for rendering azure, lake, and vermilion shadows as well as shadows in a number of other colors. . . ."

Leonardo probably began and stopped work on the *Adoration of the Magi* about the same time as *St. Jerome.* The monks of San Donato a Scopeto had commissioned it for their high altar in March 1481. The groundwork, which was left in the house of Amerigo Benci in 1482, now hangs in the Uffizi Gallery. In a break with the traditional approach to the Nativity, usually depicted as a scene of great joy, Leonardo presents us with a crowd caught up in the kind of distress already seen in *St. Jerome.* Here, too, Leonardo did not get beyond a first application of ocher.

Just as different museums boast *Annunciations* by Leonardo, so there are two versions of the *Madonna of the Rocks:* one in the Louvre, the other in London's National Gallery. Given the noticeable differences between the two paintings, naturally there has been much discussion over which version came first. At first blush, the interpretation suggested by Julien Segnaire—that the London *Madonna of the Rocks* is a later version of the one in the Louvre—seems ade-

quate. According to this hypothesis, Leonardo began the first version after stopping work on the *Adoration of the Magi* (late 1481 or early 1482) and brought it to Milan unfinished. On April 25, 1483, the Confraternity of the Immaculate Conception in Milan commissioned him to paint the central panel of the three-section altarpiece in their chapel; the da Predis brothers were assigned the side panels. However, Segnaire argues, "what he agreed to paint in Milan in 1483, with the assistance of the brothers da Predis, was simply a replica of his earlier painting. The subsequent dispute over fees and the legal battle with the monks of the Immaculate Conception concerned this replica only, namely, the London *Madonna of the Rocks.*" While it is true that there was never any mention of substitutions or replacement of one painting with another in the 1483 contract or at any time during the ensuing lawsuit, "the short deadline the painters agreed to in the original contract strongly suggests that they had a cartoon already prepared. (The deadline had been set at seven and a half months, whereas the contract for the *Adoration of the Magi* gave Leonardo a maximum of thirty months.)"

However, this interpretation is not airtight. In the first place, the arch-shaped painting perfectly matches the opening in the frame which Del Maino had carved before Leonardo's arrival in Milan. Secondly, surely the text of the 1483 contract would have read differently if Leonardo had come to Milan with a finished, or nearly finished, painting. According to Angela Ottino della Chiesa, the Louvre *Madonna of the Rocks* was still in the retable of San Francesco Grande in 1503, but the groundwork of a copy was in the da Predis workshop. In 1506 (the year the matter was settled in court), since Leonardo had not yet been paid for the first painting, it was forfeited to the artist, who in turn let the king of France have it. At the same time, for half of the additional payment he had been asking for the original version, Leonardo gave the Confraternity the groundwork, which he agreed to finish and for which the Confraternity set a two-year deadline. This, she argues, is the London version.

The Louvre *Madonna of the Rocks* was first mentioned as being in the royal collection at Fontainebleau in 1625. The London version, which remained in the church of San Francesco Grande in Milan until 1781, was taken to the hospital of Santa Caterina in Milan and purchased in 1785 by the English painter Gavin Hamilton. It was in the collection of the Marquis of Lansdown, then the Earl of Suffolk, before finally entering the National Gallery in 1880.

The gloomy rocks, the murky, almost under-

water light, and the unreal gracefulness of the faces create an atmosphere of uneasiness and mystery. The angel, wrote Théophile Gautier, "is the sweetest, purest, proudest head ever painted on canvas. . . . Certainly no Virgin, indeed, no woman was ever given a more beautiful face, yet a masculine spirit, a commanding intelligence glows in those black eyes that vaguely gaze at the spectator who would fathom their mystery."

Fra Pietro da Novellara, a Carmelite friar who had come to Florence to preach the Lenten sermons, wrote as follows to the Marquess of Mantua on April 3, 1501:

"I shall attempt to curry favor with the painter of the *Last Supper*. I can vouch for the fact that, as of this moment, he is leading so unfocused and unsettled a life that he seems to be living from hand to mouth. Since he has been in Florence, he has done only one cartoon, which shows a Christ child, about one year old, leaning away from his mother's arms as he tenderly reaches out to embrace a lamb. Meanwhile, the mother rises from the lap of St. Anne to restrain her son and distract him from the animal that symbolizes his Passion. St. Anne also rises slightly, as though to restrain her daughter, perhaps signifying that the Church wants nothing to stand in the way of the Passion of Christ. Actually, this sketch is not even finished. Leonardo is not involved in any other projects; now and again he retouches portraits that have been assigned to two of his pupils. He is working hard at Geometry and is losing all patience with his brush."

The unfinished and retouched *Virgin and Child with St. Anne* is thought to date from the second Milanese period (1507–1513). Vasari informs us that the painting was commissioned by the monks of the Santissima Annunziata in Florence for their high altar. We also know that Leonardo brought the painting with him to France and that Cardinal Louis of Aragon saw it in the manor house at Cloux. Many consider the *Virgin and Child with St. Anne* a treasure trove of esoterica and occult wonders; some see in it the expanding cosmos and an all-embracing system of beliefs. The thing that astonished Berenson, however, was the fact that "seated on no visible or inferable support, she [St. Anne] in turn on her left knee sustained the restless weight of a daughter as heavy as herself"! Dr. Freud, for his part, detected a vulture lurking in the Madonna's cloak.

Following page. ANDREA DEL VERROCCHIO AND LEONARDO: BAPTISM OF CHRIST (detail)
According to several art historians, the angel on the left and part of the background are Leonardo's, the rest of the painting by Verrocchio and his pupils. Oil on panel. Uffizi Gallery, Florence.

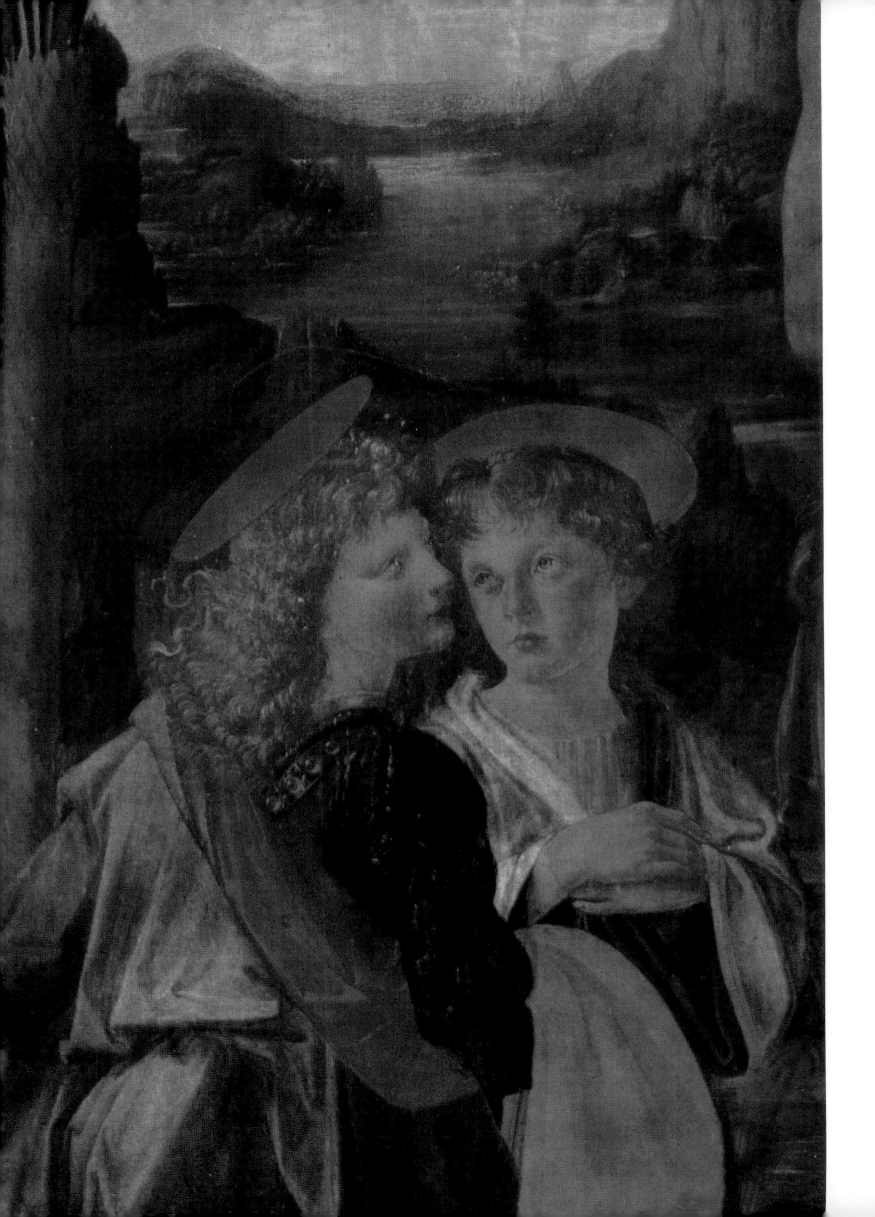

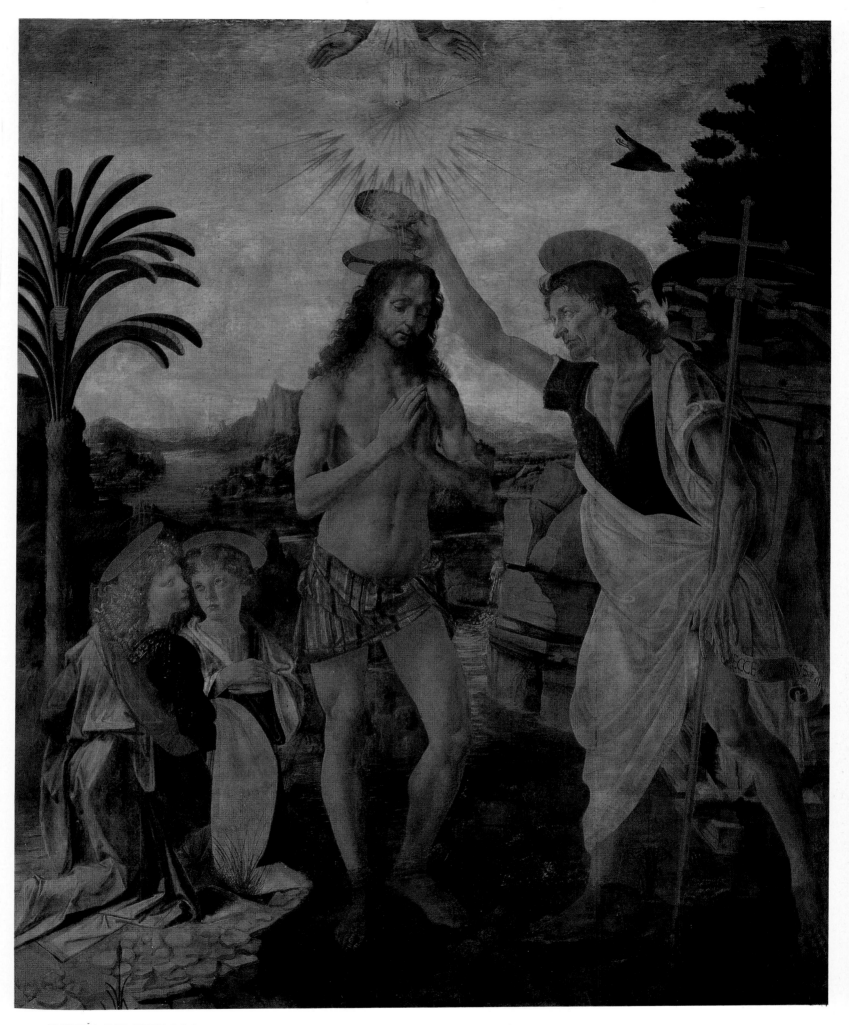

ANDREA DEL VERROCCHIO, LEONARDO, AND VERROCCHIO'S WORKSHOP: BAPTISM OF CHRIST
1472–1475. Egg tempera and oil on panel, 177 × 151 cm. Uffizi Gallery, Florence.

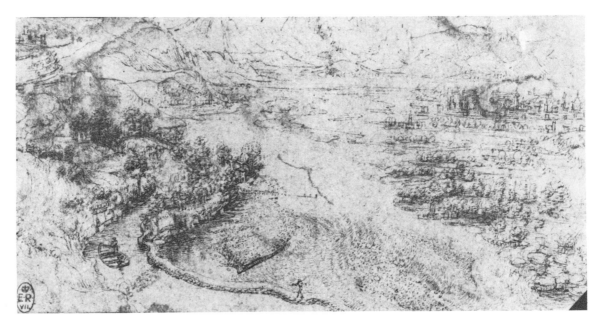

LANDSCAPE: RIVER WITH ADJOINING CANAL
Pen and ink, 8.5 × 16 cm. (reproduced original size). Royal Collection, Windsor Castle.

LANDSCAPE: HILLTOP CASTLE OVERLOOKING RIVER AND CANAL
Pen and ink, 10 × 15 cm. (reproduced original size). Royal Collection, Windsor Castle.

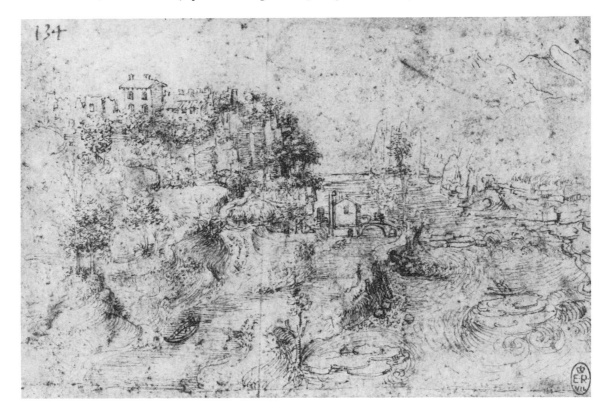

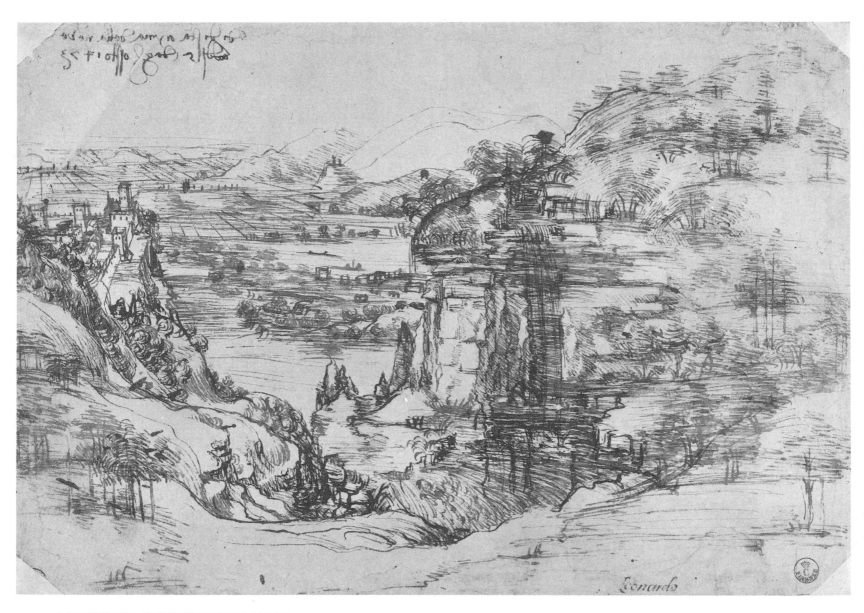

LANDSCAPE: VALLEY OF THE ARNO
(Probably a study for the landscape in the *Baptism of Christ*)
August 5, 1473. Pen and ink, 19.4 × 28.6 cm. Gabinetto dei Disegni e Stampe, Uffizi Gallery, Florence.

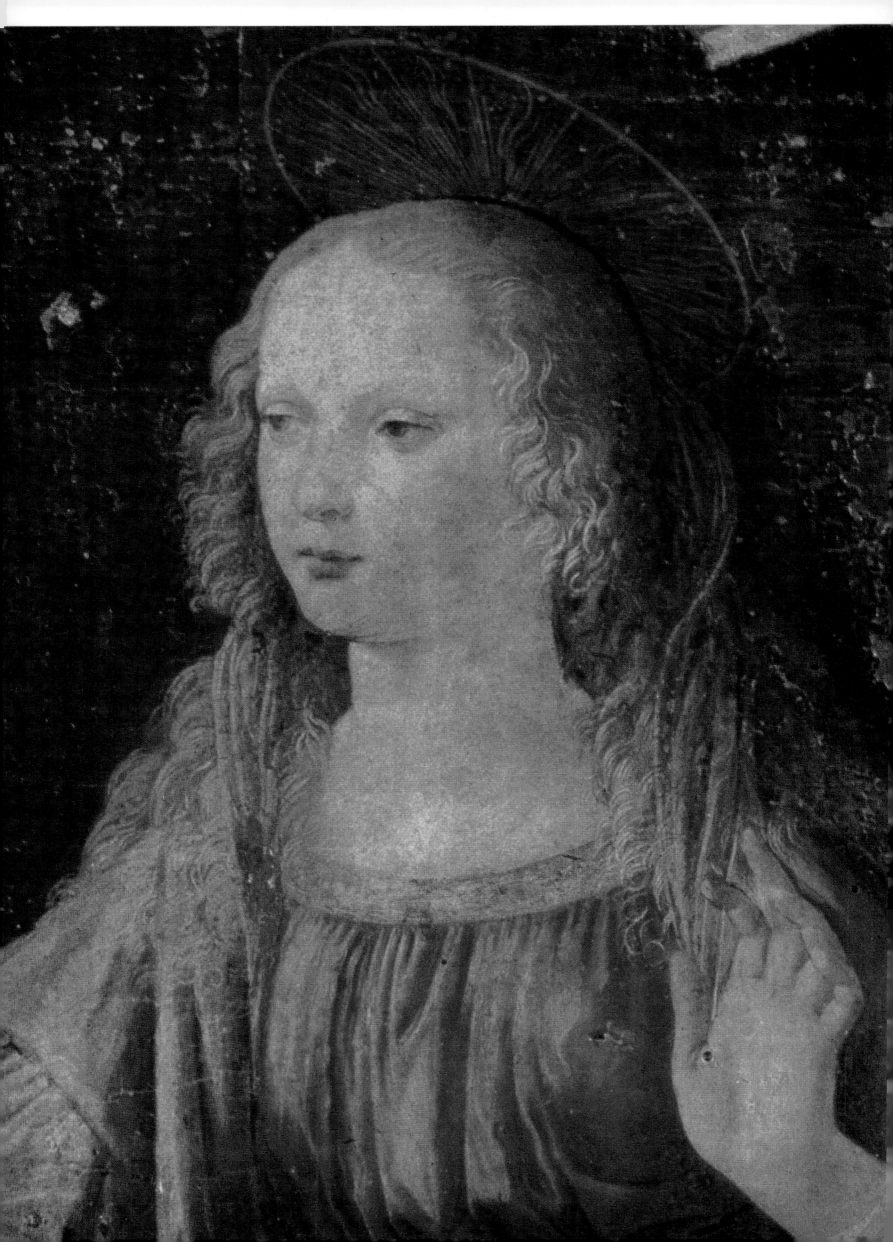

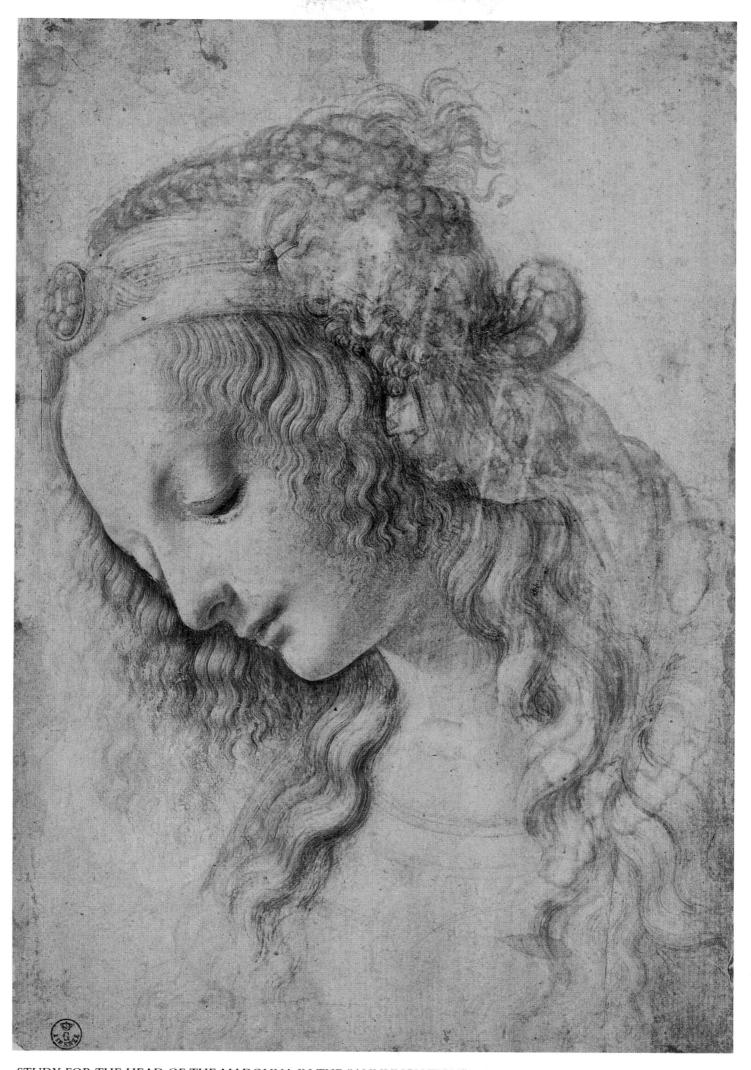

STUDY FOR THE HEAD OF THE MADONNA IN THE "ANNUNCIATION"
(Attributed to Leonardo.)
Watercolor with pencil, heightened with white, 27.5 × 19.5 cm. (reproduced original size). Gabinetto dei Disegni e Stampe, Uffizi
Gallery, Florence.

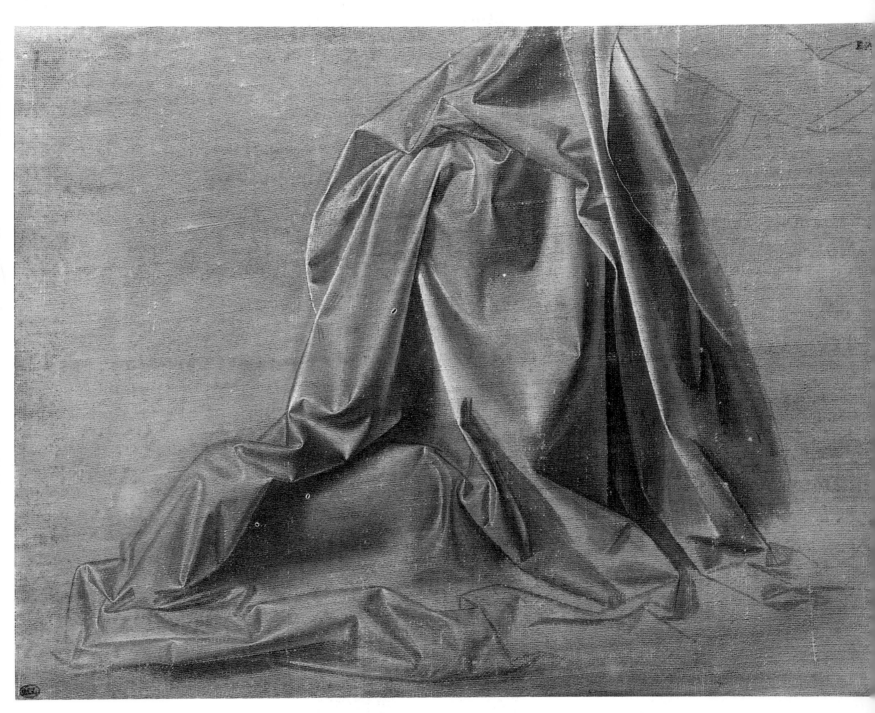

CAST OF DRAPERY FOR A KNEELING FIGURE
Drawn with the brush on linen, heightened with white.

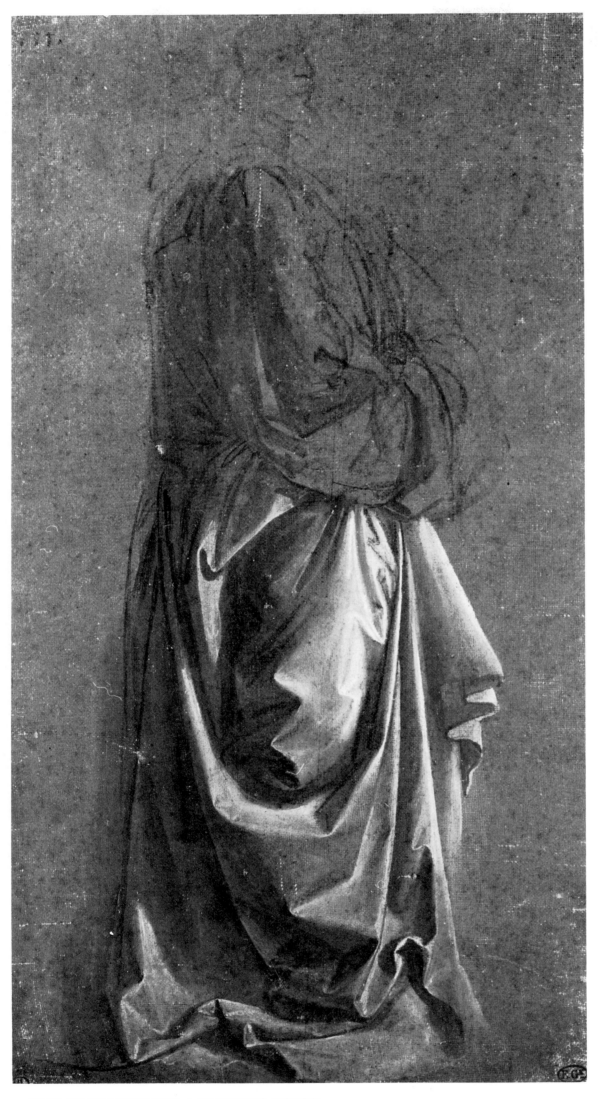

CAST OF DRAPERY FOR A STANDING FIGURE
Drawn with the brush on linen, heightened with white.

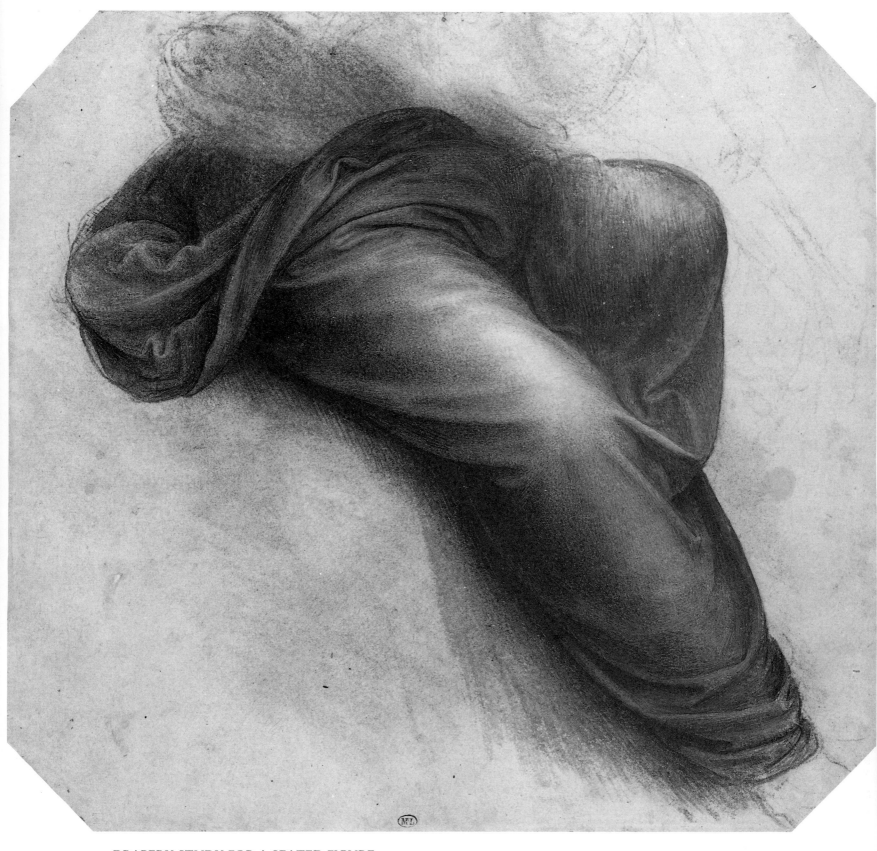

DRAPERY STUDY FOR A SEATED FIGURE
Black chalk and India ink wash.

Facing page. CAST OF DRAPERY FOR A STANDING FIGURE
Drawn with the brush on linen, heightened with white.

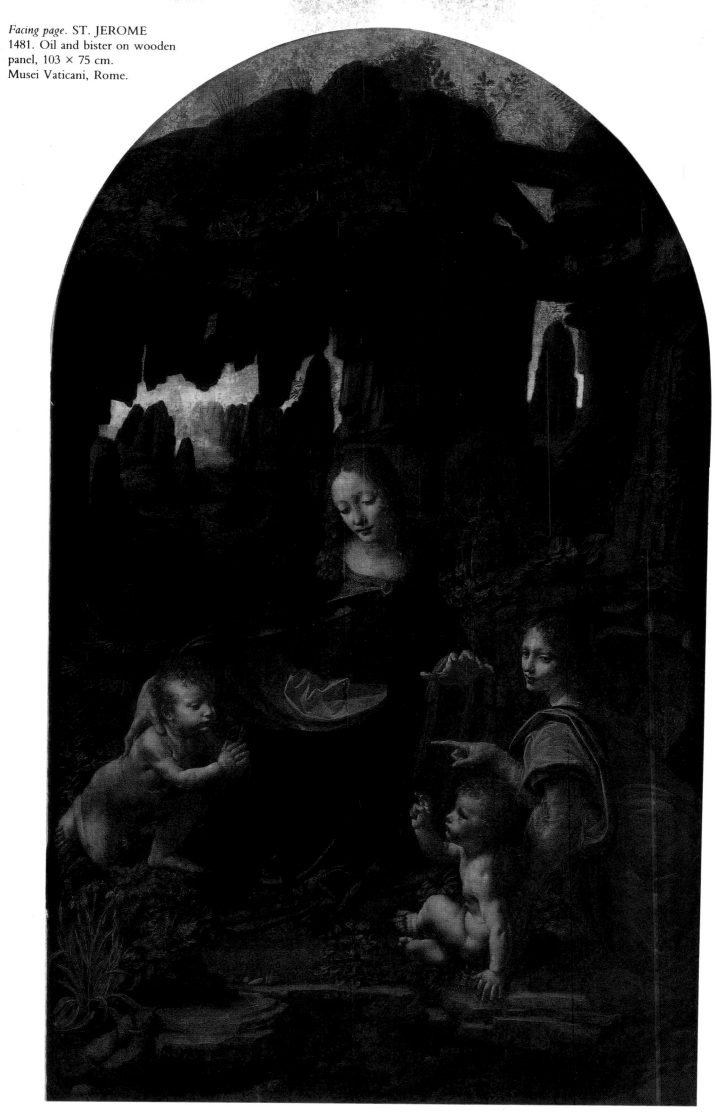

MADONNA OF THE ROCKS (LOUVRE VERSION)
1482–1486. Oil on panel, 199 × 122 cm. Musée du Louvre, Paris.

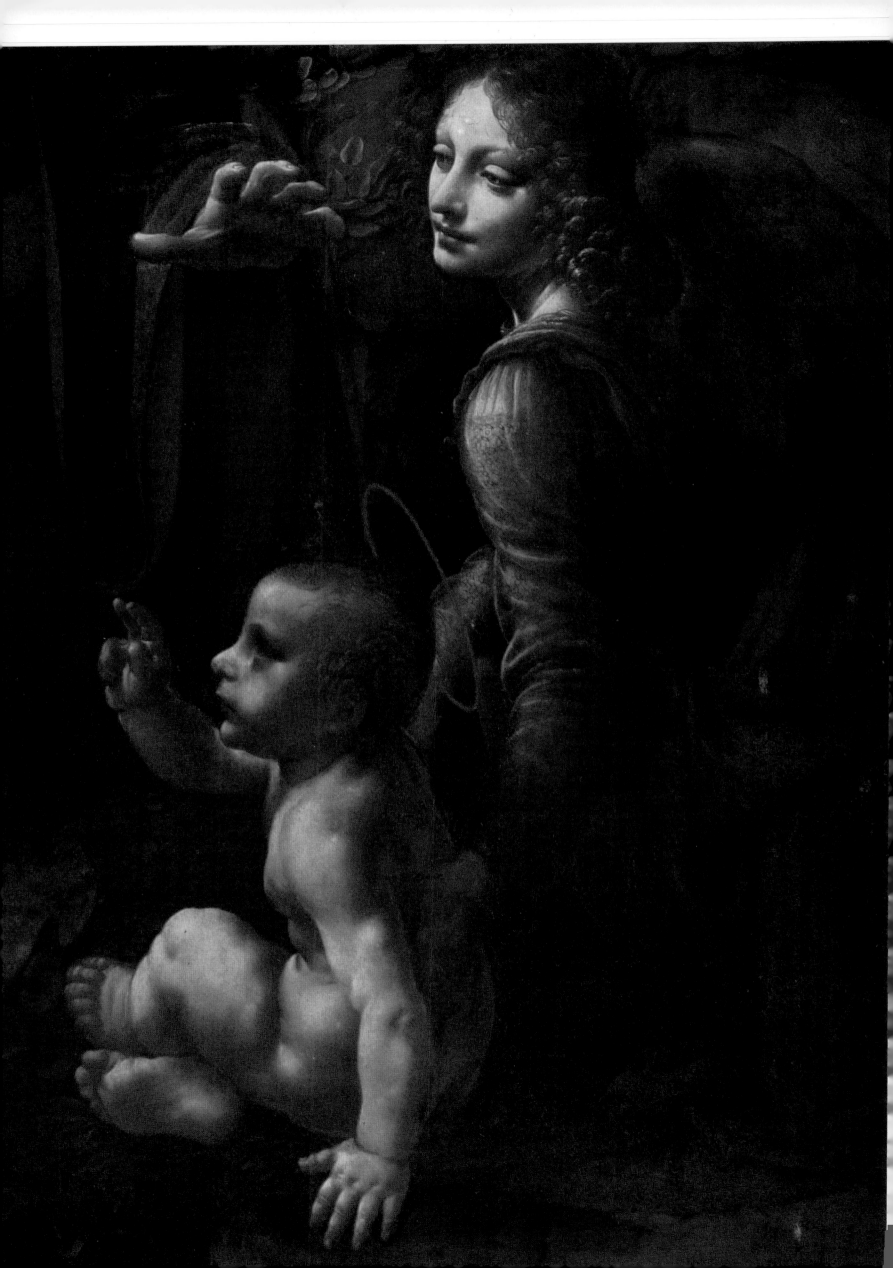

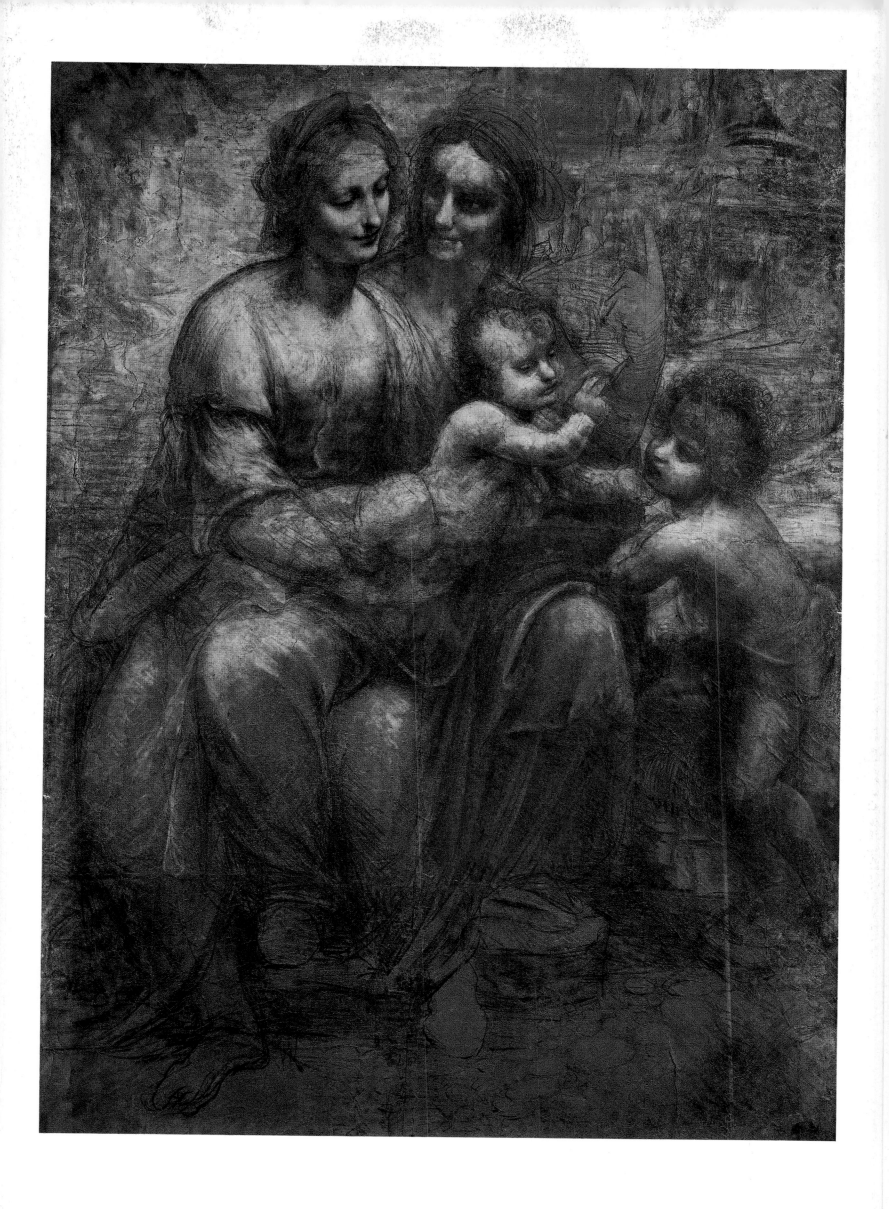

STUDY FOR THE VIRGIN'S DRAPERY
Charcoal, heightened with blue and black on pale yellow paper, 16.4 × 14.5 cm. Royal Collection, Windsor Castle.

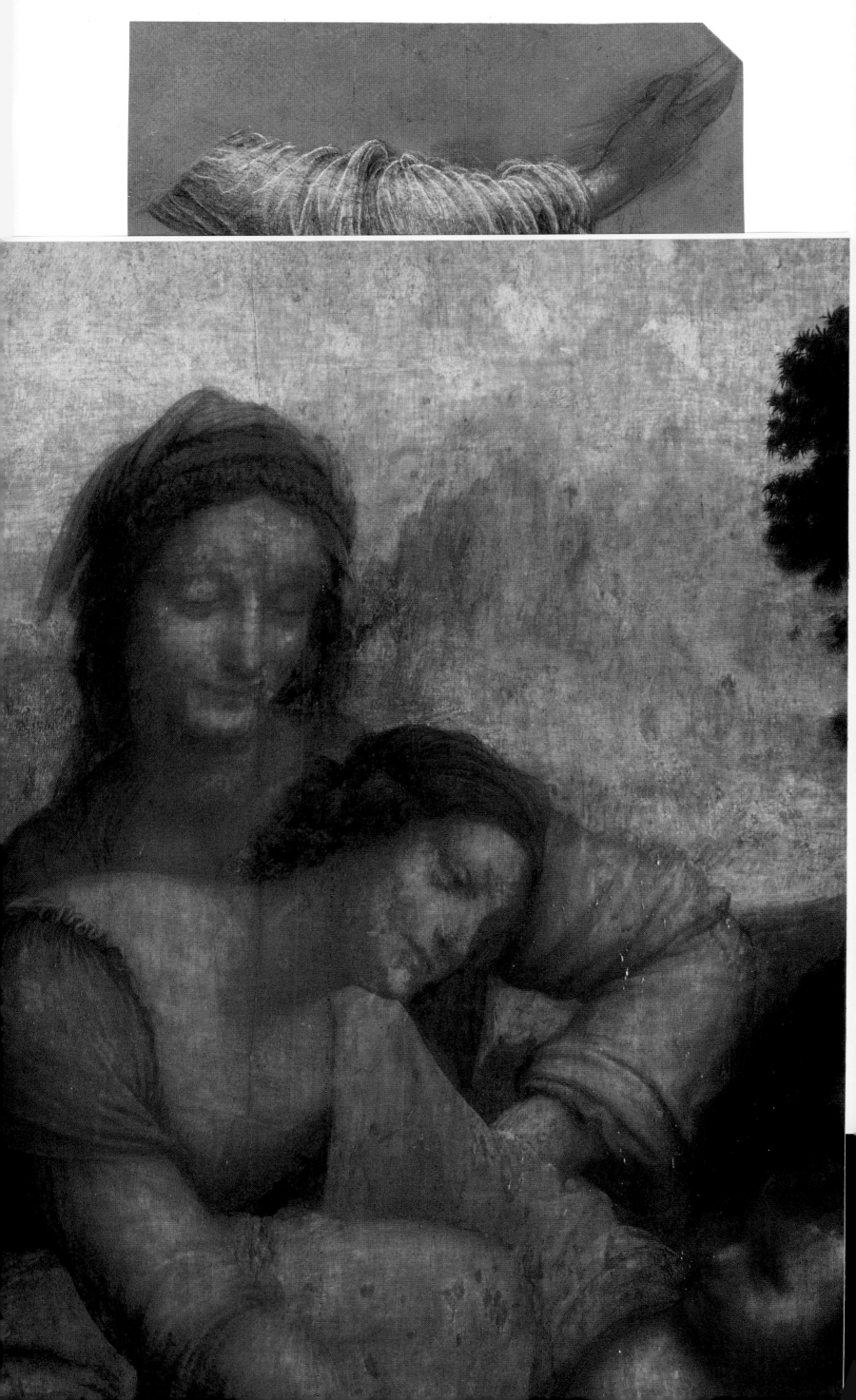

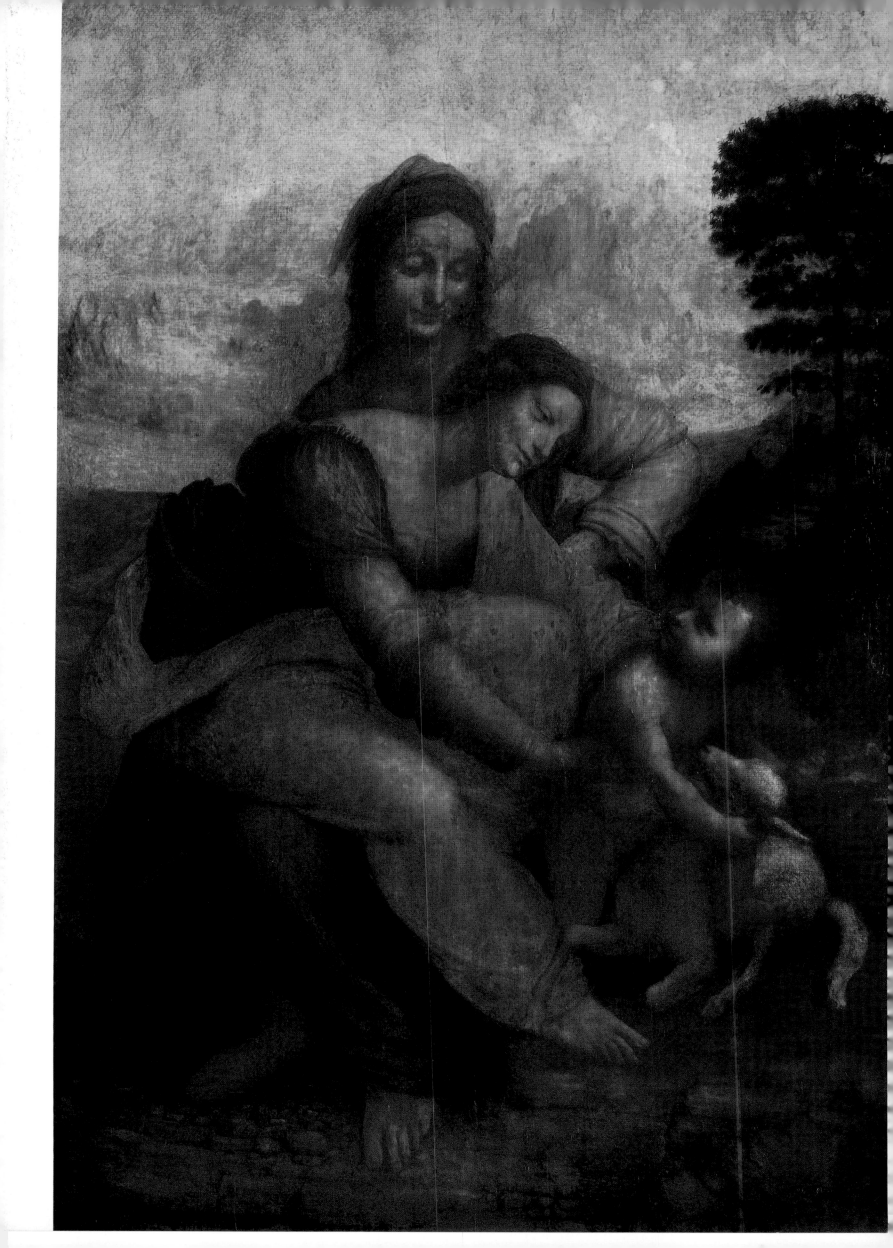

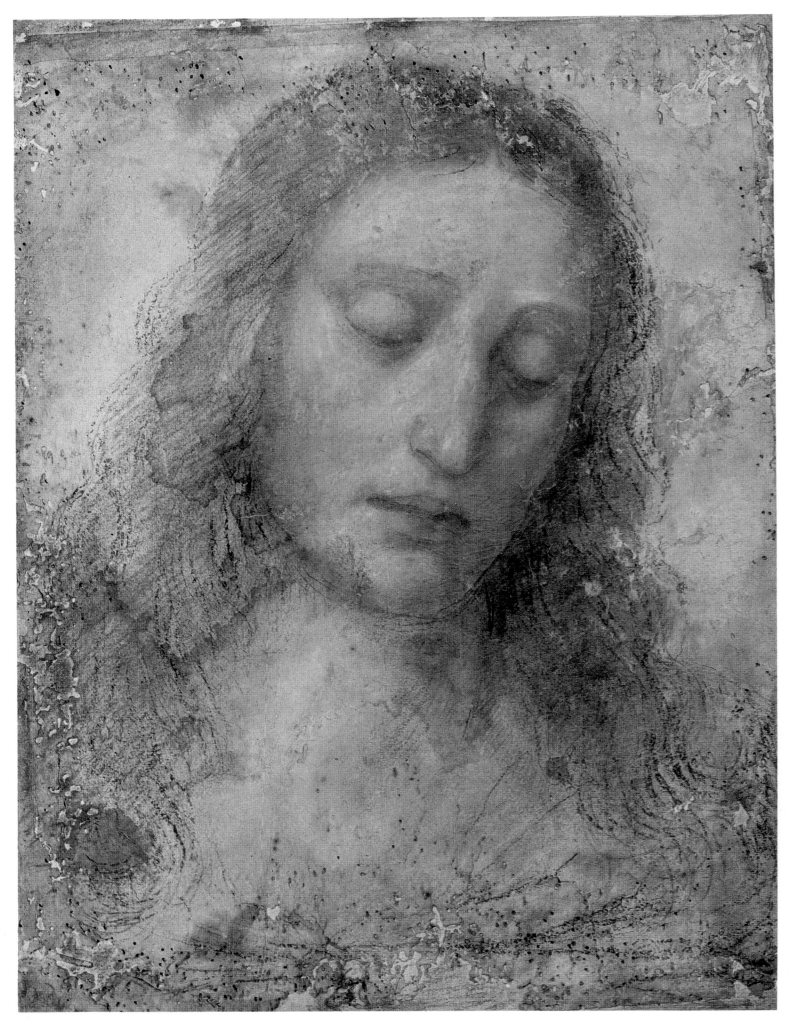

THE REDEEMER
(School of Leonardo)
Drawing with tempera, 40 × 32 cm. Pinacoteca Brera, Milan.

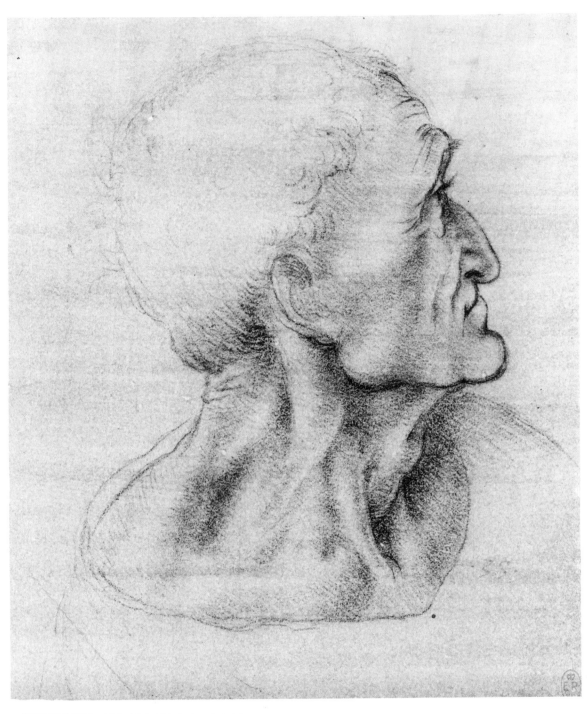

STUDY FOR AN APOSTLE (JUDAS?)
Red chalk on red prepared paper, 18 × 15 cm. Royal Collection, Windsor Castle.

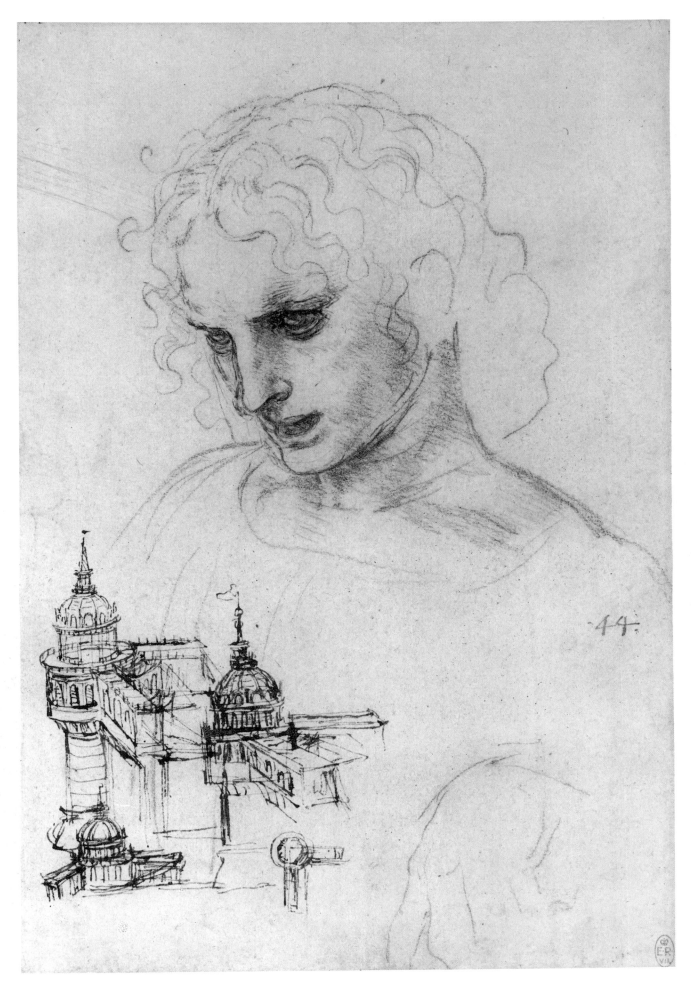

STUDY FOR ST. JAMES THE GREATER
Red chalk, pen and ink at lower left, 25.2 × 17.2 cm. Royal Collection, Windsor Castle. (The above three drawings all
reproduced original size.)

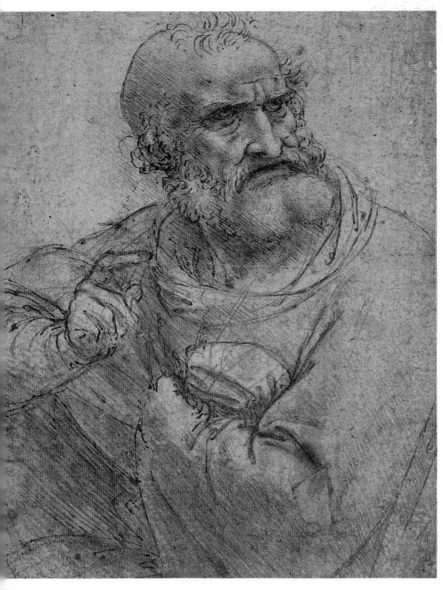

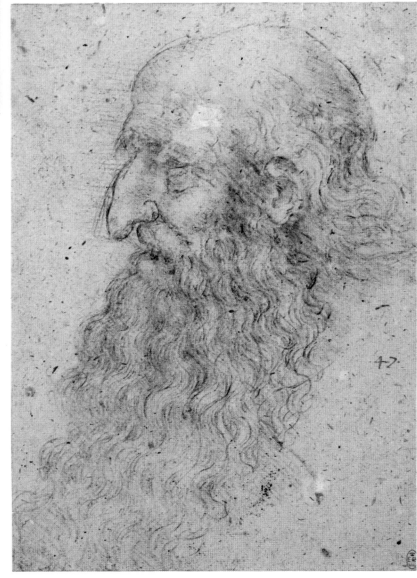

STUDY FOR ST. PETER
Pen and ink over silverpoint on blue prepared
surface, 14.5 × 11.3 cm. (reproduced original
size). Albertine, Vienna.

PROFILE HEAD OF AN OLD MAN
Black chalk on rough gray paper, 25.3 × 18.2
cm. Royal Collection, Windsor Castle.

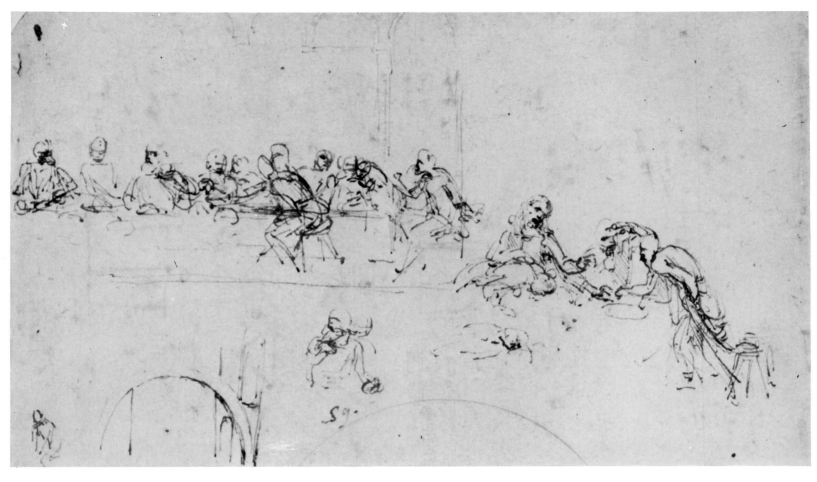

COMPOSITION STUDY FOR THE "LAST SUPPER" (fragment)
Pen and ink, 26 × 21 cm. Royal Collection, Windsor Castle.

STUDY FOR ST. PHILIP
Pencil on white paper, 19 × 15 cm. Royal
Collection, Windsor Castle.

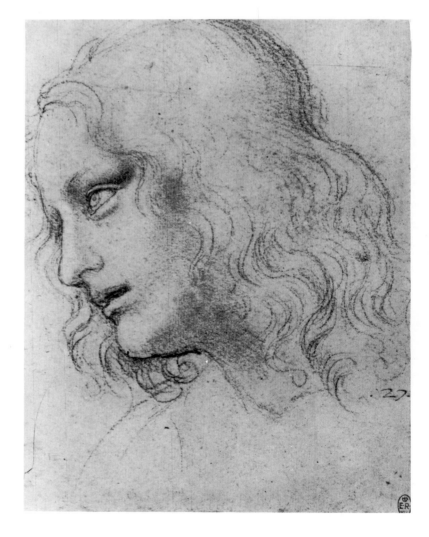

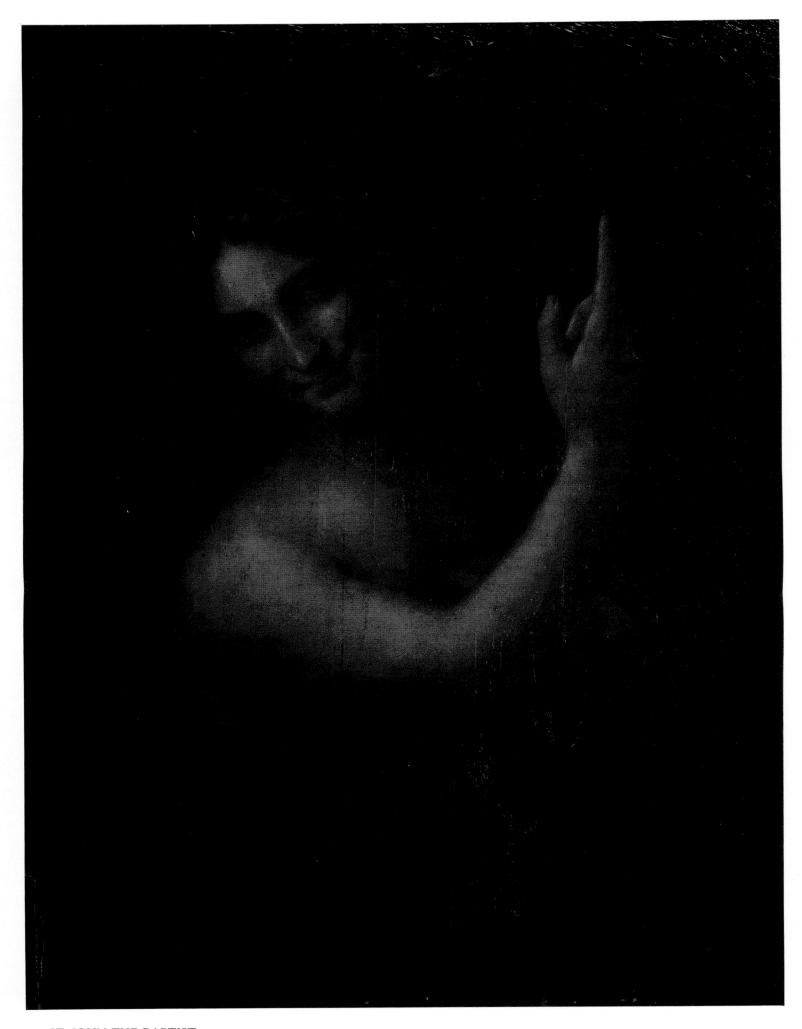

ST. JOHN THE BAPTIST
1513–1516. Oil on panel, 69 × 57 cm. Musée du Louvre, Paris.

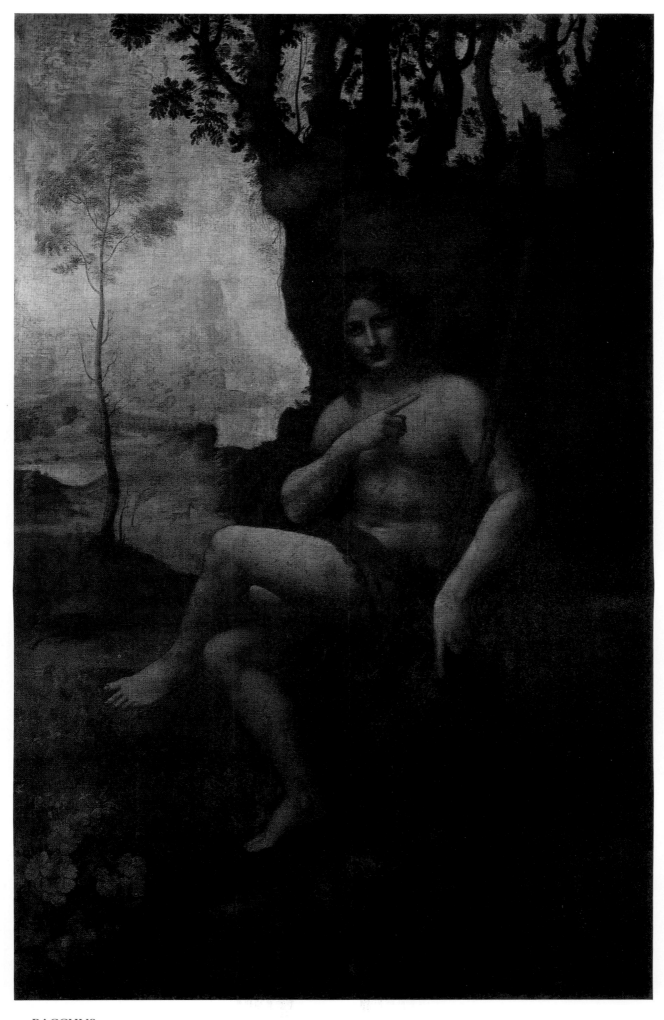

BACCHUS
(School of Leonardo)
1511–1515. Oil on canvas, 177 × 115 cm. Musée du Louvre, Paris.

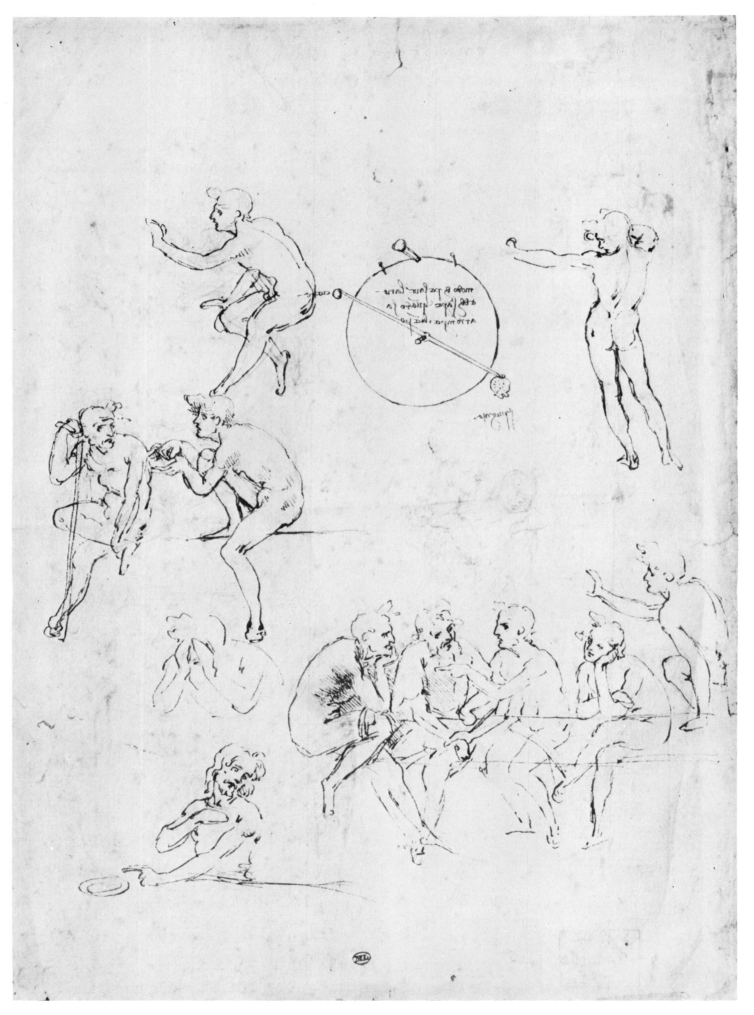

STUDY FOR THE "LAST SUPPER" OR THE "ADORATION OF THE MAGI"
Silverpoint and pen and ink on white paper, 27.8 × 20.5 cm. (reproduced original size). Cabinet des Dessins, Musée du Louvre, Paris.

IV THE PORTRAITS

ONE of the philosophers Leonardo studied in depth was Nicolas de Cues, who set forth the core of his beliefs in his treatise on "learned ignorance," *De Docta Ignorantia*. In it he demonstrates man's total inability to know absolute truth, and that the more ignorant people realize they are, the more knowledgeable they will be.

In the *Codex Atlanticus* we find this observation: "Anaxagoras. Every thing proceeds from every thing, and every thing becomes every thing, and every thing can be turned into every thing else, because that which exists in the elements is composed of those elements." Nicolas de Cues speaks of the "face of all faces." For Leonardo, the act of representing a face meant including in it the entire range of what one actually or potentially encounters in the real world. Bernard Berenson describes the *Mona Lisa* in just this way. "Its over-meanings are not only as many as there are spectators, but more still, for it will appeal differently to the same spectator at different periods of his life and in different moods." But cannot this be said of most, if not all, of Leonardo's known portraits? And in this sense, perhaps we can think of him more as a philosopher than as a portraitist. As Paul Valéry put it, "Painting was Leonardo's philosophy."

Nowadays it is customary to distinguish between religious and nonreligious painting, but this division throws Leonardo's *oeuvre* in a misleading light. Even if we concede that Leonardo went to extraordinary lengths to capture as faithful a likeness as possible, capturing a likeness remained for him a secondary consideration. "You will draw your figures so as to lay bare the secrets of souls," he wrote. Just because he painted the tablecloth of the *Last Supper* in "unbelievable detail" does not mean that his purpose was to focus our attention on it.

To be sure, there can be no ignoring Leonardo's "know-how," but it was so flawless that it no longer counts. In his work it is the spirit, and nothing else, that prevails; all that comes through is unadulterated beauty. To achieve it, Leonardo noted in his *Trattato della Pittura* the resources a painter can draw on.

As Leonardo sees it, a painter is better able to excite love in men than a poet because he "places before the one who loves the very image of the beloved; and often he clasps this image and speaks to it, something he would not do with the same charms as described by a writer." But he takes this a step further, giving us an insight into his work as both a portraitist and a painter of religious subjects: "Better still, the painter compels men to fall in love with and to love a painting that depicts no living woman." In a variation on Pliny's story about how the Venus of Cnidus could inspire passion, Leonardo relates an anecdote. "One day I made a picture of a religious subject, and the enamored swain who bought it wanted me to remove the attributes of divinity so that he might embrace it without incurring disgrace. But in the end respect won out over sighs and desire, and he had to have the picture taken out of his house." In his appraisal of the *Mona Lisa*, Julien Segnaire notes that Antonio de' Beatis, the secretary of Cardinal Louis of Aragon, mentioned seeing at the manor house of Cloux "three pictures, one of a certain Florentine lady done from the life at the instance of the late Magnificent, Giuliano de' Medici. . . . " From this he infers that the swain mentioned in Leonardo's anecdote is Giuliano de' Medici.

Before allowing themselves to respond emotionally to a portrait, many are curious to know who painted it and who the subject is, however obscure a figure he or she may be. Vasari mentions that around the time of the *Mona Lisa* Leonardo painted a portrait of Ginevra de' Benci, sometimes referred to as the "lady of the juniper bush" or the "Liechtenstein lady": "He also did a portrait of Ginevra, d'Amerigo Benci, a very beautiful painting." The book of Antonio Billi attributes the work to Leonardo as early as 1515, and in the Anonimo Gaddiano (1542–1547) we read, "In Florence he painted from life Ginevra, d'Amerigo Benci, so well done that it seemed, not a portrait, but Ginevra herself." Vasari, however, dated the portrait from the second Florentine period, the same time as the cartoon for the *Virgin and Child with St. Anne* (1501).

The daughter of Amerigo di Giovanni Benci, the Florentine aristocrat Ginevra de' Benci was born about 1457. On January 15, 1474, seventeen-year-old Ginevra married Luigi di Bernardo di Lapo Nicolini. Thus, by Vasari's reckoning, she would have had to be around forty-five when Leonardo began her portrait. For many years the identity of the man who painted this portrait of what appears to be little more than a teenager remained a subject of controversy. In 1866 Waagen attributed the little panel in the Viennese palace of the Princes of Liechtenstein to Leonardo. By the end of the nineteenth century, Bode had not only confirmed the attribution, but identified the unknown lady as Ginevra de' Benci. Purchased in 1967 by the National Gallery in Washington, *Ginevra de' Benci* is today recognized by most leading specialists as a bona fide Da Vinci, that it dates from 1474 or immediately thereafter, and that the juniper bush in the background is further proof of the subject's identity.

"This portrait of a young woman foreshadows the *Mona Lisa,*" notes Fred Bérence, "and in every respect it fits in with the guidelines Leonardo laid down. He begins with a body standing out against a flat surface. The gloomy landscape, the river and the birch trees reflected in it, the juniper bush—an allusion to the subject's name, Ginevra—attest not only to the artist's attention to perspective ('the guide and the gateway,' he called it), but to his unerring technique: the subtle distribution of shadow, his 'light, color, figures, distance'—they are all demonstrations of his theories. True, this woman of twenty to twenty-five does not show her emotions or inner turmoil, yet the thing that immediately strikes the onlooker is her unfathomable personality. As one examines her broad forehead, the heavy-lidded brown eyes, the tight-lipped mouth, the delicately turned chin, the ivory skin—'a foretaste of the artistry with which Leonardo was to paint the *Mona Lisa*' (Jean Alazard, *Le Portrait florentin*)—we strongly sense that the person before us is self-conscious, a bit aloof because she is young, a bit sad because she is not yet on the path of knowledge, but who, once she has achieved self-mastery, will blossom and glow with goodness."

We now know that the subject is, in fact, Ginevra as a teenager and that the portrait dates from Leonardo's youth. Although Vasari kept some lingering doubts alive in the minds of art historians, the fact remains that the artist painted the "lady of the juniper bush" while still an apprentice in Verrocchio's shop.

Did Leonardo da Vinci paint the *Portrait of a Musician?* While it hung in the Louvre (1796–1815) by order of Napoleon Bonaparte, it was listed as a work by Bernardino Luini. In Milan, before and after its stint in France, it was reputed to be by Leonardo, but some experts attributed it to Ambrogio da Predis, others to Giovanni Antonio Boltraffio. Who is the subject? "Portrait of Ludovico il Moro," read the catalogue of the Biblioteca Ambrosiana in the nineteenth century. When a cleaning in 1905 revealed a sheet of music and the inscription CANT . . . ANG . . . , the subject became a musician. But which musician? Attalante Miglioretti, born in 1466 and a resident of Milan until 1490? Franchino Gaffario, choirmaster of Milan Cathedral, since the inscription could conceivably be an abbreviation of the words *Canticum Angelicum?* Angelo Testagrossa, singer and future singing master of Isabella d'Este (in which case the inscription would read *cantor Angelo*)? All of these hypotheses remain tenuous. It would be unwise to attribute it to Leonardo if only because, save for the head and hair, the painting is unfinished.

Everyone knows that Francis I of France had a mistress nicknamed La Belle Ferronnière and that it was fashionable in fifteenth-century Lombardy and early sexteenth-century France to wear a *ferronnière,* or headband, about the forehead. Two portraits attributed to Leonardo include this headband, but everyone now agrees that neither subject is the mistress of Francis I. One of them has an inscription in the upper left corner that reads LA BELE FERONIERE LEONARD DA WINCI, but it is the other that has been known as *La Belle Ferronnière* ever since an error in Lepicié's inventory (1752) confused it with Bernardino dei Conti's portrait of Francis I's mistress, also in the Louvre. The former, which bears the inscription and hangs in the Czartoryski Museum in Krakow, is called the *Lady with an Ermine,* for cradled in the forearm of the young female subject is an animal that looks like a weasel.

The panel depicting the *Lady with an Ermine* was mercilessly retouched: the entire background was darkened; the transparent veil was repainted the same color as the subject's hair, making it look as though her hair reaches down and underneath her chin; the part of her dress below the ermine was retouched; and dark shadows were added between the fingers of her right hand. The inscription was probably added in France sometime in the eighteenth century before the century's end, when work was sent to Poland. Is it a portrait of Cecilia Gallerani, Ludovico Sforza's mistress, done about 1483? Or was it painted about 1491, the subject Ludovico's wife, Beatrice d'Este? Is the painting entirely or partly by Leonardo, Ambrogio da Predis, or Boltraffio? Each of these theories has its advocates.

The marvelous drawing in the Galleria Nazionale in Parma known as the *Girl with Tousled Hair* does not enjoy the place it deserves in studies of Leonardo's work, probably because, its beauty notwithstanding, some have challenged its authenticity. Art historians have refrained from commenting on it.

Similar problems concerning attribution and identification of subject arise with the lovely portrait of a lady in the Biblioteca Ambrosiana in Milan. Donated in 1618 by Cardinal Borromeo, founder of the Ambrosiana, this oil on panel was thought to be a Da Vinci during its stint in Paris (1796–1815). Not until the nineteenth century were experts willing to attribute it to Ambrogio da Predis or to an unknown painter of the Leonardesque school. Some believe the subject to be Beatrice d'Este; others, Bianca Giovanna Sforza, wife of Galeazzo da Sanseverino; still

others, Anna Maria Sforza. However, the most likely candidate is Bianca Maria Sforza, wife of the Holy Roman Emperor Maximilian.

At a public auction in 1860, the Louvre purchased a portrait of an unknown female subject: a black- and red-chalk drawing heightened with pastel, but in very poor condition. The outlines were pricked with a needle for transfer, which suggest that a painting, now lost, was done after it. The Uffizi and the British Museum each has a replica or old copy. Today the subject is known to be Isabella d'Este and that Leonardo drew the profile in late 1499 or in the spring of 1500. He may have drawn two, perhaps even three sketches of the sister-in-law of Lucrezia Borgia and Ludovico il Moro, but he dodged his model's persistent requests for an oil painting. There are those, like Siren, who feel that the cartoon in the Louvre—quickly drawn, possibly in a single sitting—"still glows with freshness and grace" and see it as an example of Leonardo's genius. For Goldscheider, however, the hands look as though done by a "second-rate pupil," and the only part of the portrait he is willing to attribute to Leonardo is the profile proper.

As for the *Mona Lisa* . . .

Approximately 7 cm. of the Lombardy poplar panel (77 cm. x 53 cm., no crosspieces or backing) were trimmed from both the right and left sides. On these strips, Bodner argues, were painted the two columns that appear in Raphael's drawing for the portrait of Maddalena Doni.

The history of "the world's most famous painting" is still shrouded in uncertainty. Though neither signed nor dated, it is universally acknowledged to be a genuine Leonardo. But when was it painted, and who is the subject?

The oldest reference to the *Mona Lisa* occurs in the diary of Antonio de' Beatis, who paid a visit to Leonardo at the manor house of Cloux on October 10, 1517. The secretary of Cardinal Louis of Aragon (and, incidentally, illegitimate brother of King Alfonso II of Naples) notes that the "graybeard"—Leonardo was only sixty-five at the time—showed them three pictures: ". . . one of a certain Florentine lady done from life at the instance of the late Magnificent, Giuliano de' Medici, another of St. John the Baptist as a youth, and one of the Madonna and Child in the lap of St. Anne. . . ." But who is this "Florentine lady"? René Huyghe believes it to be "beyond a shadow of a doubt, the Gioconda," that is, a Florentine noblewoman by the name of Mona Lisa Gherardini, third wife of Francesco di Bartolommeo di Zanobi del Gio-

condo. Francis I of France paid four thousand gold crowns for the painting (according to Père Dan, *Trésor des merveilles de la Maison royale de Fontainebleau* 1642), but it is not known if the seller was Leonardo himself, the executor of his will (Francesco Melzi), or the heirs of Francesco del Giocondo. It comes as rather a surpise to learn that for many years the royal catalogues gave it the title of *Courtisane au voile de gaze*!

In the middle of the sixteenth century, Vasari reported that "for Francesco del Giocondo Leonardo undertook to execute the portrait of his wife, Mona Lisa. He worked on this painting for four years, and then left it still unfinished; and today it is in the possession of King Francis of France, at Fontainebleau." Vasari goes into raptures over the portrait, especially the eyebrows, noting that "on looking closely at the pit of her throat one could swear that the pulses were beating. Altogether this picture was painted in a manner to make the most confident artist—no matter who—despair and lose heart." Another detail: "Leonardo also made use of this device: while he was painting Mona Lisa, who was a very beautiful woman, he employed singers and musicians or jesters to keep her full of merriment and so chase away the melancholy that painters usually give to portraits. As a result, in this painting of Leonardo's there was a smile so pleasing that it seemed divine rather than human; and those who saw it were amazed to find that it was as alive as the original." Vasari does not mention in his description the landscape in the background, and he may have borrowed from Leonardo's *Trattato della Pittura* the colorful detail about the painter who "often has himself accompanied with music or the sound of different, beautiful works being read." One wonders which copy of the *Mona Lisa* he had seen or what sort of descriptions he had read that made it possible for him to comment on eyelashes and eyebrows that are nowhere to be found in the painting. The fact is that Vasari never saw the portrait we refer to as the *Mona Lisa*.

Cassiano del Pozzo, who had a copy of the *Trattato* and had read Vasari, was the first to suggest that the *Courtisane au voile de gaze* was Mona Lisa del Giocondo. After seeing the portrait at Fontainebleau in 1625, Del Pozzo described it as follows: "A life-sized painting on wood, in a carved walnut frame, a half-length portrait of a certain Gioconda. It is the painter's most complete work, for it does everything but speak." The Duke of Buckingham, the story goes, expressed a wish to own the painting, by then considered the most beautiful in France. King Louis XIII is said to have

gladly let him have a portrait of a *courtisane,* but he kept the "Florentine lady" for himself.

In the first half of the twentieth century, the art historian Adolfo Venturi argued that the subject was Costanza d'Avalos, duchess of Francavilla, "the heroine who defended Ischia against French troops and saved Naples." Now, a short poem by Eneo Irpino suggests that a portrait Leonardo da Vinci painted of Costanza d'Avalos did indeed exist in Ischia in the early sixteenth century. The lady was a widow shown "under a lovely dark veil." Does not the Mona Lisa, "who is no longer in the bloom of youth," wear a widow's veil of mourning? Leonardo, Venturi continues, painted a portrait of the duchess in early 1502 during his brief stay in Rome at the behest of Giuliano de' Medici. It was during this period that the artist was busy drawing maps and charts for Cesare Borgia. However, as Fred Bérence points out, "assuming he painted the duchess of Francavilla just then, he could not have done anything more than a sketch akin to that of Isabella d'Este. He simply did not have the time. . . . He may have brought this drawing back with him to Florence, and it may have been Raphael's inspiration for the drawing of Maddalena Doni, one of the hidden treasures of art."

In his description of the *Mona Lisa,* Vasari notes, "The eyes had their natural lustre and moistness, and around them were the lashes and all those rosy and pearly tints that demand the greatest delicacy of execution. The eyebrows were completely natural, growing thickly in one place and lightly in another and following the pores of the skin." The only problem, as a puzzled Stendhal points out, is that "this pretty woman has no eyebrows." Heinrich Wölfflin came to the rescue. "The absence of eyebrows is striking," he writes. "The curved surface of the eye-sockets runs, without transition, into the exceedingly high forehead, but this is not an individual peculiarity, for a passage in [Baldassare Castiglione's] 'Cortigiano' tells us that it was fashionable for women to pluck their eyebrows. A wide extent of forehead was also accounted a beauty, so that the hairs above the forehead were also sacrificed. . . ." We must bear in mind, however, that Stendhal and Wölfflin had one advantage over Vasari: they actually saw the painting!

Vasari marveled at how "the mouth, joined to the flesh tints of the face by the red of the lips, appeared to be living flesh rather than paint." Théophile Gautier, for his part, believed that "the sinuous, serpentine mouth, its corners turned up beneath purplish areas of semi-darkness, scoffs at you with such sweetness, charm, and superiority that you feel as shy as a schoolboy before a duchess."

"Anyone who thinks of Leonardo's paintings," observed Sigmund Freud, "will be reminded of a remarkable smile, at once fascinating and puzzling, which he conjured up on the lips of his female subjects. It is an unchanging smile, on long, curved lips; it has become a mark of his style and the name 'Leonardesque' had been chosen for it. In the strangely beautiful face of the Florentine Mona Lisa del Giocondo it has produced the most powerful and confusing effect on whoever looks at it." As the famous psychoanalyst saw it, Leonardo was captivated by the smile of Mona Lisa because "it awoke something in him which had for long lain dormant in his mind—probably an old memory. This memory was of sufficient importance for him never to get free of it when it had once been aroused; he was continually forced to give it new expression. . . . If the beautiful children's heads were reproductions of his own person as it was in his childhood, then the smiling women are nothing other than repetitions of his mother, Caterina, and we begin to suspect the possibility that it was his mother who possessed the mysterious smile—the smile that he had lost and that fascinated him so much when he found it again in the Florentine lady."

Some are of the opinion that Leonardo was "merely the slave of an ironic smile"; no matter, in the opinion of Oscar Wilde. It may be, as someone once pointed out, that the painter "merely concerned himself with certain arrangements of lines and volumes, with new and curious schemes of blues and greens." Walter Pater's assessment of the *Mona Lisa* is still "of the highest order."

But Mona Lisa del Giocondo was not the first to wear the famous smile that reappears in the work of all of Leonardo's pupils, beginning with the second Milanese period. There can be no mistaking the same turning up of the left side of the mouth in the face of St. Anne in the *Burlington House Cartoon.*

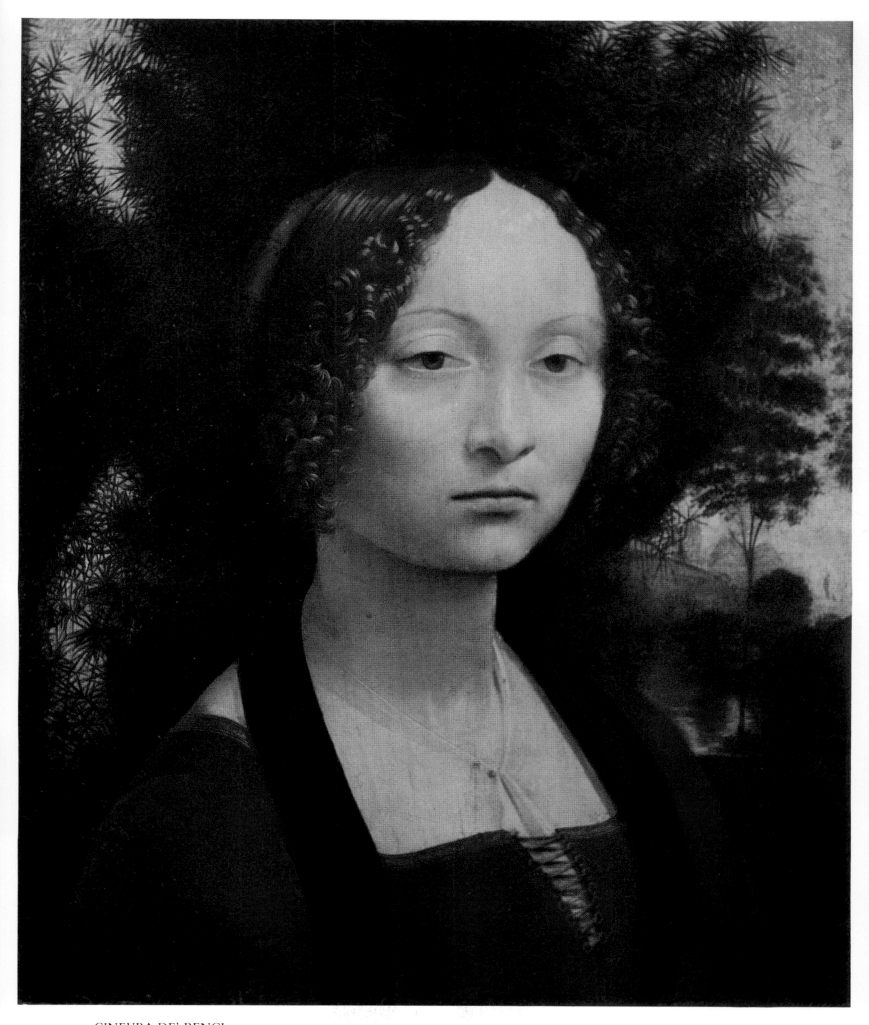

GINEVRA DE' BENCI
1474–1476. Oil on panel, 42 × 37 cm. National Gallery, Washington, D.C.

90

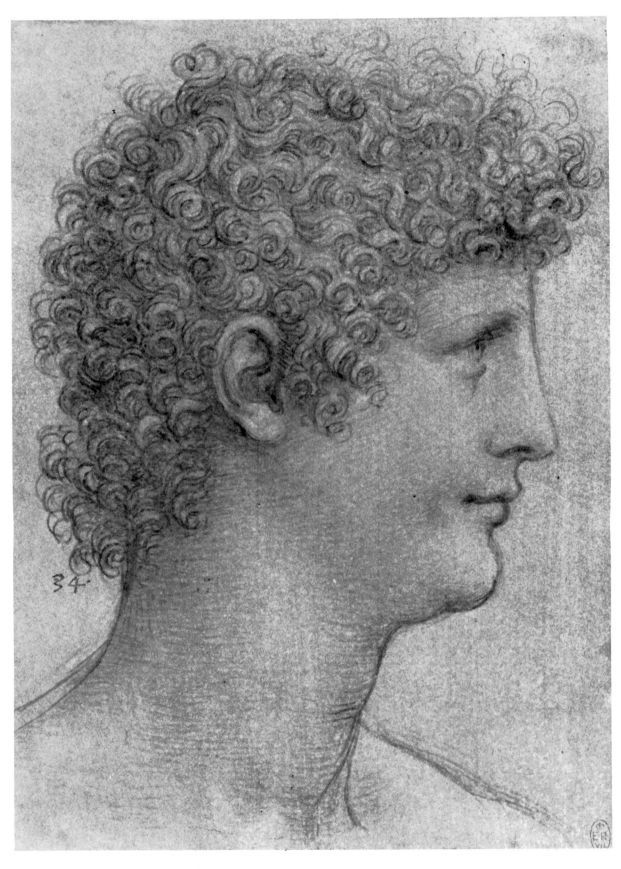

PROFILE HEAD OF A YOUTH
Red chalk heightened with black chalk on red prepared surface, 21.7 × 15.3 cm. (reproduced original size). Royal Collection, Windsor Castle.

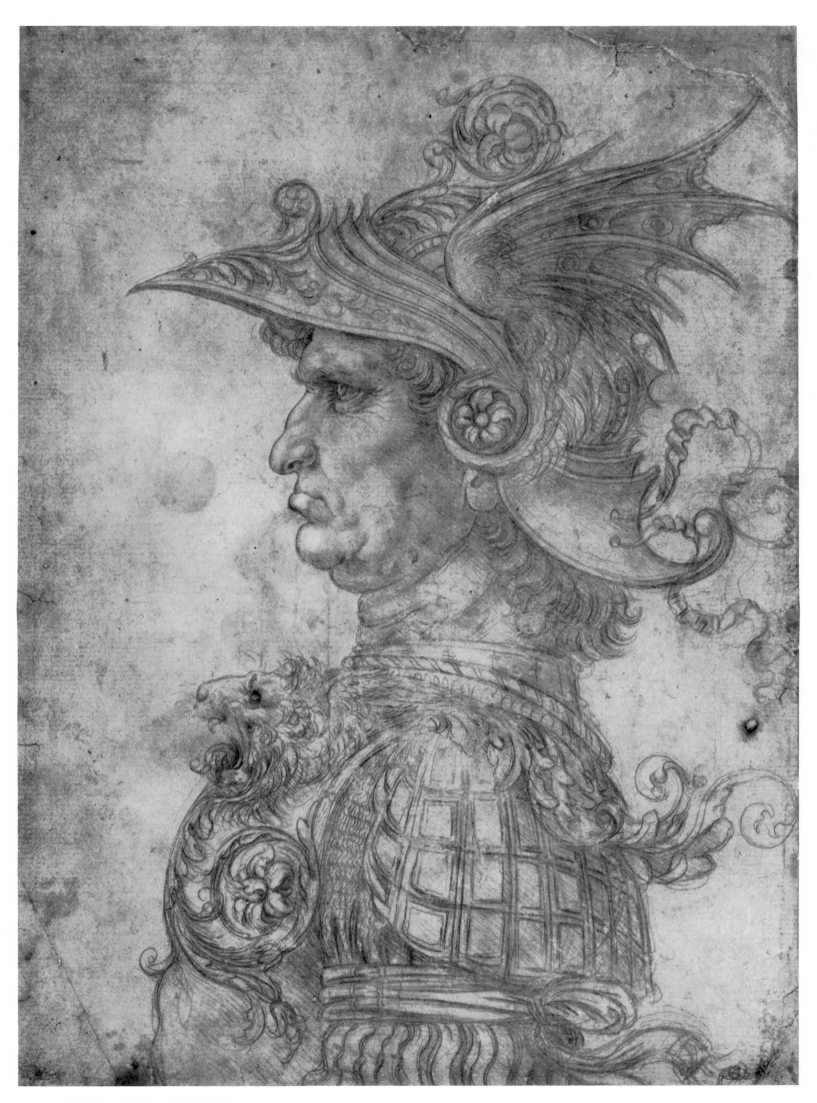

PORTRAIT OF A WARRIOR
Silverpoint on cream-colored surface, 28.5 × 20.7 cm. (reproduced original size). British Museum, London.

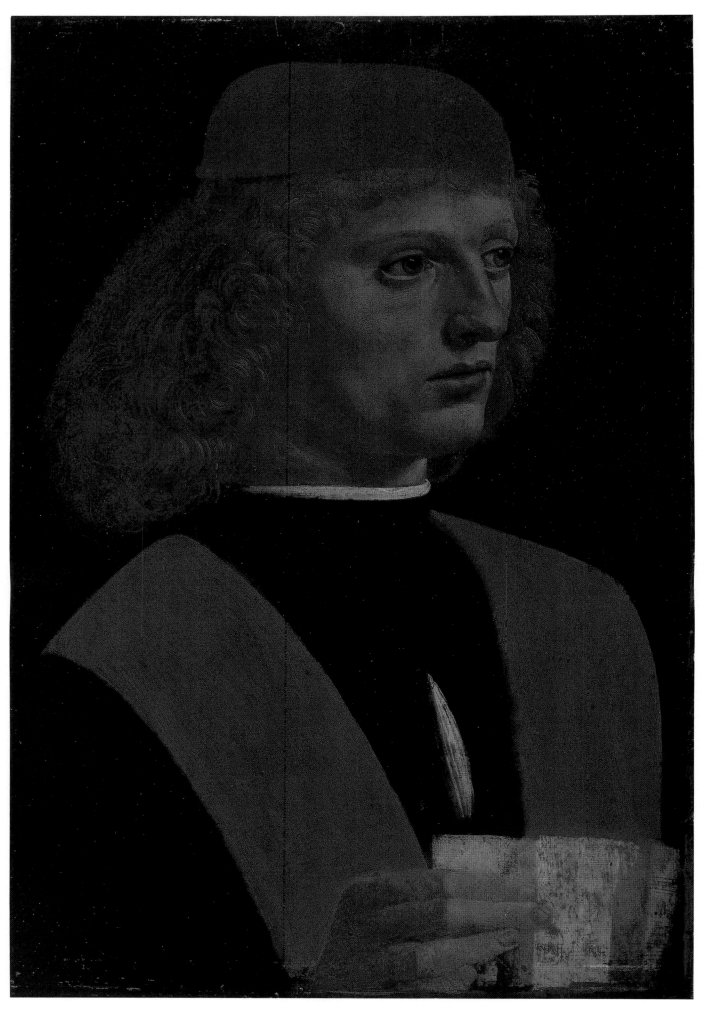

PORTRAIT OF A MUSICIAN
(Leonardo or School of Leonardo)
1490. Oil on panel, 43 × 31 cm. Pinacoteca Ambrosiana, Milan.

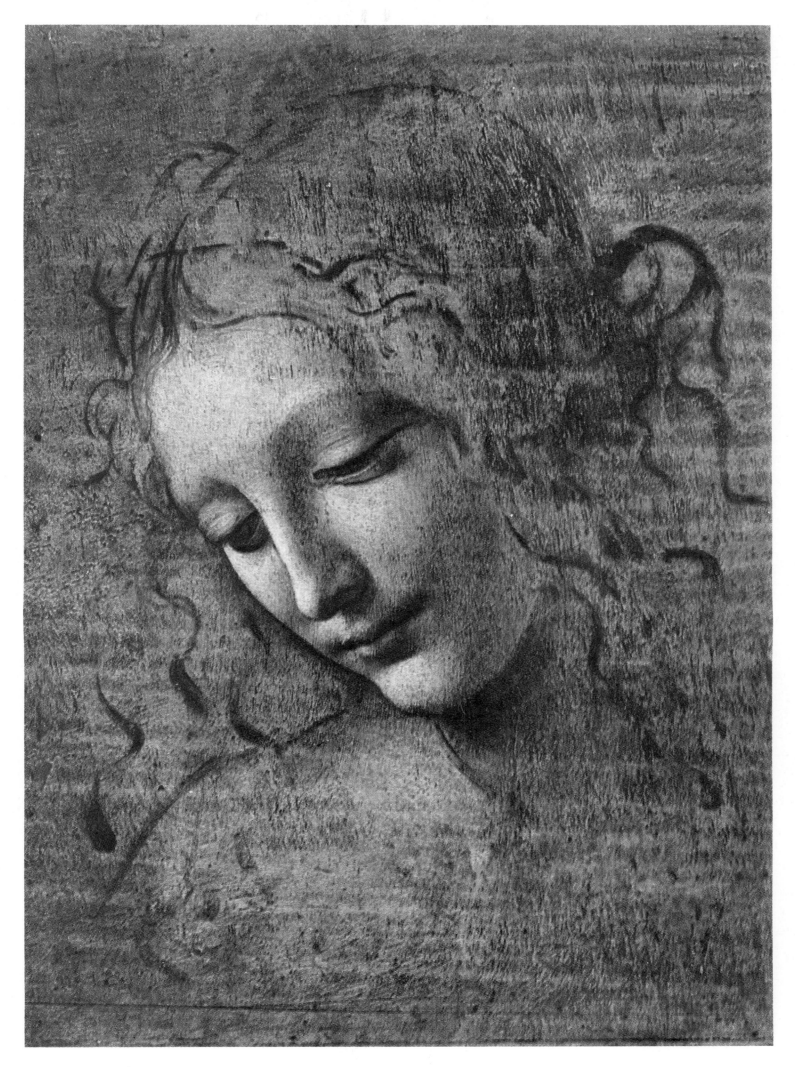

PORTRAIT OF A YOUNG WOMAN
(Attributed to Leonardo)
Drawing on panel, 27 × 21 cm. (reproduced original size). Galleria Nazionale, Parma.

Facing page. LADY WITH AN ERMINE
1483–1490. Oil on panel, 54 × 39 cm. Czartoryski Museum, Krakow.

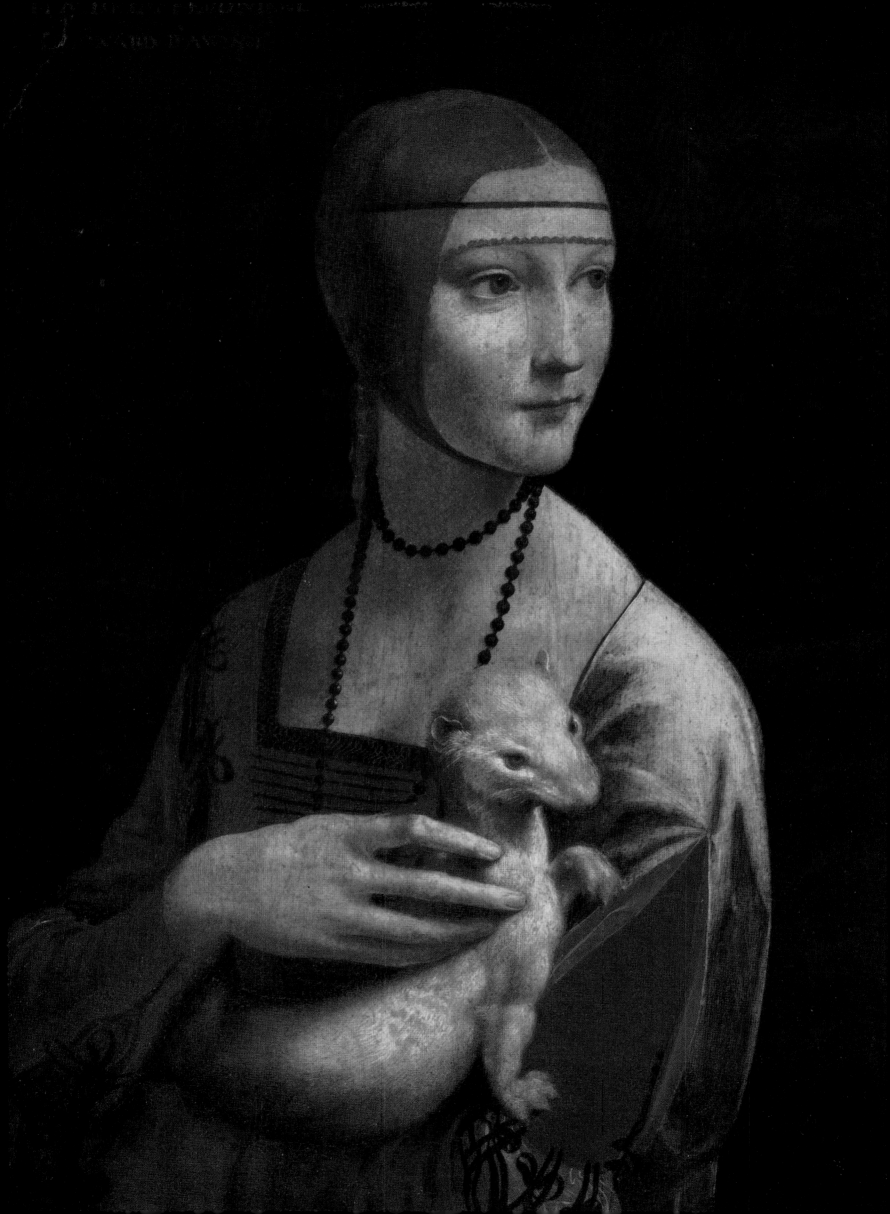

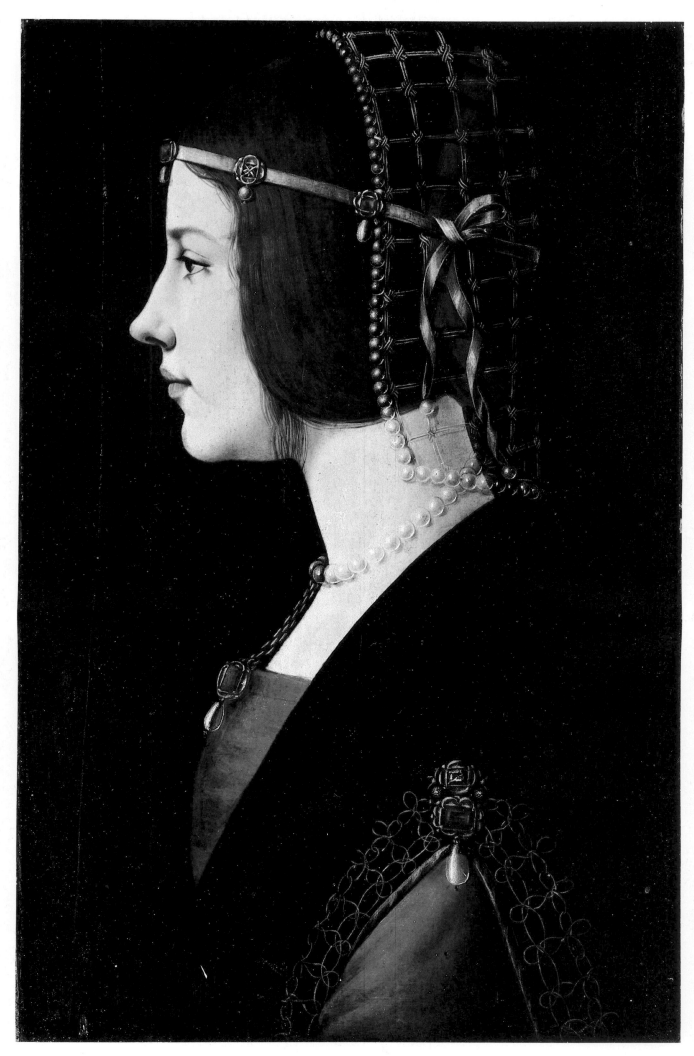

PORTRAIT OF BEATRICE D'ESTE (?)
(School of Leonardo)
Oil on panel, 51 × 34 cm. Pinacoteca Ambrosiana, Milan.

Facing page. LA BELLE FERRONNIÈRE
(School of Leonardo)
1490–1495. Oil on panel, 62 × 44 cm. Musée du Louvre, Paris.

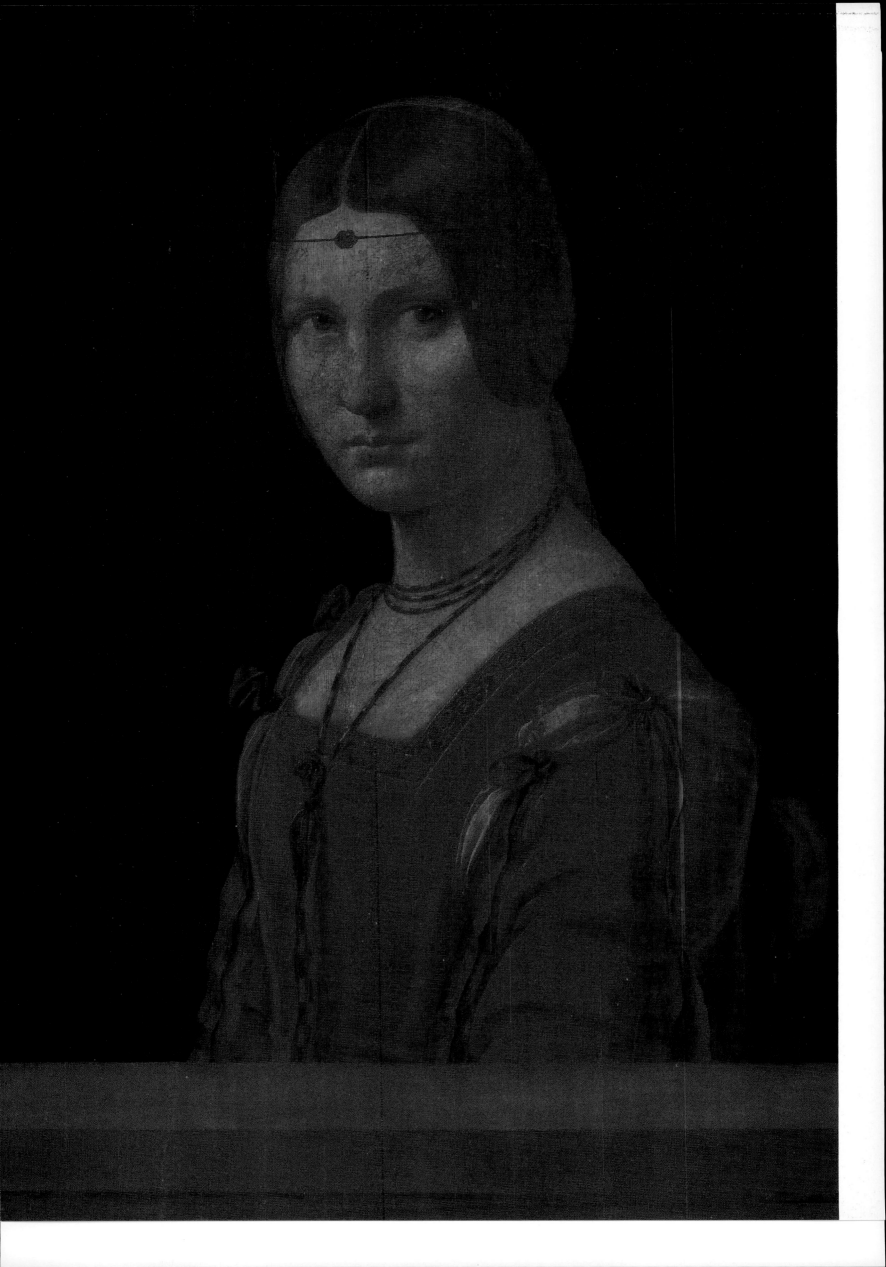

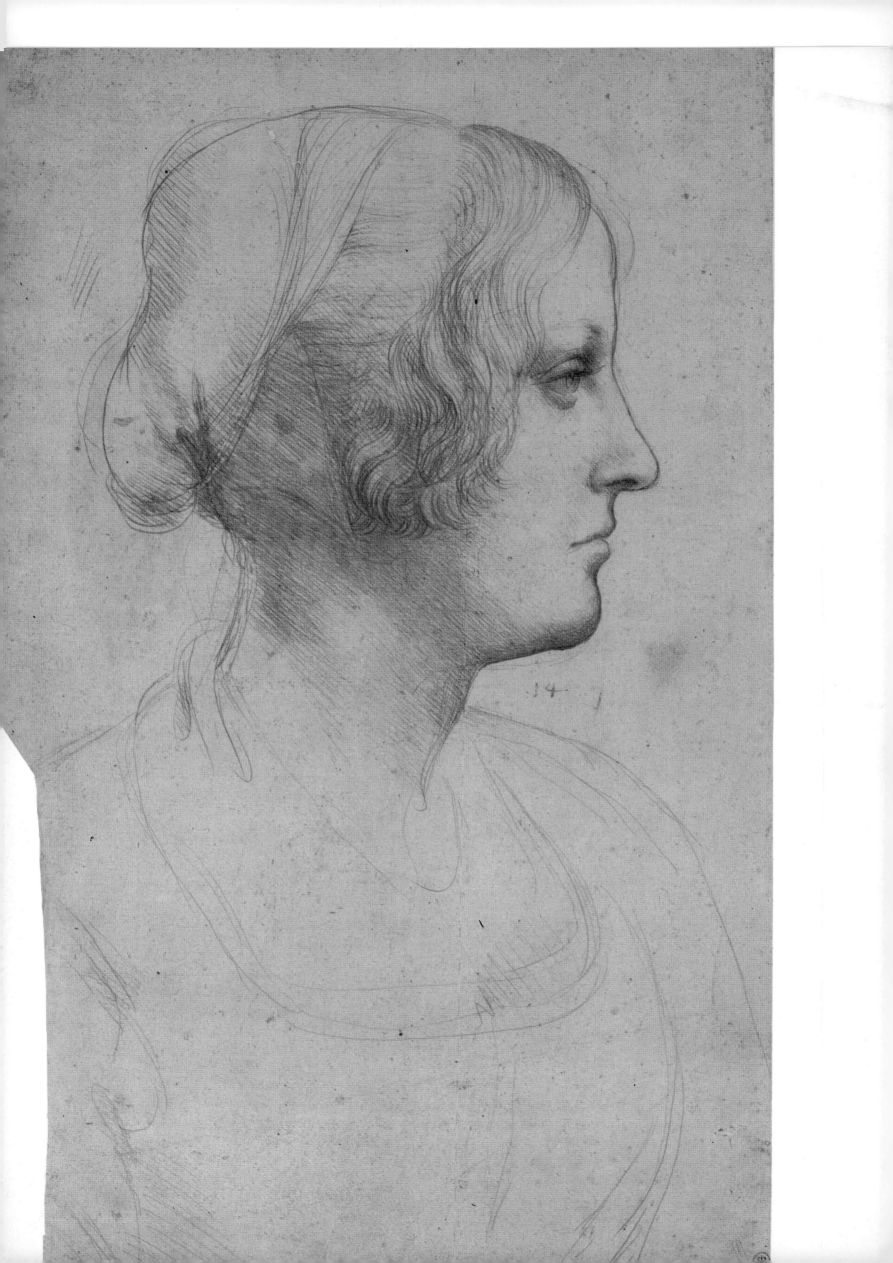

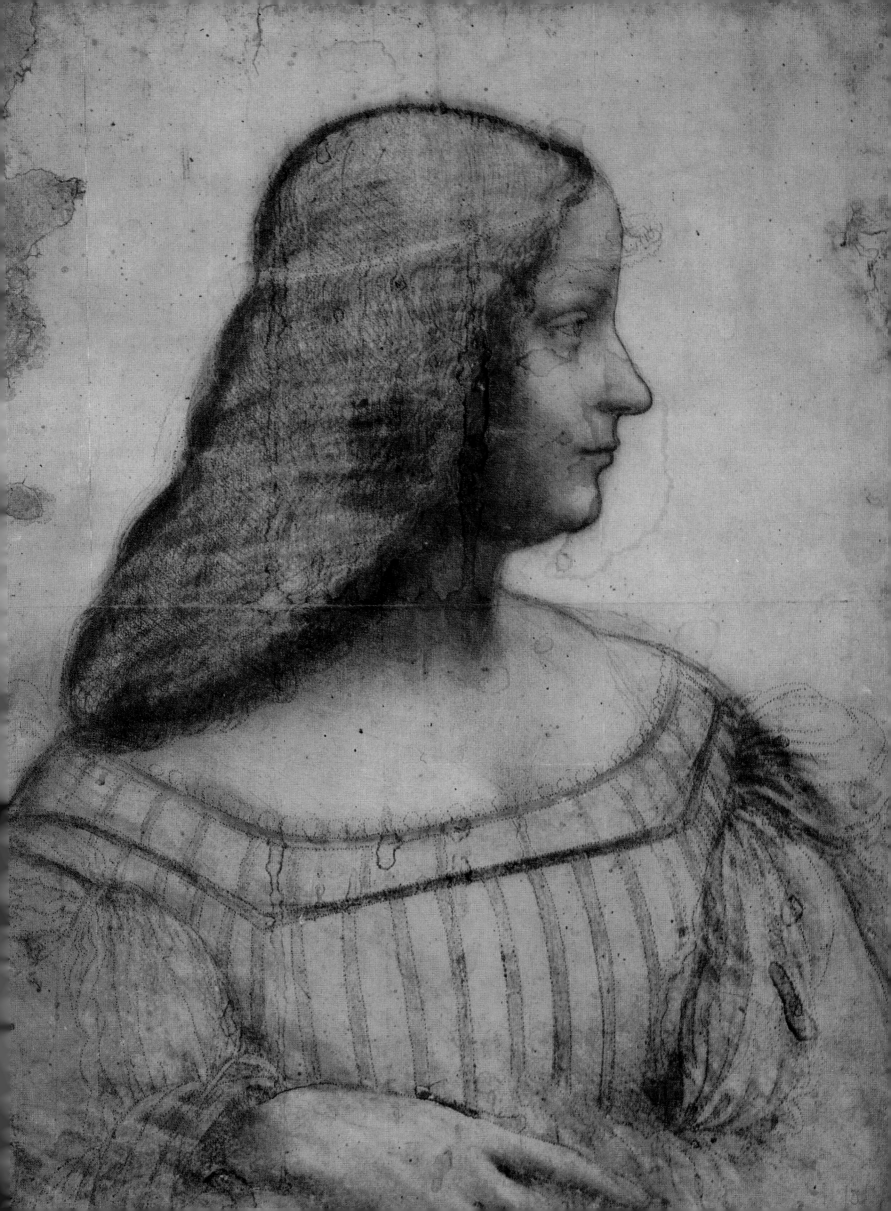

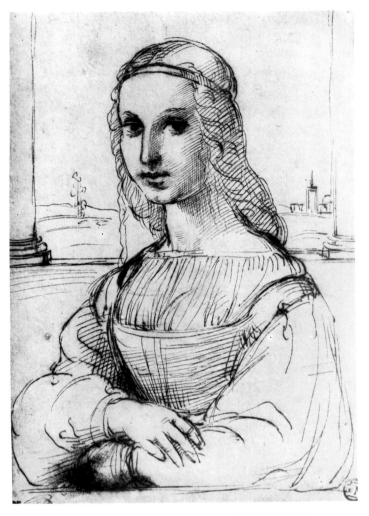

RAPHAEL: PORTRAIT OF A YOUNG WOMAN
(Inspired by the *Mona Lisa*)
1505. Pen and ink, 22 × 16 cm. Musée du Louvre, Paris.

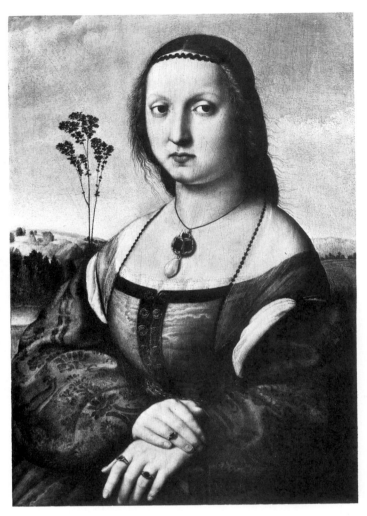

RAPHAEL: PORTRAIT OF MADDALENA DONI
1505. Oil on panel, 63 × 45 cm. Palazzo Pitti, Florence.

MONA LISA, AFTER LEONARDO
Spanish engraving: *La Hermosa Gioconda*.

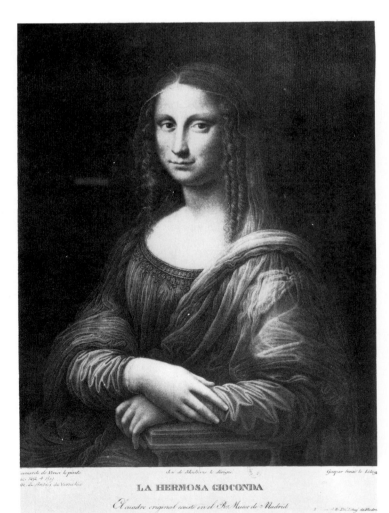

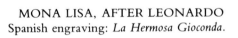

LA HERMOSA GIOCONDA

102

NUMA: MONA LISA, AFTER LEONARDO
Engraving.

CHARTIER: MONA LISA,
"MISTRESS OF FRANCIS I,"
AFTER LEONARDO
Engraving by Lambert.

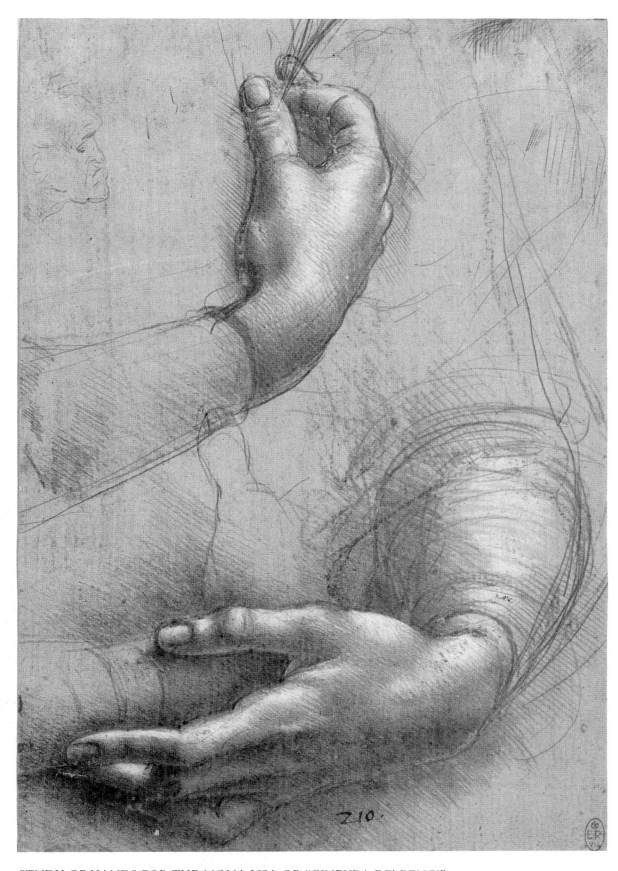

STUDY OF HANDS FOR THE MONA LISA OR "GINEVRA DE' BENCI"
Silverpoint, heightened with white, 21.5 × 15 cm. (reproduced original size). Royal Collection, Windsor
Castle.

Facing page.
MONA LISA
1503–1505. Oil on panel, 77 × 53 cm.
Musée du Louvre, Paris.

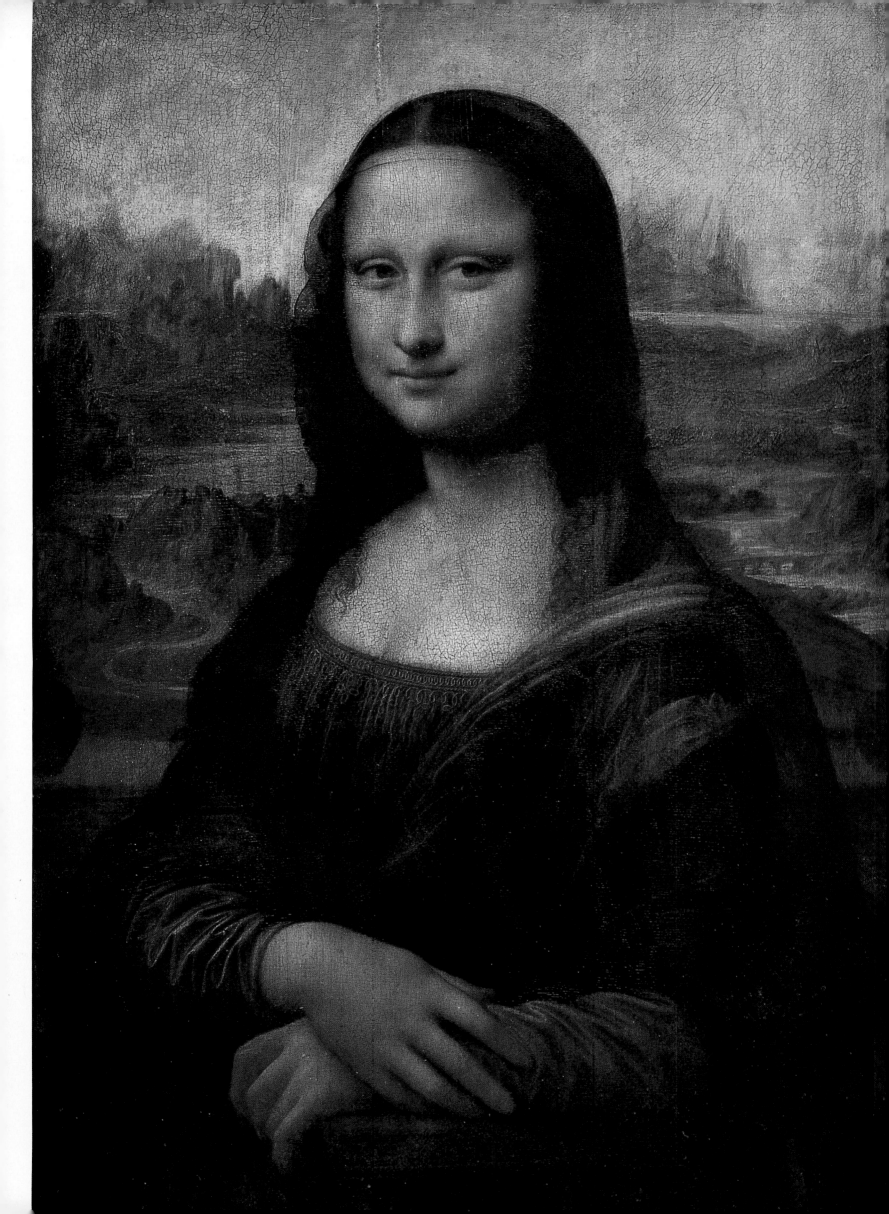

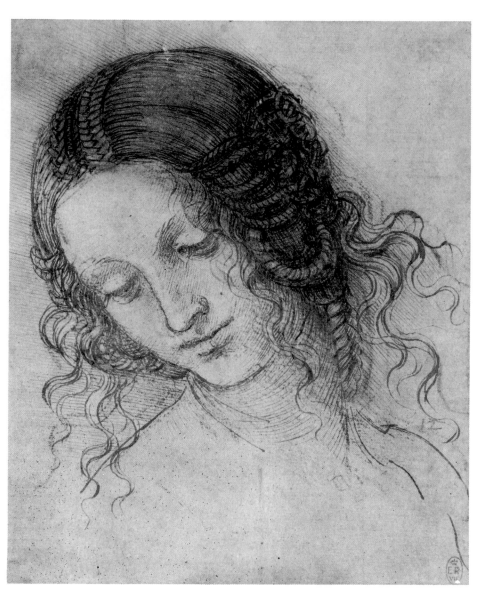

STUDY OF A WOMAN'S HEAD
Pen and ink with watercolor,
17.7 × 14.7 cm. (reproduced original size).
Royal Collection, Windsor Castle.

SKETCH FOR "LEDA AND THE
SWAN" AND STUDY OF A
HORSE
Pen and ink and pencil, 28.7 × 40.5
cm. Royal Collection, Windsor Castle.

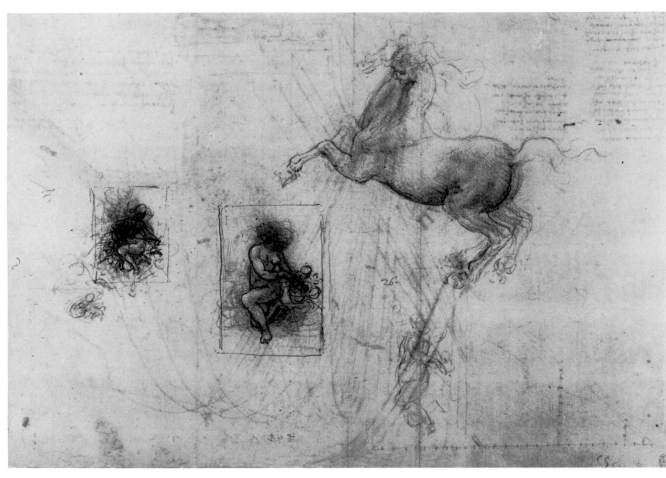

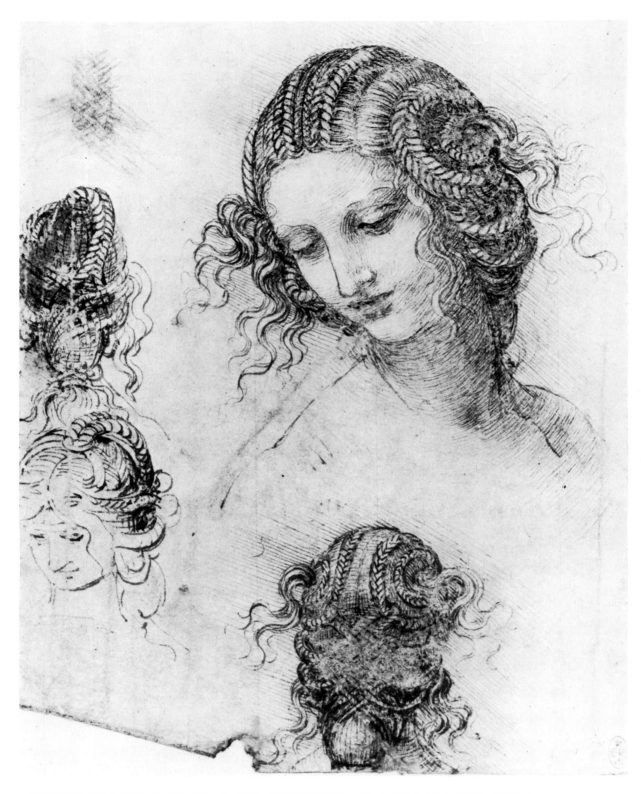

STUDIES OF A WOMAN'S HEAD AND HEADDRESS FOR "LEDA AND THE SWAN"
Pen and ink with some watercolor on white paper, 20 × 16.2 cm. (reproduced original size). Royal Collection,
Windsor Castle.

Following left-hand page. LEDA AND THE SWAN
(School of Leonardo)
1510–1515. Oil on panel, 112 × 86 cm.
Galleria Borghese, Rome.

Following right-hand page. SELF-PORTRAIT
1514. Red chalk, 33.3 × 21.4 cm. (reproduced original size).
Biblioteca Reale, Turin.

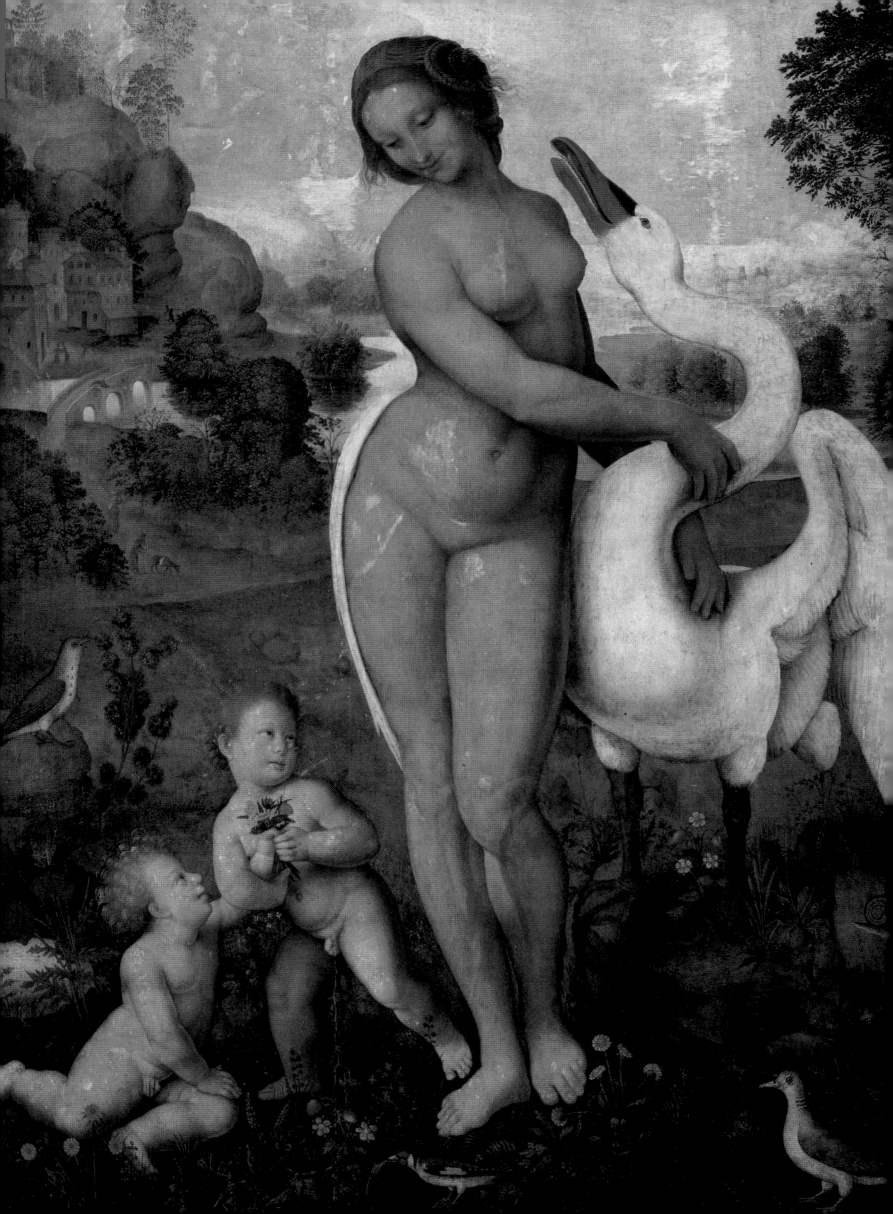

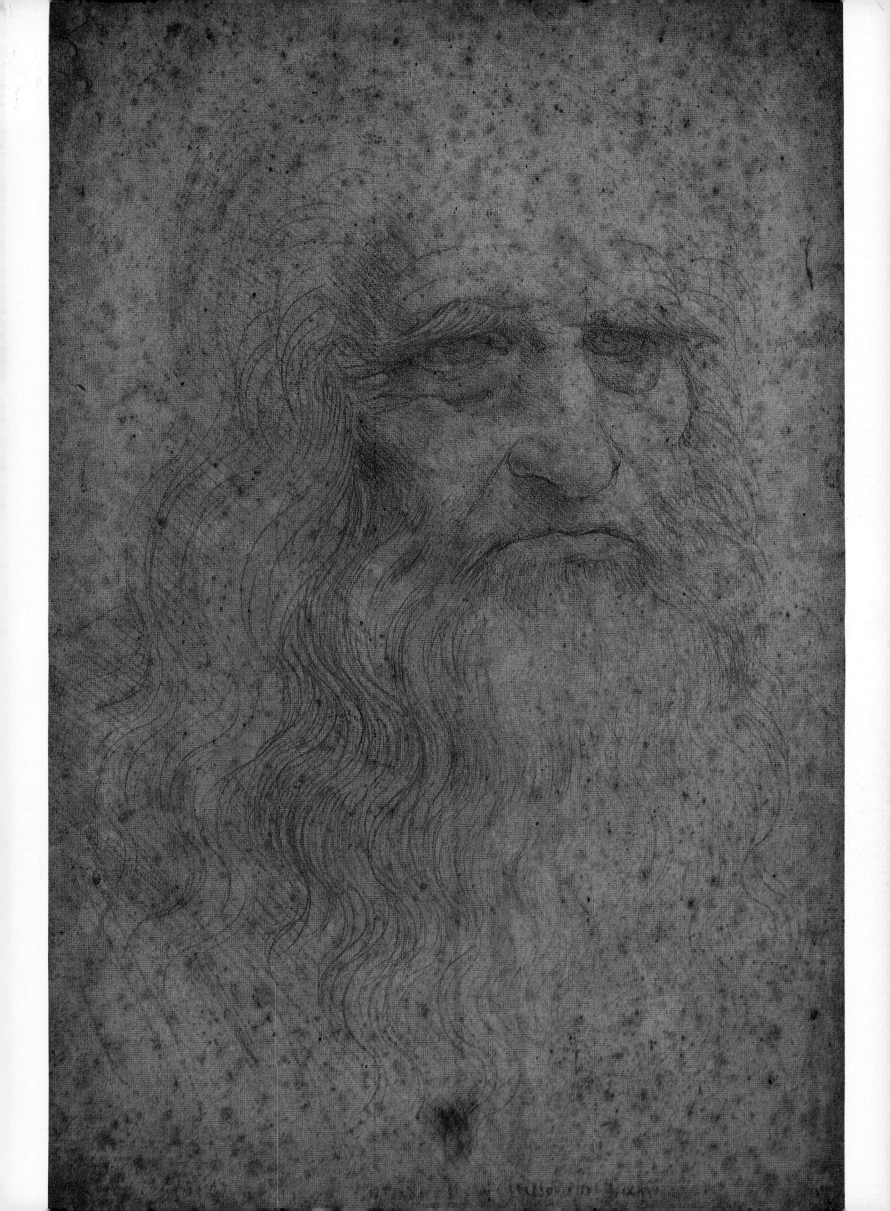

V THE COMPLETE ARTIST

In the fifteenth century, artists found themselves set apart from craftsmen who readied their masterpieces in workshops, and this change took place more rapidly in Italy than in the rest of western Europe. Their contemporaries began to acknowledge the superior character of their work, and artists found themselves catapulted to prominent positions in the social hierarchy. Those considered the most accomplished were showered with honors; the great treated them as equals.

In the late fifteenth and early sixteenth century, Italy fell victim to her neighbors' designs, but war and political upheaval had little effect on the artist's newfound status. On the contrary, they strengthened it. It is significant that Leonardo da Vinci entered the service of Francis I of France, not to mention the legend that the artist died in the king's arms. To be sure, the humble title of artisan still befitted a great many painters, decorators, sculptors, and architects, but a handful of "creators of beauty" rose to the highest levels of the new social order. At the pinnacle of this select group we find Leonardo da Vinci.

There is probably some truth to the stories about his talent as a musician, singer, and poet. Time and again, biographers tell of how he arrived in Milan with Attalante Miglioretti, how he devised a silver lyre in the shape of a horse's skull, how he triumphed at a music competition presided over by Ludovico il Moro. However, Leonardo failed to mention these gifts in his letter to the Duke. The assumption that he invented the violin appears to be unfounded. Leonardo's interests lay especially in the mechanization of the hurdy-gurdy and making keyboards easier to play by designing a faster mechanism, enhancing tonal quality, and refining polyphony.

MECHANICAL DRUM
Codex Atlanticus.

HORSEMAN WEARING A BAGPIPE COSTUME
Royal Collection, Windsor Castle.

While in Milan he may have met Josquin des Prés of France, and at least we are sure that Leonardo considered music second only to painting in his hierarchy of artistic values, calling it the figuration of things invisible and ranking it above poetry. Granted, he designed many musical instruments, such as flutes with mouthpieces based on his anatomical research into the larynx; he devised the *viola organista,* a complicated keyboard instrument with strings that were sounded by means of a wheel, a bow, and a horsehair strap; he invented several mechanisms enabling a drummer to tighten or slacken the skin with a single hand and move the drumsticks by means of cogs. However, the only conclusion we can draw from his methodical observations on instruments and acoustics is that he probed these subjects with the same enthusiasm and attention to detail that characterized everything he did.

The misfortunes visited on the *Battle of Anghiari,* a fresco that the *gonfaloniere* Soderini commissioned Leonardo to paint in the Sala del Gran Consiglio (or Hall of the Five Hundred) in the Palazzo Vecchio, were many and grievous. Michelangelo, who had been assigned another wall in the same room, took as his subject the battle of Cascina. Leonardo's battle scene was a reminder of how, on June 29, 1440, the Florentine army triumphed over the *condottiere* of Filippo Maria Visconti on a plain of a tributary of the

STRINGED INSTRUMENT
Institut de France, Paris.

Tiber, between Arezzo and Borgo San Sepolcro. "Ironically," notes Angela Ottino della Chiesa, "fate decreed that, aside from Vasari's minutely detailed description (albeit limited to the central scene depicting cavalrymen fighting for a battle standard), there is virtually nothing to give us an idea of what the original fresco looked like; yet, its history is thoroughly documented in no fewer than twenty different sources. These include a lengthy account in the *Codex Atlanticus* (f. 74, not in Leonardo's handwriting and believed to be by Machiavelli) and reports of the opening on October 24, 1509, of the Hall of the Pope and adjoining buildings in the church of Santa

MOLD FOR THE HEAD OF THE SFORZA MONUMENT
Red chalk. *Madrid Codex.*

Maria Novella in Florence, where Leonardo may have drawn the cartoon. We know about the contract, when it was signed (May 4, 1504), details about legal obligations, fees, and deadlines as well as about disbursements for advances and expenses incurred while the cartoon was being prepared and transferred, right up to February 1505, when the cartoon was to have been finished." We know all about who constructed the adjustable scaffolding in the Sala del Gran Consiglio, how much it cost, how much plaster, linseed oil, resin, and white lead was purchased in order to prepare the wall in accordance with Pliny's method. We also know that a trial run of the preparation on a board yielded favorable results—it dried quickly in a warm environment—and that applying it in an inadequately heated room ended in disaster: the wall sweated, causing the paint to run. In 1513 a protective frame was set up to enclose the wall, and in 1559 Vasari was called on to cover over Leonardo's fresco.

Water damage from a storm on June 6, 1505, had ruined the cartoon. It simply vanished from sight. As the year drew to a close, so did Leonardo's work on the project. The few surviving copies of the *Battle of Anghiari* show only the central section, the so-called Battle of the Standard. The most vivid and celebrated copy, now in the Louvre, is Rubens's in black chalk, pen-and-ink, and touches of gouache. It was probably taken from an engraving Lorenzo Zacchia made in 1558. Of Rubens's copy Stendhal said, "It is Virgil translated by Mme. de Staël."

Only a very few of Leonardo's sketches and elaborate studies for the *Battle of Anghiari* survive: eight composition studies and three large studies for heads. "Such large studies," writes A. E. Popham, "were intended and used by the artist to assist him in painting details on the wall or panel. They were exposed to much greater risks of loss and damage in the course of their use, to being splashed with oil or pigment, to being lost or stolen. If these risks in the case of a businesslike artisan were considerable, in the case of a wayward genius like Leonardo they were much increased. Few of his commissions were ever completed; some involved him in disputes or even litigation with his patrons; in others he released himself from engagements by a more or less precipitate flight, which may well have involved the loss of the type of study we have been discussing."

Leonardo offered his services to Ludovico as a sculptor "in marble, bronze, or clay," and Vasari reports that while still a youth he took up sculpture, making "several heads of women with smiling faces . . . as well as some children's heads executed as if by a mature artist." There is no reason to doubt

111

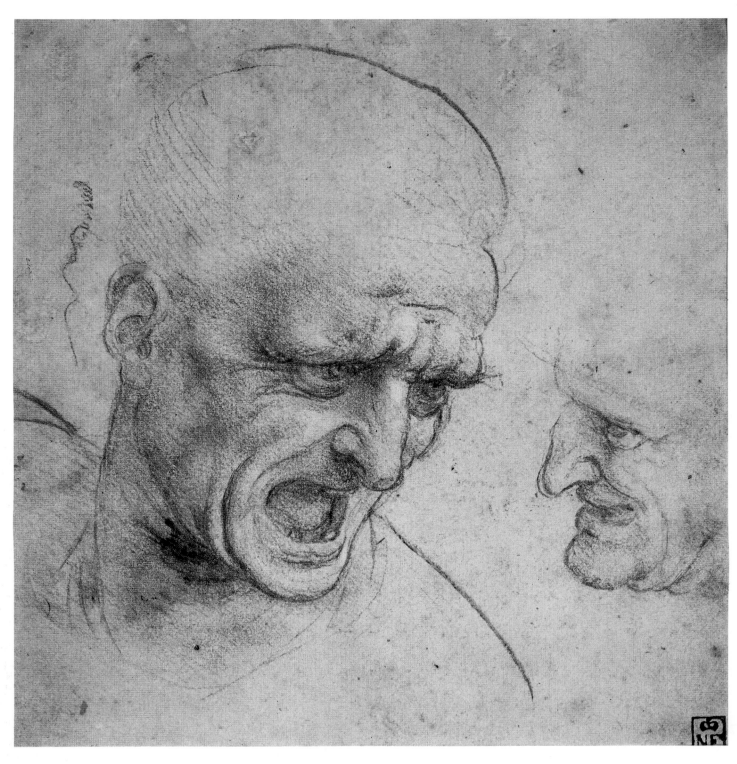

HEAD OF A MAN SHOUTING
Study for the *Battle of Anghiari*. Black and red chalk, 19.2 × 18.8 cm. Szepmuveszeti Museum, Budapest.

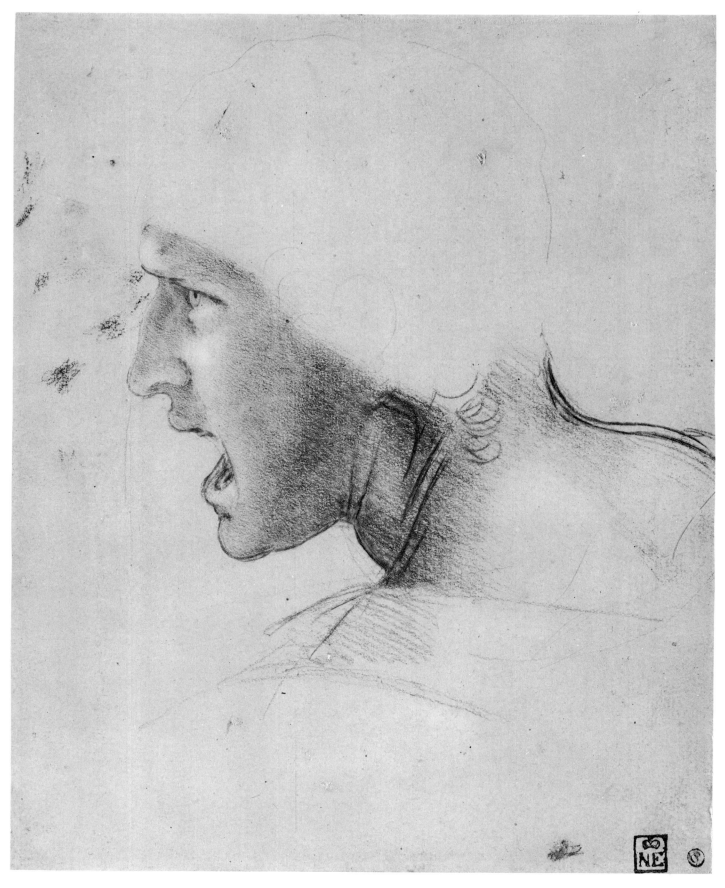

HEAD OF A MAN SHOUTING
Study for the *Battle of Anghiari*. Red chalk, 22.7 × 18.6 cm. (reproduced original size). Szepmuveszeti Museum, Budapest.

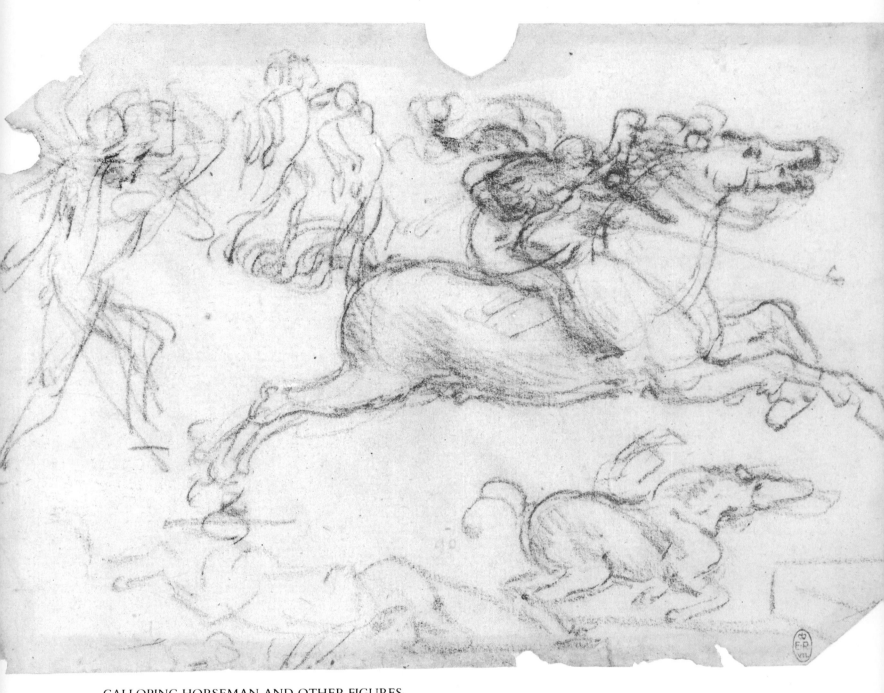

GALLOPING HORSEMAN AND OTHER FIGURES
Study for the *Battle of Anghiari*. Red chalk, 18.8 × 24 cm. Royal Collection, Windsor Castle.

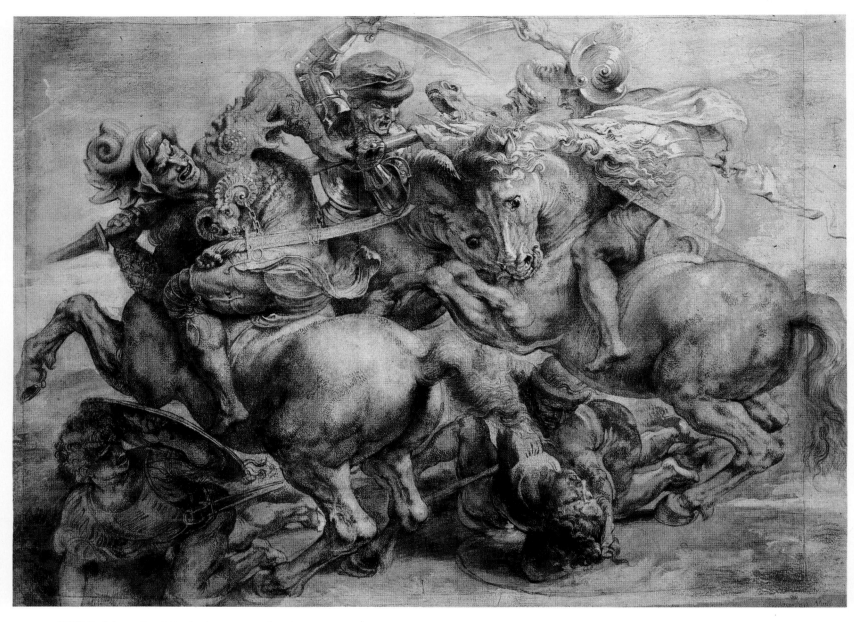

PETER PAUL RUBENS, AFTER LEONARDO: THE BATTLE OF ANGHIARI
Pen and ink, pencil and gouache, 45 × 64 cm. Cabinet des Dessins, Musée du Louvre, Paris.

this, given that, by and large, painters in those days were sculptors, too. Everyone is familiar with the story of the gigantic clay model for the equestrian statue of Francesco Sforza. Many preliminary drawings for the monument survive, but not one of Leonardo's sculptures stood the test of time, depriving us of anything tangible by which to gauge this aspect of his artistry. In the *Trattato della Pittura,* he attempts to prove that sculpture is less intellectual, less challenging, less perfect than painting. Every word of his description of the sculptor's studio smacks of belittlement. "The sculptor," he notes in his "Comparison of the Arts," "in producing his work makes a manual effort in striking the marble or stone, whichever it is, to remove what is superfluous and extends beyond the figure shut in it. This demands a wholly mechanical exercise that is often accompanied by much sweat and this combines with the dust and turns into a crust of dirt. His face is covered with paste and powdered with marble dust, like a baker, and he is covered with tiny chips as if it

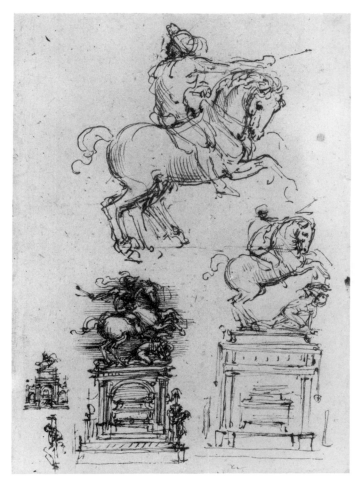

FOUR SKETCHES FOR THE TRIVULZIO MONUMENT
Pen and ink, 28 × 19.8 cm. Royal Collection, Windsor Castle.

had snowed on him. His lodgings are dirty and filled with stone splinters and dust.

"In the case of the painter, just the opposite occurs. He sits at great ease in front of his work, well dressed, moving a light brush with agreeable colors; he is adorned with such garments as he pleases, and his dwelling is clean and filled with beautiful paintings. He often has himself accompanied with music or the sound of different, beautiful works being read, which he may hear with great pleasure, undisturbed by the pounding of hammers or other noises."

As a rule, however, decorative painters did not enjoy such advantages. They worked away from home, perched atop scaffolding; and since both the exteriors and interiors of Milanese buildings in the second half of the fifteenth century were decorated with richly colored frescoes, they sometimes had to work outdoors. Decorative projects attributed to Leonardo include the *Sala delle Asse* in the Castello Sforzesco, the vaulted ceiling of the sacristy of Santa Maria delle Grazie, and the garlands painted in the lunettes above the *Last Supper.*

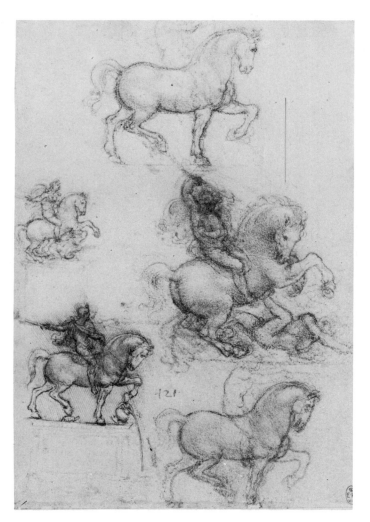

FIVE SKETCHES FOR THE SFORZA MONUMENT
Graphite, 22.4 × 16 cm. Royal Collection, Windsor Castle.

116

A debate arose as to whether the room in the Sforza castle had always been called the Sala delle Asse, or whether it was so dubbed only when a towerlike scaffolding of makeshift planks (*asse*) was erected for *maestro Leonardo*. "Taken as a whole," observes Ambrogio Annoni, "the highly original design in the Sala delle Asse is purely and organically architectonic. There is not a single superfluous element of decoration, considering what could have been done with it formally. The ornamentation is distributed in such a way that it spontaneously blends in with architectural structure. The skillful, precise way the overall pattern is compressed all around the central axis of the vault, the way eight rays of light filter through the bower like shreds of sky, offering welcome breaks in the octagonal latticework—all this was devised by a virtuoso of logic and geometric schemes. It embodies Leonardo's spirit, his penchants, his very obsessions."

A close inspection of the Sala delle Asse is needed to make sense of the foliage, so dense that it creates an impression of swarming plant life run amok. But once the key has been found, everything falls into place with flawless consistency. "The human mind," writes René Huyghe, "likes to start with rudiments and gradually build up greater complexity without losing the thread of the original whole, until, in a moment of crowning triumph, it achieves an intricacy that seems to rival nature at her most chaotic." Huyghe suggests a link between the interlacing boughs of the vaulted ceiling and the knotted pattern Leonardo used in a sketch for a seal of his future *Academia Leonardo Vinci*.

Although the design—more correctly, the concept—at the heart of the Sala delle Asse was Leonardo's, certainly the actual painting was assigned to assistants and associates. Over the centuries it fell victim to one deterioration and restoration after another. When the ceiling was freed from plaster in 1893, all that remained was a ghost of what had once been a marvelous work of art. Luca Beltrami compiled an inventory of surviving fragments and reconstructed the decoration, after which E. Rusca repainted the entire ceiling in 1901–02, using what original paint there was as his guide. Ottemi della Rotta began another restoration in 1956.

Leonardo was an engineer as well as a draftsman, and it would be odd not to come across topographical drawings and maps in his *oeuvre*. He did several of them when, as Cesare Borgia's *architetto e ingegnere generale,* he spent the summer of 1502 traveling through the Arno valley to work out the details of a navigable canal. It was supposed to start at Florence, continue to Prato, Pistoia, and the narrow channel at

MAP OF NORTHERN ITALY SHOWING THE WATERSHED OF THE ARNO
Pen and ink and brown wash, 31.7 × 44.9 cm. Royal Collection, Windsor Castle.

Serravalle, then join the Arno again at Vico Pisano. Such a regulated waterway, he reasoned, would spare crops the twin scourges of floods and low water while providing Florence with both a link to the sea and a source of power for her industry.

Leonardo's meticulous surveys and charts are among the very few drawings he intended for people other than himself, since the handwriting on them reads from left to right. Curiously enough, the handwriting on his map of Imola—considered his topographical masterpiece—is the only exception. He used pink for houses, yellow for private spaces, white for public spaces, streets, and squares, blue for water, flesh tone for countryside, and blue-gray contour lines to indicate elevation. Forested areas are indicated by tiny open circles. This map was probably drawn in 1502, for in October of that year Cesare Borgia became a virtual captive in the city when

PLAN FOR DIVERTING THE ARNO BY MEANS OF SLUICES
Royal Collection, Windsor Castle.

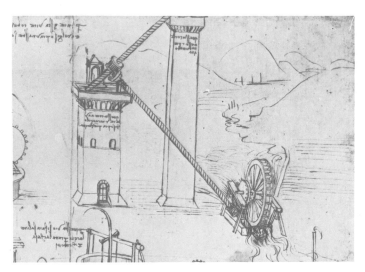

WELL PUMP AND PERSIAN WHEEL DRIVEN BY
HYDRAULIC MECHANISM
Codex Atlanticus.

some of his troops rose up in revolt. Marcel Brion
sees a connection between this map and Leonardo's
anatomical drawings in that it reveals the artist's at-
tempt to capture a certain vitality that is nothing less
than organic.

A person who studies the uses of streets and the
layout of urban areas is called a city planner. Leo-
nardo is all the more deserving of the title in that he
laid the theoretical groundwork for an "ideal city" at
the instance of Ludovico il Moro. The goal was
nothing less than the reconstruction of Milan. He
may also have worked with Ambrogio da Cortis
and Bramante in 1492 on rebuilding the marketplace
in Vigevano for Ludovico, and for Cesare Borgia on
the rebuilding of Cesena and the expansion of Cesena-
tico. In his plans for civic improvement, Leonardo
gave priority to financial and political factors; the
well-being of inhabitants was a secondary considera-
tion. "The prince had but to confer him with the
authority and he would assure without any expense
to him, assure that discipline was maintained and the
renown of the prince enhanced and the city trans-
formed." On the subject of authority: "All people
obey and are swayed by their magnates, and these
magnates ally themselves with and are constrained
by their lords in two ways, either by blood relation-
ship or by the tie of property; blood relationship
when their sons, like hostages, are a surety and a
pledge against any suspicion of their faith; the tie of
property when you let each of them build one or
two houses within your city, from which he may
draw some revenue." Hygiene: "Nothing is to be
thrown into the canals, and every barge is to be
obliged to carry away so much mud from the canal,
and this afterwards to be thrown on the bank. Con-

struct in order to dry up the canal and clean the
(lesser) canals." To ensure safety and health, "you
will disperse so great a concourse of people, who,
herding together like goats one upon the back of
another filling every part with their stench, sow the
seeds of pestilence and death."

Leonardo's plan called for streets on two levels.
The lower level would be set aside for beasts of
burden, carriages, and the lower classes, with ware-
houses and storage areas in the houses. On the upper
level, persons of rank would be free to stroll about
and look at shops on their level. Broad archways,
unobstructed views of sky, and bridges would pro-
vide light and ventilation to the lower level. There
would be a stairway connecting the two levels about
every one hundred meters; privies would be installed
in them and—Leonardo observed that city dwellers
tend to leave rubbish in corners—they would be spi-
ral. The city would be built entirely of stone and laid
out with mathematical precision: "One house must
turn its back to another, leaving the lower streets
between them. Provisions, such as wood, wine, and
such things, are carried in by doors, and privies,
stables, and other fetid matter must be emptied
away underground."

"Leonardo's city planning is quite fragmentary
and unsure," writes Bertrand Gille. "It lacks the
sweep of Alberti or his immediate successors."
Traffic management in urban areas back then must
have presented serious difficulties, and while the
notion of superimposed thoroughfares did address
the problem, it would appear that Leonardo did not
flesh out his concept. He limited himself to map-
ping out a few districts and to areas in the vicinity
of monuments.

CITY PLAN SHOWING MULTILEVEL THOROUGH-
FARES FOR PEDESTRIAN AND COMMERCIAL TRAF-
FIC
Manuscript B. Institut de France, Paris.

Water always played a decisive role in Leonardo's thinking. As a painter he was interested in eddies; as a geologist, in land erosion; as a physicist, in power supply; as an engineer, in harnessing waterways and soil drainage. Naturally, he planned a treatise—more precisely, an engineering abstract—on hydraulics: "Book of the various ways of leveling waters. Book of how to divert rivers from places where they do damage. Book of how to straighten the course of rivers which cover too much ground. Book of how to divide rivers into many branches and make them fordable. Book of how waters pass through seas and different movements. Book of how to deepen the beds of rivers by different currents of water. Book of how to control rivers so that the small beginnings of the damage they cause may not increase. . . ."

The notebooks reveal that, in most instances, Leonardo concentrated on technical details and practical advice; when it came to presenting an overall

STUDY FOR THE DOME OF MILAN CATHEDRAL
Codex Atlanticus.

ARCHITECTURAL DRAWING: TOWER
Pen and ink. Cabinet des Dessins, Musée du Louvre, Paris.

STABLE WITH MECHANISM FOR AUTOMATIC RE-FILLING OF RACKS
Manuscript B. Institut de France, Paris.

picture, his approach tended to be superficial. For example, he suggests that work on canal projects should be done from mid-March to mid-June, when farming activity is minimal, days are long, and the heat still bearable. He also points out that willows should be planted to strengthen riverbanks and prevent erosion. In 1493 Leonardo helped plan improvements in Lomellina and the regulation of canals in Novare; in 1498–99 he turned his attention to drainage and general improvements in the Vigevano region. He drew a rough draft of a scheme to drain the Pontine marshes, taking up where the Romans had left off. (The engineer Alberti had already repaired one of Rome's main aqueducts, the Aqua Virgo, at the behest of Pope Nicholas V.) In November–December 1504 Leonardo went to Piombino and presented Iacopo IV of Appiano with plans of the land and harbor defense works he had already studied for Ludovico il Moro and Cesare Borgia.

At that time Venice lay under the threat of a Turkish invasion. Noting that the plain of Isonzo was the weak spot in the city's northern defenses, Leonardo traveled through the Isonzo valley, drew sketches of the river's flow, and designed what he

CROSS SECTIONS OF A CORNER TOWER OF A FOR-
TRESS; SKETCH OF A DOUBLE SPIRAL STAIRWAY
Manuscript B. Institut de France, Paris.

called a "cogged bracket"—in effect, a movable
sluice. When needed, these sluices could act as bar-
riers to the current and cause the water to rise,
thereby flooding the area and rendering it useless.
Leonardo's "cogged bracket" was to be of wood and
adapted to the force of the current and the height of
the embankments. Later on in France, Leonardo
harked back to this scheme—"let the sluice be mov-
able like the one I arranged in Friuli"—to make
some land along a branch of the Loire more fertile.
He also envisioned a major drainage project between
Romorantin and Amboise: a canal beginning at
Tours or Blois would cross the Allier and the Loire,
pass through the mountainous Charollais region,
and empty into the Saône near Mâcon. In so doing,
the marshland of the Sologne would be drained and
made suitable for crops.

From the time he brought to Sforza's attention
his talent as an architect "in the construction of
buildings both public and private, and in conducting
water from one place to another" to the day he died
in the manor house of Cloux, Leonardo worked on
a variety of building projects aimed at accommodat-
ing both water and human beings. But does even a
single structure that can be positively attributed to
him still stand? We must be satisfied with his draw-
ings and the praise his contemporaries or those who
came after showered on him. As early as 1478 Leo-
nardo the architect proposed a way of safely lifting
the octagonal church of San Giovanni in Florence

Below left. ABBEY OF VIBOLDONE: CEILING DECORATION INSPIRED BY LEONARDO'S SALA DELLE ASSE

Below right. SALA DELLE ASSE: DETAIL OF THE VAULTED CEILING
Castello Sforzesco, Milan.

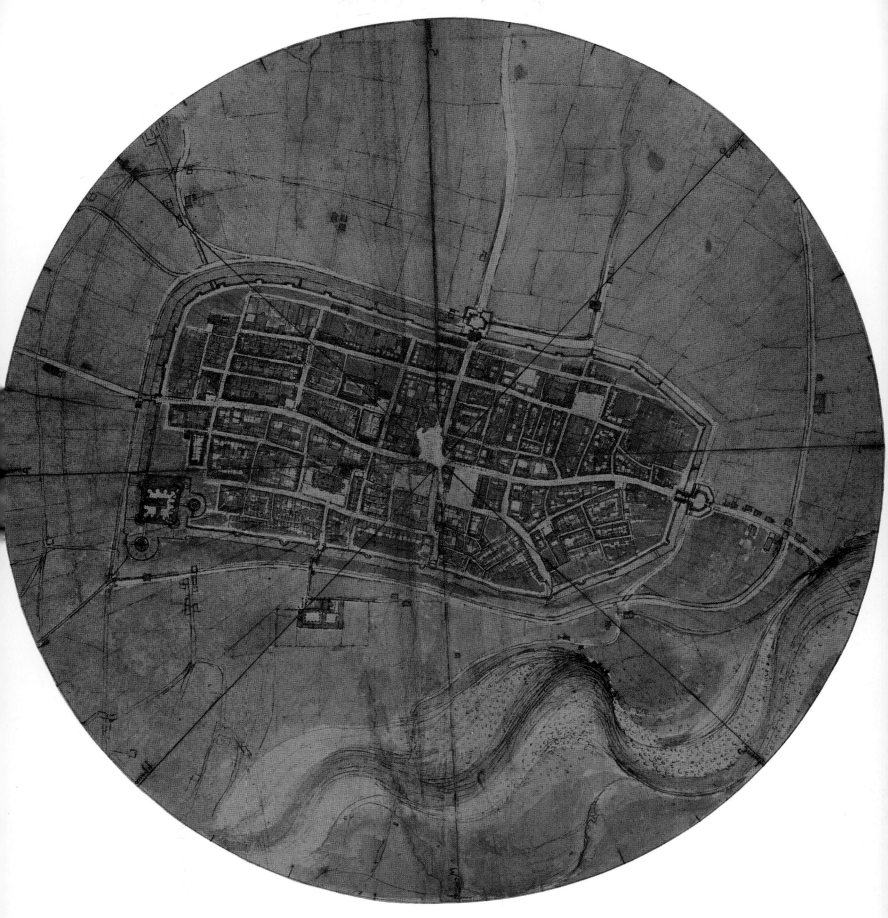

PLAN OF IMOLA
Pen and ink and watercolor, 44 × 60 cm. Royal Collection, Windsor Castle.

DOMED CHURCH AND PLAN
Manuscript B. Institut de France, Paris.

Following right-hand page. SKETCHES OF A ROOF, A DOME,
AND A TWO-TOWER FORTRESS
Manuscript B. Institut de France, Paris.

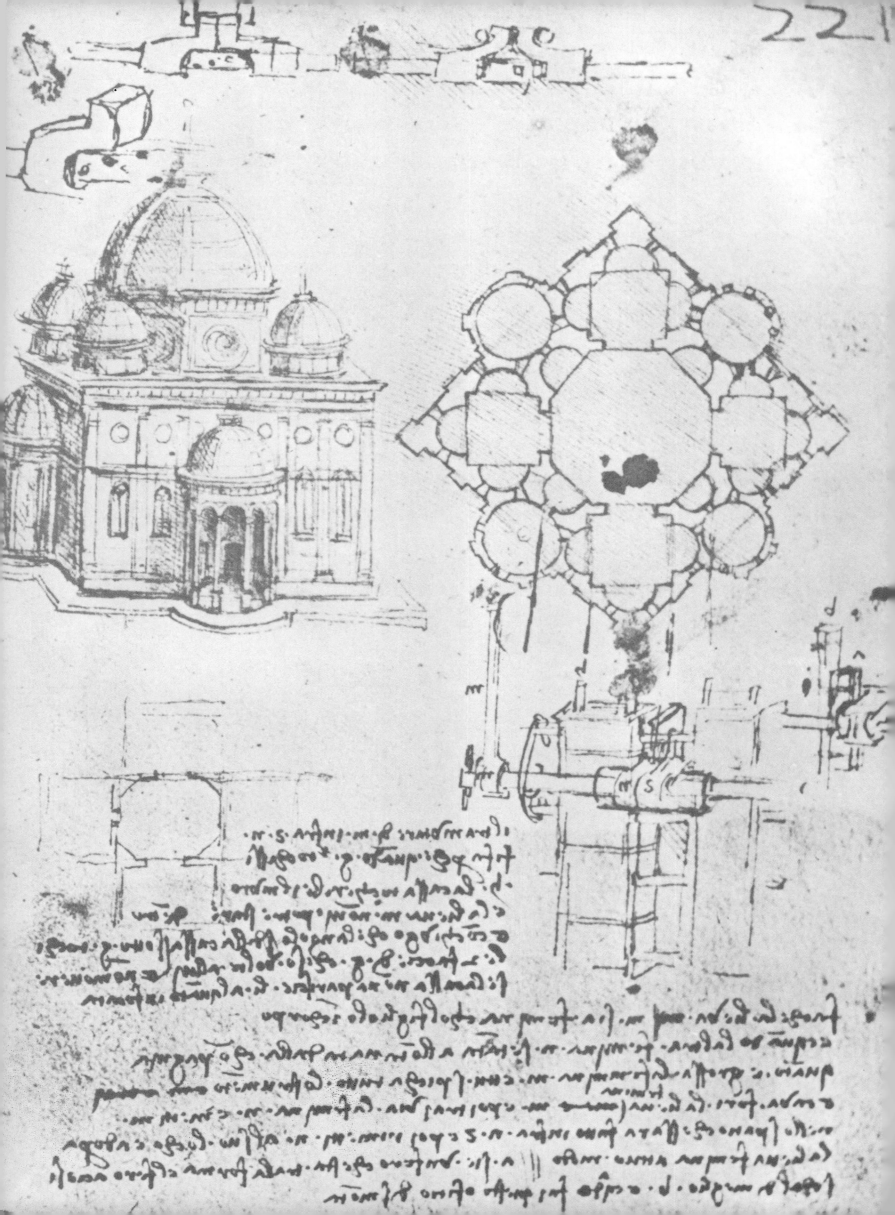

Note: The handwritten text is in Leonardo da Vinci's mirror script and is largely illegible.

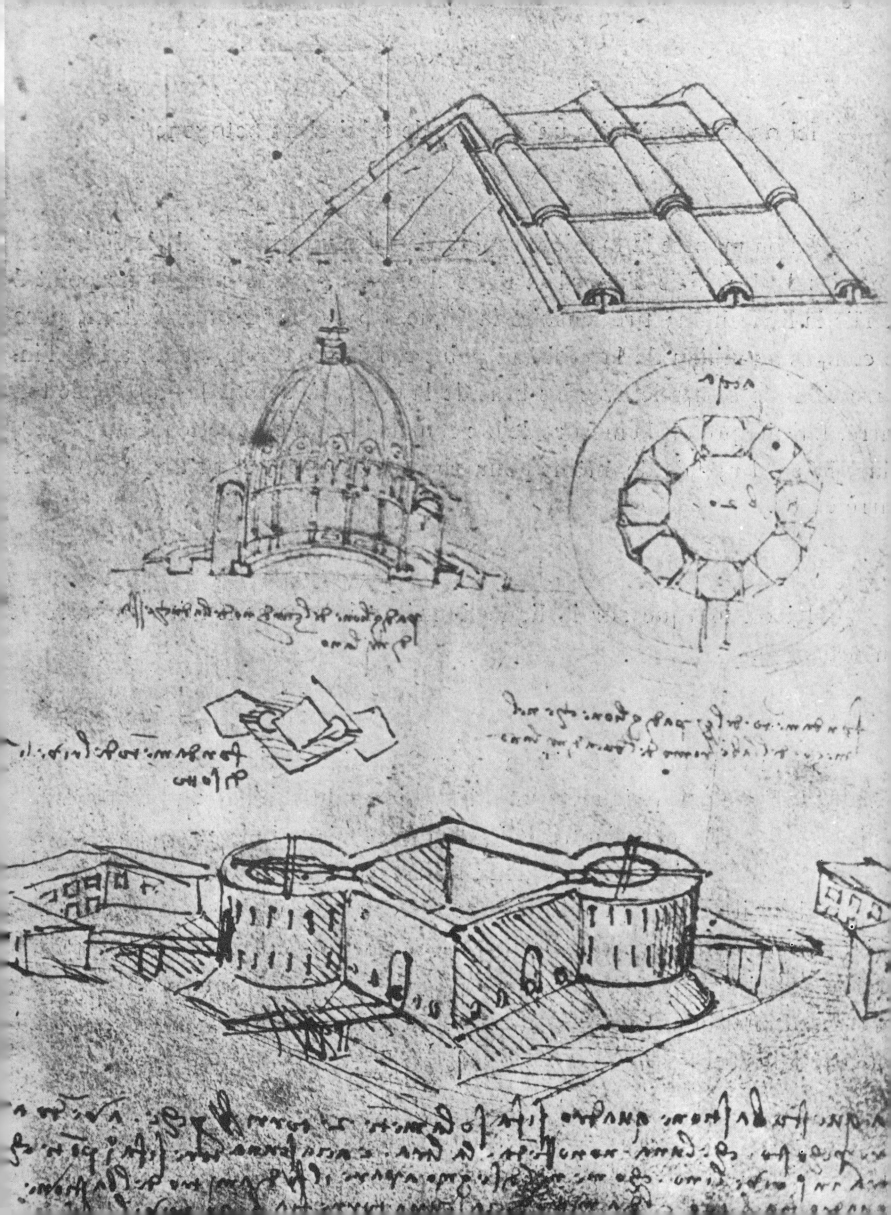

LUNETTES ABOVE THE "LAST SUPPER"
Paint on stone wall. Santa Maria delle Grazie, Milan.

Below left. STONE ALTAR: DETAIL OF "ANNUNCIATION"
Uffizi Gallery, Florence.

Below right. VASE OF FLOWERS: DETAIL OF "MADONNA WITH THE CARNATION"
Alte Pinakothek, Munich.

(the present-day Baptistry) and adding a foundation with steps. The scheme never got past the planning stage. In 1490 Francesco di Giorgio and he sat on an advisory committee for the cathedral of Pavia. Leonardo also submitted a model for the central tower (*tiburio*) of Milan cathedral. His first model, completed and paid for on January 11, 1488, was rejected, probably on May 10, 1490; he was asked to submit another model but never finished it. In addition, a positive attribution has yet to be made for the church of Santa Maria della Fontana in Milan.

As Leonardo's life drew to a close, he made sketches for the queen mother's castle at Romorantin. Although never carried through, they are interesting in that they prefigure French architecture of the seventeenth century. There is no question that he intended to write a treatise on architecture, despite the fact that the chapter headings we find in his notes—"The Manner in Which One Must Set Up a Stable," "How to Set Up a Framework for Making Decorations in the Shape of a Building," "How to Decorate a Platform Which Has Been Erected for a Celebration," etc.—are somewhat disappointing. Many sketches show an enormous dome supported and buttressed by a closely set ring of chapels, and although Leonardo seems to have been intrigued by this architectural concept, he did not carry any of his studies to fruition. What we find instead are definitions: "What is an arch? An arch is nothing else than a force originated by two weaknesses, for the arch in buildings is composed of two segments of a circle, each of which being very weak in itself tends to fall;

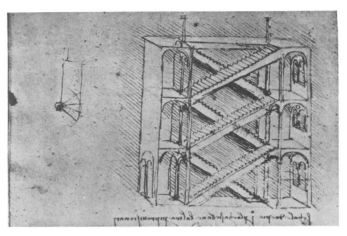

SKETCH FOR A TWO-WAY STAIRCASE
Manuscript B. Institut de France, Paris.

but as each opposes this tendency in the other, the two weaknesses combine to form one strength."

According to Antonina Vallentin, Leonardo approached Francis I of France about making improvements to the castle of Amboise "above all based on practical considerations," and Jacques Sourdeau, the architect in charge of ongoing improvements at the castle of Blois, may have consulted with him. "You would think," notes Vallentin, "that someone had stepped in after the building had begun to take shape and added the staircase which juts out like a wholly independent structure. This was an architectural invention of unprecedented boldness, and only a man of undisputed authority could have so intervened. In fact, the concept goes beyond architecture and seems inspired by nature herself, by one of those shells Italians so often find on their northwestern shores. The design must have been quite unfamiliar to the inhabitants of Touraine. The odd thing is that the spiral staircase at Blois winds from right to left, as though designed by an architect who was born left-handed or by a man who had lost the use of his right hand. . . ."

After recalling Leonardo's interest in shells and fossils, the fact that he lived near Blois and made frequent trips there, and the fact that not a single allusion to work on this staircase appears anywhere in the notebooks, Antonina Vallentin asks, "Was it coincidental that this strange, exotic piece of work—nothing like it had ever been thought of before or since—should have been done during Leonardo's stay in France and near his place of residence? Did the French architect use a plan drawn by Leonardo that has since vanished into thin air, while Leonardo's own cartoons abound with plans for monuments that were never built? Did fate decree that his name should never be associated with his only completed architectural masterpiece?"

SKETCH FOR A FOUR-WAY STAIRCASE
Manuscript B. Institut de France, Paris

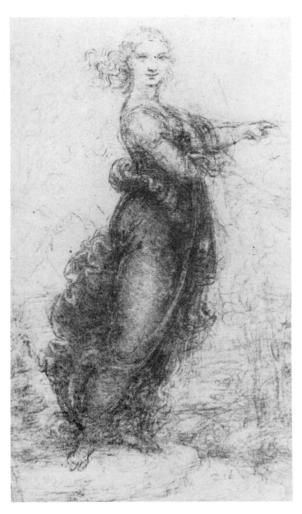
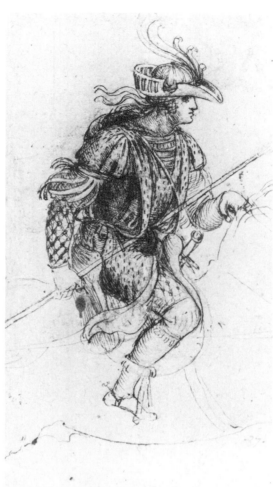
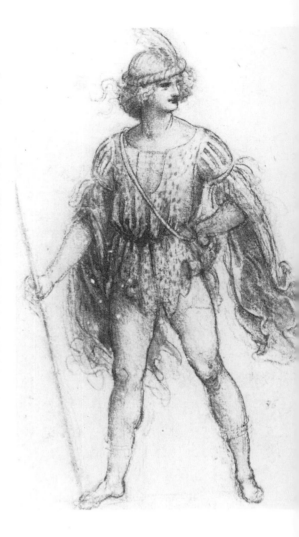

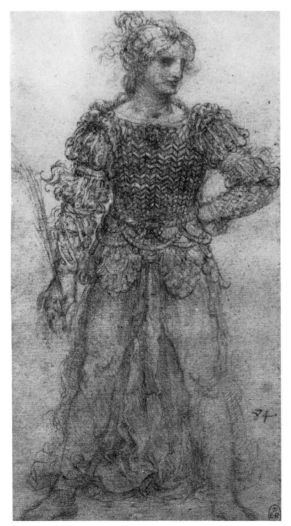

Above left. SKETCH OF A YOUNG WOMAN POINTING
Charcoal, 21 × 13 cm. Royal Collection, Windsor Castle.

Above center. YOUTH ON A HORSE
Pen and ink over black chalk, 24 × 15.2 cm. Royal Collection,
Windsor Castle.

Above right. YOUTH WITH A LANCE
Pen and ink and wash over black chalk, 27.3 × 18.3 cm. Royal
Collection, Windsor Castle.

FIGURE WEARING A BODICE OF INTERLACED
RIBBONS
Black chalk, 21.5 × 11.2 cm. Royal Collection, Windsor Castle.

VI PHYSICIST AND MATHEMATICIAN

FOR many years—perhaps as early as the last decades of the fifteenth century but certainly for more than a century—Leonardo da Vinci has been on trial, and the verdict is still a long way off. People attempting to understand Leonardo have found it necessary to arraign him, and almost invariably he has triumphed simply by remaining silent. His contemporaries often admired him, but sometimes they took him to task. This extraordinary, elusive soul wrought marvels and broke his contracts, got worked up one day over something he would temporarily set aside the next. He was always switching from one project to another simply because that was the way he liked it; he felt he was answerable to no one, at least when it came to matters of little consequence. Our contemporaries admire him more than ever and are that much more perturbed by it.

Who was Leonardo da Vinci? The greatest painter of his time; for many, the greatest painter of all time. Yet, because he left so few works that are indisputably his, the legacy of Leonardo has also led to incomprehension and a sense of outright frustration. Was he a penetrating philosopher who failed to mold a disciple, leaving instead only some scattered notes? An inspired precursor in the field of science? An engineer of matchless daring? The thousands of pages he wrote and illustrated allow for interpretations so conflicting that we end up mired that much more deeply in mystery. Was he a versatile genius so far ahead of his contemporaries that they never could have appreciated him? Or should we characterize him as a remarkable dreamer, a "master schemer" whose curiosity knew no bounds? How shall we account for this superb founder and sculptor who did not leave a single work that can be positively attributed to him? What shall we say about an architect, city planner, and engineer who cannot be credited with a single monument, civic improvement, fortification, or canal? A theoretician who never finished a treatise, yet who is justly famous the world over?

Some have seen this "unlettered" man who wrote so much (and about whom even more has been written) as an extraordinary individual who cannot be gauged by ordinary standards, a soul adrift in a world still shrouded in the mists of the Middle Ages. Others, determined to ferret out what he borrowed from his predecessors and contemporaries, have tried to create a niche for him—a lofty one, to be sure—among the men of the Renaissance.

A brief moment in the history of western European civilization, Leonardo's era seems to have been one in which people attached increasing importance to technical problems, although engineering special-

ists as such had not yet come into their own. It was a time when technical people were singled out for their knowledge, but not compelled to confine themselves to technical matters alone. The engineers of the Renaissance, Bertrand Gille notes, "did not operate in the realm of pure technique and had virtually nothing to do with what is commonly known today as industrial engineering. Their link with that was only indirect in that they utilized machinery borrowed from their surroundings. They had come with different outlooks and had gradually undergone a kind of standard training, not to mention the whole movement of ideas in which western Europe was caught up at the time. They tried their hands at molding these incongruous, at times conflicting, elements into something unified, however clumsy it still might be. A newfound awareness of nature, a desire to harness it, an obsession with controversy (no doubt a distant holdover from scholasticism)—all this mingled in the minds of the technocrats of the Renaissance."

Leonardo was one of these engineers, but, as Gille points out, Renaissance engineers "in no way brought about real technical progress. Often all they did was fall in step with a movement they had not set in motion and that, in many instances, they did not even help to perpetuate. The fact is that, when all is said and done, they played a very minor role. Soldiers, artists, and architects, their affinity for technical matters and quest for *invention,* strike us as a kind of pastime or even as so much diversion or mental play." Can Leonardo da Vinci at least be ranked the foremost engineer of the Renaissance, the prolific inventor tradition has made him out to be? As Gille sees it, defending this view "required a great deal of ignorance and no less imagination." The only problem is that, to refute it, we would have to be familiar with Leonardo's thinking in its "finished" state, to have before us something other than some notes jotted down as part of a planned book, something other than projects ultimately dropped for reasons not directly connected with technical considerations.

It may be relatively easy for an expert to evaluate a painting, which is a single work of art, and assess its inherent qualities without giving too much thought to what other artists did later on or to the influence it may have had on them. But it is far from easy to read an old scientific text dispassionately, even if one's knowledge of science is not particularly wide-ranging. Our minds spontaneously complete what we read, and we ascribe to the author an understanding of a future that, from the reader's point of view, is history. On reading the statement, "Fire

COMPASS
Manuscript H. Institut de France, Paris.

taking on adversaries. Pierre Duhem made an exhaustive study of authors whom Leonardo read as well as those who read him: clearly what we call plagiarism was then an established practice, but in no way should one infer from this that even one plagiarist did not act in good faith.

Apparently everything excited Leonardo's curiosity, but mathematics and physics held a special fascination for him. Quite naturally, he borrowed a great deal from those who came before him, and just as naturally, as Duhem points out, "those who came after were familiar with the new ideas that abound in Da Vinci's notes. They found their way into many books on statics and dynamics throughout the sixteenth century."

The engineer's deep attachment to mathematics is apparent both in Leonardo's writings and in accounts of his life. However, this does not necessarily imply that Leonardo ranked among the preeminent mathematicians of his day—something that those who marvel at his inspired paintings are all too quick to infer. In Ms. B (Institut de France) he notes, "There is no certainty where one can neither apply any of the mathematical sciences nor any of those which are based upon the mathematical sciences." Elsewhere we read, "No human inquiry can be called truly scientific which does not allow of mathematical proof." His description of mechanics

COMPASS FOR DRAWING PARABOLAS
Codex Atlanticus.

continually destroys the air that nourishes it," one is tempted to think of oxygen and assume that Leonardo discovered combustion. Actually, all he is saying is that fire requires air to burn and that, once deprived of air, it dies out. Likewise, how can anyone familiar with the writings of Galileo or Newton read one or another of Leonardo's texts and not sense foreshadowings of their work?

Those who study Western thought of the fifteenth, sixteenth, and early seventeenth centuries also tread on perilous ground when it comes to attributing a discovery, invention, or interpretation to one author instead of another. In those days, people had a different view of what we refer to as plagiarism. Simply because a manuscript was widely read, or a book printed a number of times, or the person who wrote it was still living did not prevent one author from borrowing all or substantial parts of a book from another without ever giving his sources. At most a "borrower" would name names when

128

as "the paradise of the mathematical sciences" is famous even today. "Let no man read me in my beginnings who is not a mathematician," he warns; and on April 4, 1501, Fra Pietro da Novellara wrote to Isabella d'Este, who was determined to secure the artist's services in Mantua, that "his mathematical experiments have so distracted him from painting that the sight of a brush puts him out of temper."

Leonardo was especially intrigued by three problems that had puzzled geometers since ancient times: the squaring of the circle, the duplication of the cube, and the trisection of an arbitrary angle. He erroneously thought he had found the solution of the third. He delved into the theory of lunules (a figure formed by three segments of a circle) and worked out their area. He grappled with the problem of the circular billiard table that Alhazen had posed around the year 1000 and arrived at an approximate solution by devising a multilegged compasslike instrument. (As it turned out, the only way to solve the problem was to use fourth-degree equations.) Part of Leonardo's research may be considered no more than geometric acrobatics. But other work, such as the transformation of solids "without diminution or increase of substance," or determining the center of gravity of a solid, was truly experimental. His proof for locating the center of gravity of the tetrahedron was hailed for its elegance.

An engineer whose overriding concern was efficiency, Leonardo used simple formulas and rough calculations. The art of thinking out technical problems in mathematical terms was still in its infancy. He made little use of applied geometry and no use whatsoever of algebra. However, an often quoted passage at the beginning of Ms. F sheds light on the direction Leonardo wanted his research to take. "When you put together the science of the movements of water," he reminds himself, "remember to put beneath each proposition its applications, so that such science may not be without its uses."

As a youth, Leonardo may have been intrigued by perpetual motion: witness his various studies on the screw or methods for lifting water. However, as Roberto Marcolongo notes, "in any event it is absolutely certain that he saw his mistake." A number of highly interesting drawings in the *Codex Atlanticus* are aimed at refuting perpetual motion, precisely in his notes concerning the motion of water. "This motion cannot continue because the water of the pool which causes the initial motion must always weigh more than the water that is drawn from it and poured into it." There are a number of passages entitled "Against perpetual motion," one of which

STUDY FOR THE DUPLICATION OF THE CUBE
Codex Atlanticus.

ends with a famous invective that is a scathing indictment of alchemists: "O speculators about perpetual motion, how many vain chimeras have you created in the like quest? Go and take your place with the seekers after gold."

Like the physicists of the Middle Ages, Leonardo probed the forces that move objects, in particular, projectiles hurled by instruments of war. In the fourteenth century, the schoolmen of the University of Paris held that the motive power that kept a newly flung projectile in motion was *impetus,* a power created within the moving body by the device that set it in motion. Albertus Magnus worked out a complete theory of *impetus.* A stone thrown upward receives an *impetus* that carries it upward; but it also holds on to its natural gravity, which tends to pull it downward. Here *impetus* is a property imparted to a movable body by force, that is, against its inherent nature; consequently, the *impetus* grows weaker over time until it dies out. So long as the *impetus* exceeds gravity and the resistance of the air around it, the stone rises; it falls when gravity is stronger than the *impetus* and air resistance combined. *Impetus* is violent if it causes the object to move in a way that goes against its natural, inherent movement. A falling heavy body accelerates due to an accumulation of *impetus acquisiti:* "Assume that a

Following left-hand page. STUDY ON LUNULES
Codex Atlanticus.

Following right-hand page. GEOMETRIC DESIGNS
Codex Atlanticus.

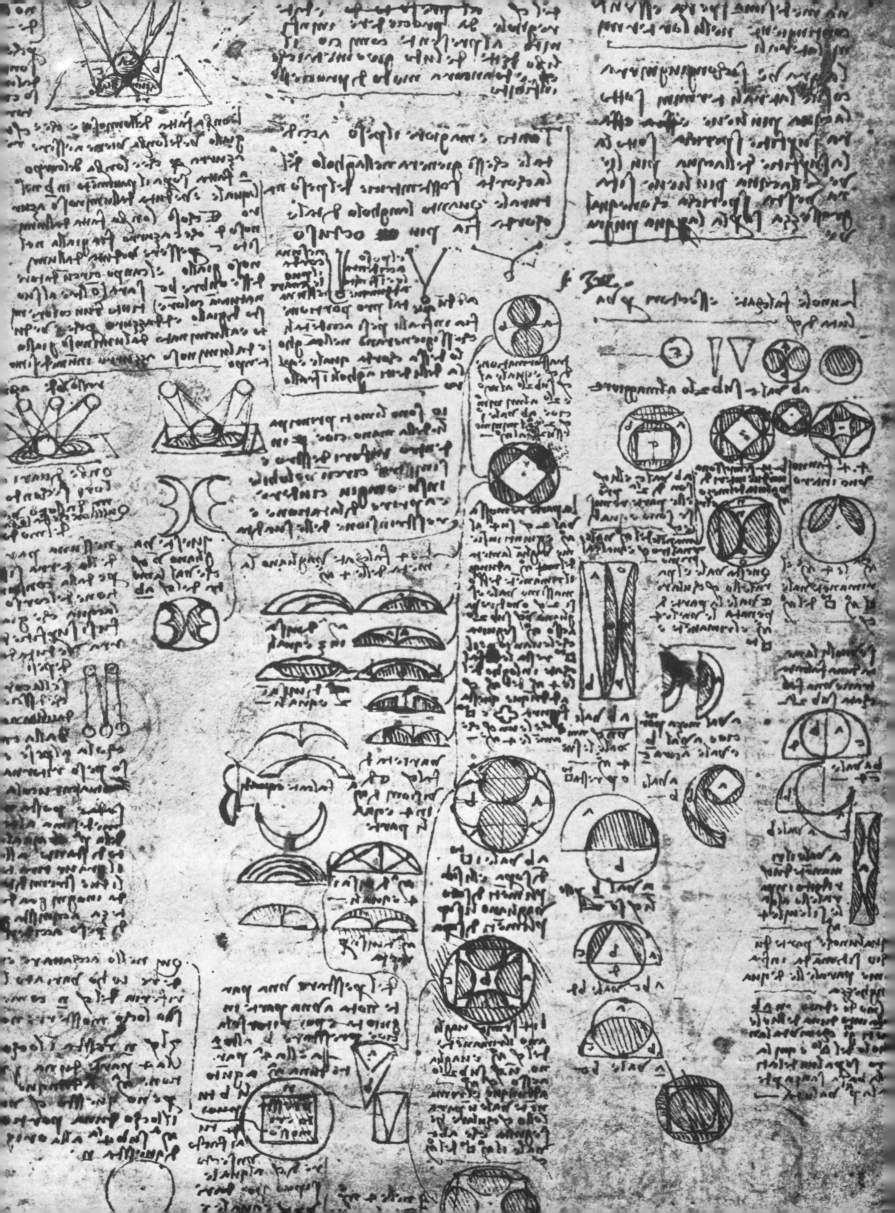

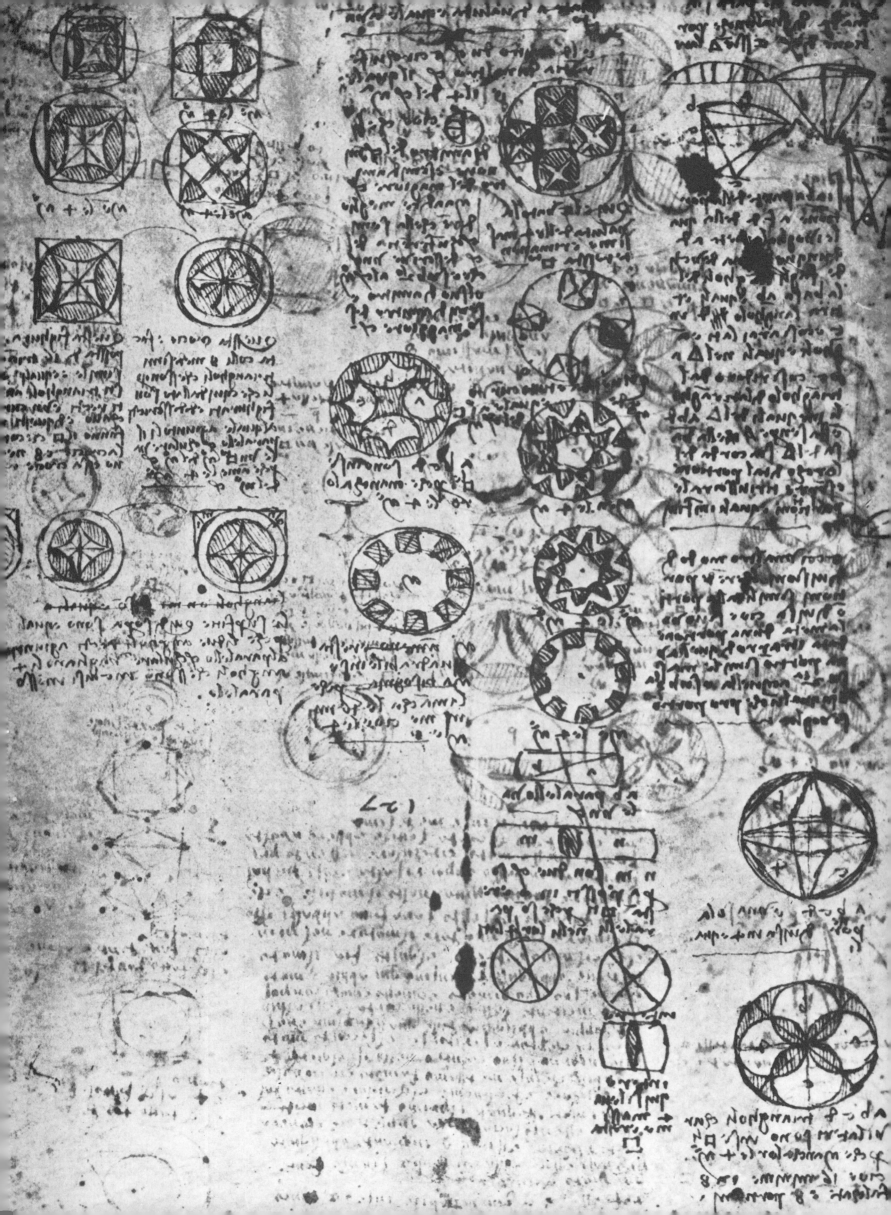

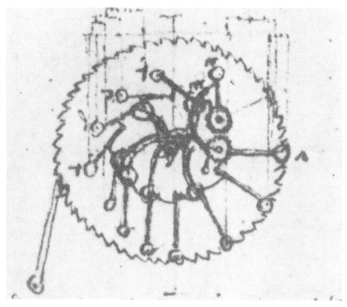

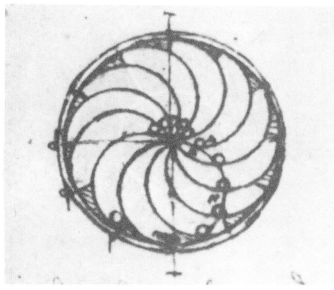

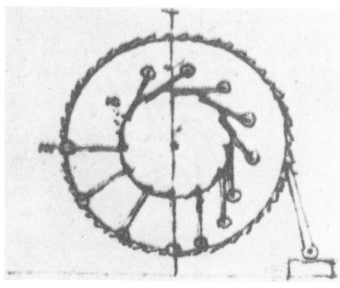

STUDIES ON THE IMPOSSIBILITY OF PERPETUAL
MOTION
Codex Forster.

smith's grinding wheel, very large and very heavy, were turned until it moves very quickly. If one then stops turning it, its motion will continue for a long time. This could only come about through an *impetus acquisiti* that comes from without and which is imparted to it by the person turning it." If it ultimately stops, "that is because the material form of the grinding wheel has a tendency contrary to that of the *impetus.*" If we then imagine a grinding wheel that is not subject to lessening of speed, or change, or resistance, the *impetus* would impart to it a perpetual motion. If this is the case, there is no point trying to picture intelligences that keep celestial bodies in orbit: "When God created the heavenly bodies, he set each one of them in motion as he saw fit; they move even now, by virtue of the *impetus* he then imparted to them. This *impetus* undergoes neither corruption nor diminution, for the moving body has no inclination that goes against it, so that there is nothing to cause corruption."

From the theory of *impetus* Leonardo deduced a way of saving energy. "If a wheel of which the movement has become very rapid continues to make many revolutions after its motive power has abandoned it, then if this motive power continues to cause it to turn with the same quickness of movement, it would seem that this continuance necessitates but little force. And I conclude that in order to maintain this movement only a slight effort by the motive power would be needed, and so much more as by nature it tends to become fixed."

Like Albertus Magnus, Leonardo divided the motion of a projectile into three periods, but described these three periods differently. During the first period, the medieval schoolman argued, *impetus* exceeds the sum of gravity and external resistance; during the second—he calls it *quies media*—*impetus* is less than this sum but greater than the amount by which gravity exceeds resistance; during the third, *impetus* is less than the amount by which gravity exceeds external resistance. According to Leonardo, the first period lasts so long as *impeto*—he referred to it as *impeto,* not *impetus*—cancels out natural gravity and the projectile moves by virtue of a *purely violent motion,* as though it had been robbed of weight. The last period occurs when the *impeto* dies out and the moving body, now subject to gravity alone, moves by virtue of a *purely natural motion.* During the intermediate period, called compound impetus, the moving body moves by virtue of a *combined natural and violent motion:* gravity and *impeto* coexist and struggle with each other. A cannonball shot from a piece of artillery first moves in a straight line in the direction in which the cannon was aimed; it will fall vertically during the

third period; only during the period of compound impetus will its trajectory be curvilinear.

Before describing this phenomenon as *impeto,* Leonardo used the word *forza,* which he defines as "a spiritual power, incorporeal and invisible, which with brief life is produced in those bodies which as the result of accidental violence are brought out of their natural state and condition. I have said spiritual because in this force there is an active, incorporeal life; and I call it invisible because the body in which it is created does not increase either in weight or size; and of brief duration because it desires perpetually to subdue its cause, and when this is subdued it kills itself." A spiritual entity, *forza* is related to a moving body the same way the soul is related to the body in a living being. The difference is that the soul is natural, therefore immortal, whereas *forza* dies out by its very expenditure of energy and is therefore essentially perishable.

Forza is always generated by movement of one kind or another. This can be a "sudden increase of a rare body in a dense body, as when the flame multiplies in a mortar. This fire, as it is not in a void

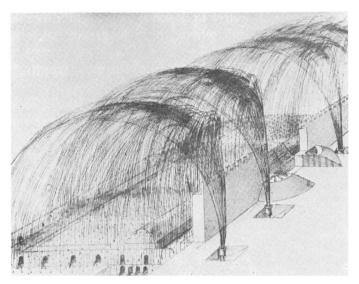

DEFENSIVE WORKS AND PATH OF PROJECTILES
Royal Collection, Windsor Castle.

SKETCH OF A WINGED BOMB
Royal Collection, Windsor Castle.

capable of accommodating its expansion, rushes furiously into a more ample space, expelling everything that is contrary to its desire. . . ." *Forza* can also be generated "in bodies that are bent and twisted against their nature, like crossbow or other similar machines, which do not readily yield and which, when loaded, seek to straighten themselves and, as soon as they are given the freedom to do so, furiously eject the thing that resists their path." In collision, *forza* itself, through motion, generates a new *forza:* "If the thing struck is similar to the thing doing the striking, it receives a blow, weight (that is, accidental gravity or *forza*), and motion. It rushes from its place and leaves the thing that struck it entirely without power." Elsewhere Leonardo observes that "the blow is born in the death of motion, and motion is born in the death of *forza.*"

Another way of generating *forza* is typified in the fall of a heavy body: when a body is coerced into a state that is contrary to its nature, on regaining its freedom it reverts to its natural state. Convinced that "every part tends to reunite with its whole to escape its imperfection," Leonardo concludes that

FIRING A PROJECTILE
Manuscript B. Institut de France, Paris.

"every weight desires to descend to the center by the shortest way; and where there is greater weight there is the greater desire, and that thing which weighs the most if it is left free falls most rapidly."

Once it reaches the end of its fall, weight becomes stable and motionless. *Forza* will die out, but weight remains indestructible. It exerts pressure on obstacles that sustain it and prevent it from continuing its movement toward the center. "Weight," writes Leonardo, "which acts eternally through the pressure it exerts, is less powerful than the other three inclinations which are still in it, namely, *forza,* motion, and the blow. The second, less permanent thing is *forza,* which is more powerful than weight but shorter lived. The third is motion, which is more powerful than *forza* and is generated by the selfsame *forza.* The fourth, still less permanent thing is the blow, which is the son of motion and the grandson of *forza.* And all of them are the offspring of weight."

Impeto Leonardo defines a number of ways: "a power created by movement and transmitted from the mover to the movable thing; and this movable thing has as much movement as the impetus has life" or "the impression of movement transmitted by the mover to the movable thing." "Impetus," we read elsewhere, "is a power impressed by the mover on the movable thing. Every impression tends to permanence or desires permanence. This is proved in the impression made by the sun in the eye of the spectator and in the impression of the sound made by the clapper as it strikes the bell. Every impression desires permanence as is shown by the image of the movement impressed upon the movable thing."

The persistence of light impressions (afterimages) and impressions made on the ear and nose, Leonardo argues, are examples of *impeto* and prove that *impeto* lies in the movable body proper—something not all physicists had acknowledged. There was, it is true, general agreement that the motion of a projectile is caused by a certain enduring similarity of the movement of the mover. However, for the Aristotelians and Averroists, this similarity was "impressed" in the air surrounding the movable thing; whereas for the *Terminalistes* (and Leonardo), *impeto* was impressed in the movable thing itself. Simply place your ear to the surface of a bell after it has been struck, Leonardo tells us; the murmur of the blow will be heard within.

For those who believed that all things lead to God, even a child playing with a top could be interpreted as something marvelous and significant. Certainly that was how Nicolas de Cues, a cardinal and physicist, saw it. "The child grasps this teetotum

which is dead, that is, without movement, and wishes to bring it to life. To do so he devises a procedure which is a tool of his intelligence. He impresses on this top the likeness of the idea he has conceived. By moving his hands he creates both straight and oblique motion—namely, simultaneous pressure and pulling—and thereby imparts to it a movement which, for the top, is supernatural. In its natural state, the top has nothing except the downward movement shared by all heavy bodies. The child causes it to move in a circle, as do the heavens. This motive spirit imparted by the child is invisibly present in the substance of the top and remains there for as long a time as allowed by the force of the impression which transmitted this power. When this spirit no longer imparts life to the top, the top reverts to its movement to the center, as before. Is this not an image of what takes place when the Creator wishes to breathe life into a lifeless thing?"

Leonardo must have read this before studying the struggle between the *impeto* of revolving movement and natural gravity when a child spins a top. "Of the revolving movement.—The pegtop or 'chalmone,' which by the rapidity of its revolving movement foregoes the power that comes from the inequality of its weight round the center about which it revolves, is a body which will never have such a tendency to fall as the inequality of its weight desires, so long as the power of the impetus that moves this body does not become less than the power of this inequality.

"But when the power of the inequality exceeds the power of the impetus it makes itself the center of the revolving motion and so this body brought to a recumbent position completes upon this center the remainder of the aforementioned impetus.

"And when the power of the inequality is equal to the power of the impetus the top is bent obliquely, and the two powers contend in a concerted movement and move one another in a great circuit until the center of the second variety of revolving movement is established, and in this the impetus ends its power."

Roberto Marcolongo notes that Leonardo was the first to analyze force in terms of two given directions. "Using modern terminology, the two theorems [Leonardo used] state that two component vectors are of equal value with respect to a point on the resultant vector, and that with respect to a point on one of the component vectors, the value of the resultant vector equals the value of the other component vector. They yield a mathematical solution to a problem which Leonardo posed and on several occasions applied numerically. Transposed into geomet-

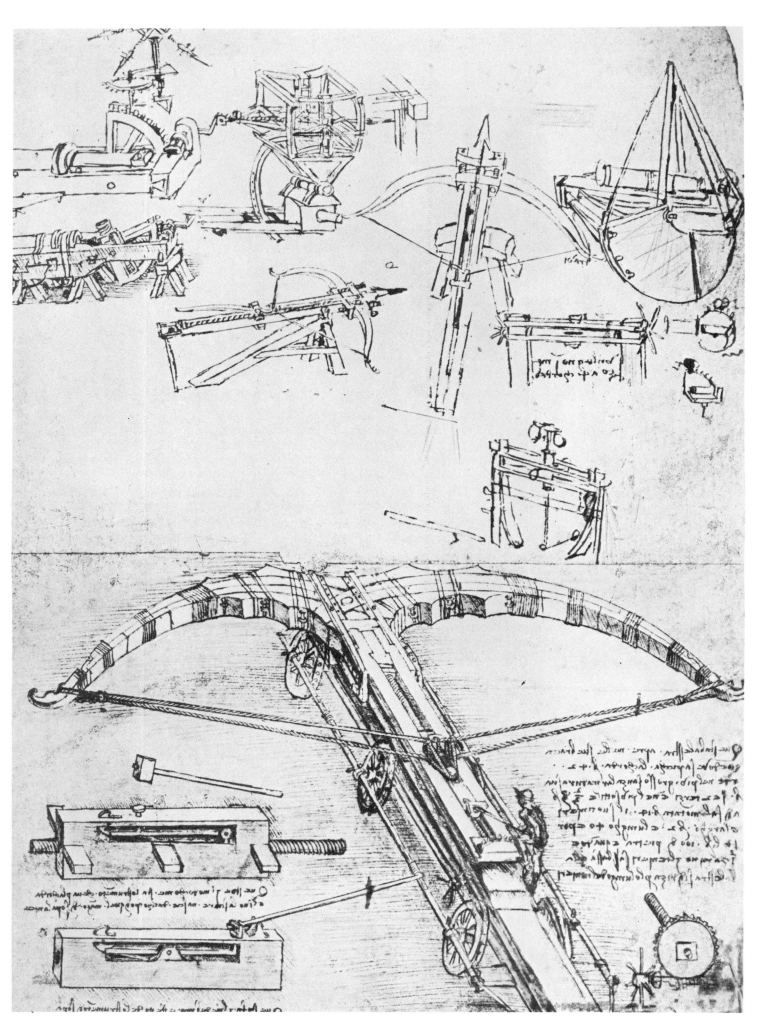

COLOSSAL CROSSBOW
Codex Atlanticus.

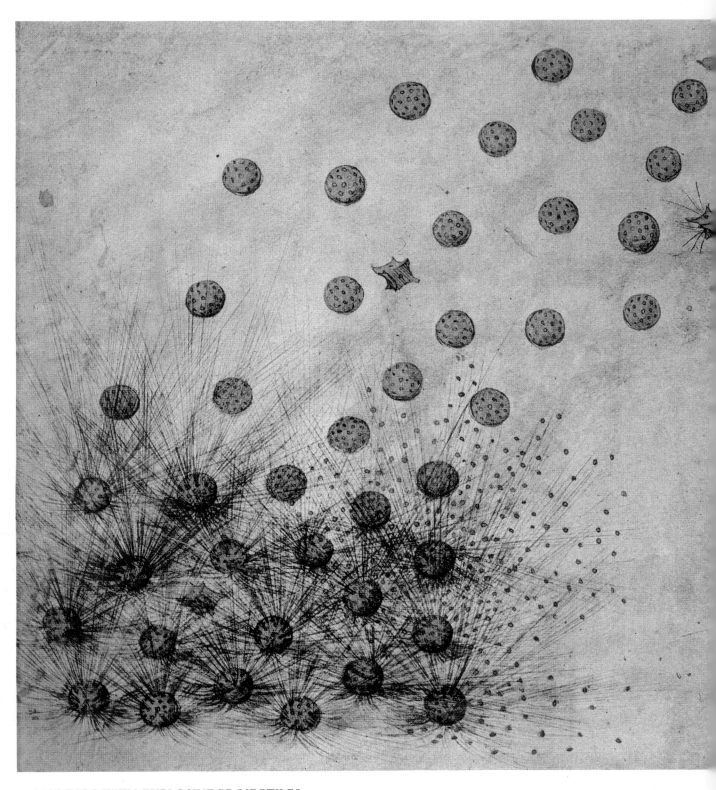

MORTARS WITH EXPLOSIVE PROJECTILES
Pen and ink and sepia wash, 19.3 × 37.2 cm. *Codex Atlanticus.* (The cannon is loaded
with shot that explodes on impact, scattering metal fragments.)

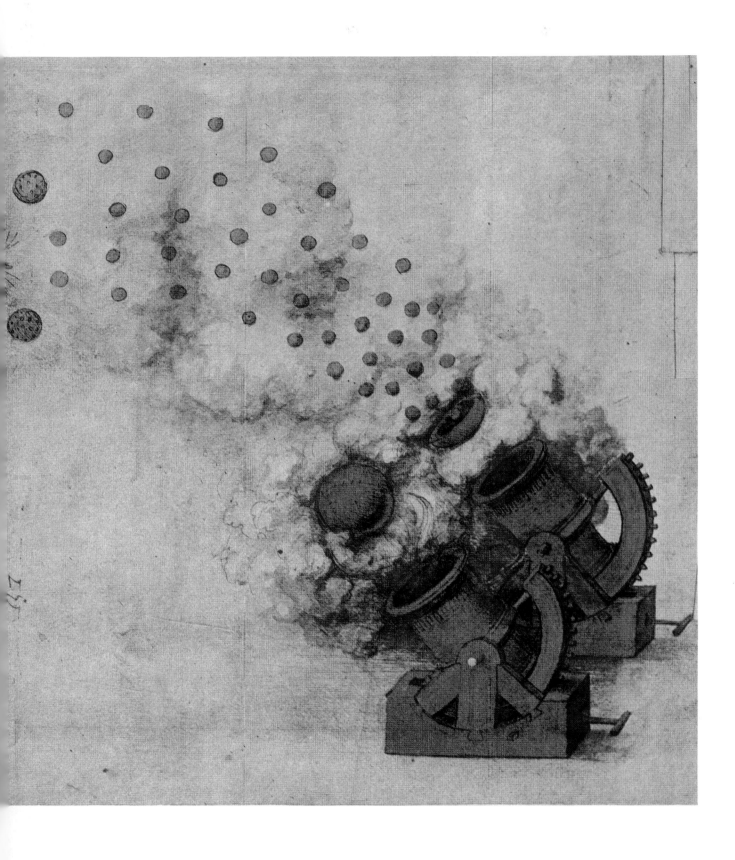

137

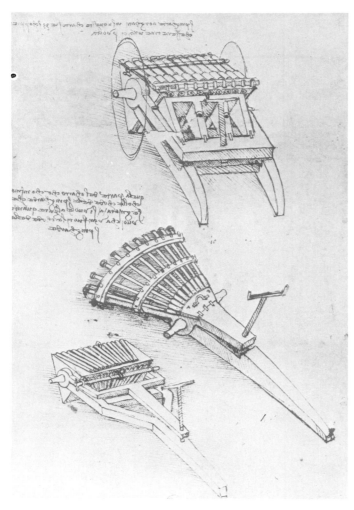

MULTIBARRELED CANNON AND MACHINE GUN
Codex Atlanticus.

ric terms—something Leonardo never did—this solution tallies with the well-known parallelogram law of forces."

Can it be said that Leonardo's goal was to make formal experimentation the bedrock of science, or simply to add to what we know through observation? Out of respect for Leonardo the man, the latter seems preferable. Perhaps he had an insatiable thirst for knowledge and an inexhaustible passion for observation, but certainly not a yearning for academic disquisition. He had too much respect for the object of his quest to venture to stop along the way. True, he laid the groundwork for ten, twenty, thirty books, only to put off a final arrangement that would have made deletion—in other words, betrayal—inevitable. The infinite complexity of his subject precluded this. Now, it is all well and good to provide second-raters with a number of statements they will adopt as truths just so they do not have to do their own thinking; and it is true that

people with limited horizons who pedantically convey these observations to others perform a useful service. But a passion for in-depth understanding means that one must never limit the scope of one's research or waste precious time in unchallenging pedagogical activity.

At a time when researchers were not salaried as such, when people could still suspect them of ill intent, Leonardo was a true seeker after truth, spurred on by a need to know. Vasari's anecdote about Leonardo's dilatoriness is telling: "It is said that a work being given to him to execute by the Pope, he immediately began to distill oils and herbs in order to make a varnish. Whereupon Pope Leo X exclaimed, 'Alas! The man will never do anything, for he begins by thinking about the end before the beginning of the work.' " Leonardo may not have been the preeminent mathematician and physicist of his day, but his interest in mathematics and physics, and the results his work yielded, are enough to earn him a special place in the history of ideas. As Remy de Gourmont observed, "Even if we take away from Leonardo a few legendary trappings, what remains still makes him one of mankind's great minds."

FLOATING ARTILLERY MOUNTED ON A BOAT
Pen and ink, 28.2 × 20.5 cm. Royal Collection, Windsor Castle.

VII ASTRONOMER

Since ancient times, theologians, philosophers, and poets satisfied man's need to account for nature and the motion of heavenly bodies and, in so doing, freed his mind for other matters. True, it is said that the Gauls were afraid of seeing the sky come crashing down on their heads; but they remain a psychological oddity. The publication in 1543 of Copernicus's *De Revolutionibus Orbium Coelestium* signaled the dawn of the modern age and the end of the period when man believed himself to be the focal point of the universe. However, since people went right on fancying themselves the hub of creation, the only ones to feel the full impact of the Copernican revolution were astronomers. Self-centered, proud, miserly, lascivious, vain, flighty, and absurd, man has always thought he holds the key to truth.

Combining the geocentric theory with the Platonic notion that the heavenly bodies move in a circular, uniform manner, Eudoxus of Cnidus devised a system of twenty-seven "homocentric spheres"—a complex, ingenious system that accounted for the apparent movement of the heavenly bodies. The Aristotelians then added their own refinements to this scheme, but not everyone subscribed to it. To explain diurnal motion, Heraclides of Pontus proposed the axial rotation of the earth, one full rotation approximately every twenty-four hours. Aristarchus of Samos, pioneering proponent of the heliocentric theory, not only held that the earth rotates on its own axis, but went a step further, suggesting that the earth, with all the other planets, revolves around the sun. Thus, the moon was the only "planet"—it was so considered in Aristarchus's system—to revolve around the earth.

In Alexandria in the second century A.D., Ptolemy wrote a compendium of what was then known about astronomy and supplemented it with observations of his own. The Arabs adopted the Ptolemaic system. A specialist in the history of science, Pierre Brunet, points out that in medieval Europe "as far back as the fourteenth century, François de Mayronnes, like John Scotus Erigena before him, had already attempted to reestablish the Heraclidean system, which managed to survive in one form or another throughout the Middle Ages. The Nominalists of Paris stressed the rotational movement of the earth: Nicole d'Oresme was an especially vigorous advocate, but equally important arguments may be found in the writings of Albertus Magnus and Jean Buridan."

In his lengthy study on Leonardo da Vinci, Pierre Duhem notes the artist's debt to Albertus Magnus, in particular with respect to astronomy. Robert Lenoble, taking issue with Duhem and "his well-known obsession with finding precursors everywhere," argues for the originality of Leonardo's thinking. With him, Lenoble writes, there suddenly appeared "the notion that nature could be explained in mathematical terms. . . . As is the case with every trailblazer, the art of pinpointing his inevitable borrowings from predecessors leads, in the final analysis, to the conclusion that he owes them nothing." The comparisons Duhem makes between Leonardo's writings and those of other thinkers are striking just the same, and one is hard put to deny their influence on him. Since Leonardo never wrote, much less published, a book on astronomy—he simply jotted down notes on the subject strictly for his own use—there seems to be no way to judge impartially.

Would it be right for us to place on the same level the *Maximes* of La Rochefoucauld or the *Pensées* of Joubert with the texts known collectively as Pascal's *Pensées*? Pascal took notes for his personal use and intended to organize them into a book. Had he lived ten years longer, some, if not all of these "thoughts" would have found their way into the

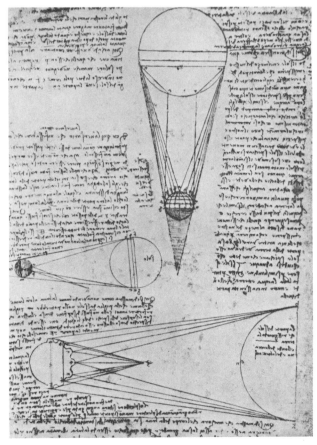

DISTANCE FROM THE SUN TO THE EARTH; SIZE OF THE MOON
Codex Leicester.

139

magnum opus: one would have become a paragraph in one chapter or another, another would have been expanded into a chapter, still another would have been reconsidered or discarded. Leonardo, too, was planning to write a book (actually, several books), including one on heavenly bodies, and did not think it necessary to make up a special "file" for each of these forthcoming treatises. His notes were so private that he jotted them down in his usual right-to-left handwriting, making it difficult for anyone but himself to read them. Deciphering Leonardo's texts and categorizing them under rubrics may help to determine with some degree of certainty the books he may have read and the ideas that may have interested him. However, in no way would this allow us to surmise what he might have included in the treatises he was planning to write and structure for prospective readers.

With the notes themselves as our guide, what we *can* assume is that Leonardo did not plan to come out with a special treatise on heavenly bodies until fairly late in his career and that he took issue with the Aristotelian theory that stars were incorruptible, divine, and wholly unrelated to the moving, corruptible, mortal earth. "All your discourse points to the conclusion that the earth is a star almost like the moon, and thus you will prove the majesty of our universe." By integrating the earth into the heavens, Leonardo aimed at applying to the heavens what we know about phenomena here on earth. Henceforth the laws governing our world governed the universe.

Since ancient times, the ingenious system of moving spheres had caused people to wonder whether the motion of heavenly bodies produced any sound. Leonardo, for his part, reasoned as follows:

"Whether the friction of the heavens makes a sound or no. Every sound is caused by the air striking a dense body, and if it is made by two heavy bodies one with another, it is by means of the air that surrounds them; and this friction wears away the bodies that are rubbed. It would follow therefore that the heavens in their friction, not having air between them, would not produce sound. Had however this friction really existed, in the many centuries that these heavens have revolved they would have been consumed by their own immense speed of every day. And if they made a sound it would not be able to spread, because the sound of the percussion made underneath the water is but little heard and it would be heard even less or not at all in the case of dense bodies. Further, in the case of smooth bodies the friction does not create sound, and it

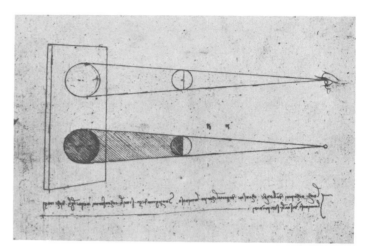

STUDIES ON LIGHT AND SHADOW
Manuscript C. Institut de France, Paris.

would happen in a similar manner that there would be no sound in the contact or friction of the heavens. And if these heavens are not smooth at the contact of their friction, it follows that they are full of lumps and rough, and therefore their contact is not continuous; and if this is the case the vacuum is produced, which it has been concluded does not exist in nature. We arrive therefore at the conclusion that the friction would have rubbed away the boundaries of each heaven, and in proportion as its movement is swifter toward the center than toward the poles it would be more consumed in the center than at the poles; and then there would not be friction anymore, and the sound would cease, and the dancers would stop, except that the heavens were turning one to the east and the other to the north."

It so happened that the spheres devised by Eudoxus of Cnidus, which so captivated medieval schoolmen, supplied the heavenly bodies with a means of physical support. They were thought to be mounted in their revolving spheres like enormous diamonds. If the possibility of friction meant ruling out this hypothesis, how could the heavenly bodies be supported in space? Not only is the earth a star like other stars, but, Leonardo argues, "it is not in the center of the circle of the sun, nor in the center of the universe, but is in fact in the center of its elements that accompany it and are united to it." In other words, the heavenly bodies consist of elements that an inherent force holds in balance, regulates, and maintains.

The moon is made up of the same elements as the earth, and "if you were upon the moon or upon a star our earth would appear to you to perform the same function for the sun as now the moon does." If we assume that the moon is in effect another earth,

"if it had density, it would have weight, and having weight, it could not be sustained in the space where it is, and consequently it would fall toward the center of the universe and become united to the earth; or if not the moon itself, at least its waters would fall away and be lost from it, and descend toward the center, leaving the moon without any and so devoid of luster. But as this does not happen, as might in reason be expected, it is a manifest sign that the moon is surrounded by its own elements: that is to say, water, air, and fire; and thus is, of itself and by itself, suspended in that part of space, as our earth with its element is in this part of space; and that heavy bodies act in the midst of its elements just as other heavy bodies do in ours."

Since the moon, being dense, heavy, and solid, does not fall toward the center of the universe, the logic of the system breaks down unless it allows for a lunar makeup of the four elements: earth, water, air, and fire. Here on earth, we know that water is lighter than earth, air lighter than water, and fire lighter than air. The same holds for the moon, and that is why the presence of fire is an essential part of the hypothesis. The moon does not "become united with the earth" and "its waters do not fall away and become lost to it" because, as on earth, its elements are joined together and, once separated, tend to reunite by virtue of the principle that "every part tends to be reunited with its whole to escape its imperfection." Furthermore, as Pierre Duhem points out, "the presence of fire in the moon is indispensable because the lightness of fire exactly offsets the weight of the other lunar elements. It is this lightness which holds the moon back and prevents it from falling toward the center of the universe, just as the heaviness of lunar earth, water, and air keep it from moving away from the center. Likewise, terrestrial elements guarantee the neutral equilibrium of earth in space." In Duhem's opinion, Leonardo's source for this argument was Nicolas de Cues.

Leonardo deduced from moonglow—that is, the sun's reflected light—that most of the moon is covered with water, adding that this water must be turbulent in order for the moon to appear as large as it does. Given the fact that the moon shines solely by virtue of reflected sunlight, if the lunar sea were as uniform as a polished, spherical mirror, the sun would cause only a small part of its surface to shine brightly; the rest would remain dark. Leonardo asks us to take a "ball of burnished gold and place it in the darkness and set a light at some distance from it. . . . The eye only sees it reflected on a small part of its surface. . . ." To extend the area of this light, the gilded ball would have to be "made up of many small globules like mulberries, which are a black fruit composed of minute round balls, in which case each of the parts of this rounded mass visible to the sun and to the eye will reveal to the eye the radiance produced by the reflection of the sun. And thus in the same body there will be seen many minute suns and very often on account of their great distance they will blend one with another and seem continuous." In other words, the waves of the lunar sea act as countless minute globules reflecting the light of the sun.

By comparing Albertus Magnus's *Quaestiones in Libros de Coelo et Mundo* and Leonardo's Ms. F. in the Institut de France (published by Ravaisson-Mollien), Pierre Duhem showed the extent of Leonardo's borrowings from the renowned schoolman of the University of Paris. The artist's debt to Albertus Magnus is especially patent in his discussion of spots on the moon.

"Of the spots on the moon. Some have said that vapors are given off from the moon after the manner of clouds, and are interposed between the moon and our eyes. If this were the case these spots would never be fixed either as to position or shape; and when the moon was seen from different points, even although these spots did not alter their position, they would change their shape, as does a thing which is seen on different sides.

"It has also been said that the spots on the moon are created in the moon itself, by the fact of its being of varying thinness or density. If this were so, then in the eclipses of the moon the solar rays could pierce through some part where it is thin, as has

STUDIES ON THE REFLECTION OF LIGHT
Codex Atlanticus.

been stated, but since we do not see this result the aforesaid theory is false.

"Others say that the surface of the moon is smooth and polished, and that, like a mirror, it receives within itself the reflection of the earth. This theory is false, since the earth, when not covered by the water, presents different shapes from different points of view; so when the moon is in the east it would reflect other spots than when it is overhead or in the west, whereas the spots upon the moon, as seen at full moon, never change during the course which it makes in our hemisphere.

"A second reason is that an object reflected in a convex surface fills only a small part of the mirror, as is proved in perspective. The third reason is that when the moon is full it only faces half the orb of the illuminated earth, in which the ocean and the other waters shine brightly, while the land forms spots amid this brightness; and consequently the half of our earth would be seen girded round by the radiance of the sea, which takes its light from the sun, and in the moon this reflection would be the least part of that moon. The fourth reason is that one radiant body cannot be reflected in another, and consequently as the sea derives its radiance from the sun, as does also the moon, it could not show the reflected image of the earth, unless one also saw reflected there separately the orb of the sun and of each of the stars which look down upon it.

"Others have said that the moon is made up of parts, some more, some less transparent, as though one part were after the manner of alabaster, and another like crystal or glass. It would then follow that when the rays of the sun struck the less transparent part, the light would stay on the surface, and consequently the denser part would be illuminated, and the transparent part would reveal the shadows of its obscure depths. Thus, then, they define the nature of the moon, and this view has found favor with many philosophers, and especially with Aristotle. But nevertheless it is false, since in the different phases which the moon and the sun frequently present to our eyes we should be seeing these spots vary, and at one time they would appear dark and at another light. They would be dark when the sun is in the west and the moon in the center of the sky, because the transparent hollows would then be in shadow, as far as the tops of their edges, since the sun could not cast its rays into the mouths of these same hollows; and they would appear bright at full moon, when the moon in the east faces the sun in the west; for then the sun would illumine even the lowest depths of these transparent parts, and in consequence as no shadow was created, the moon

would not at such times reveal to us the aforementioned spots, and so it would be, sometimes more sometimes less, according to the change in the position of the sun to the moon, and of the moon to our eyes, as I have said above."

According to Leonardo, virtually the entire surface of the moon was covered with a surging sea, thus causing sunlight to be brightly reflected to earth; the dark spots he believed to be areas of solid ground. Elsewhere he adds, "The extremities of the moon will be more illuminated and will show themselves more luminous because nothing will appear in them except the summit of the waves of its waters; and the shadowy depths of the valleys of these waves will not change the images of those luminous parts which from the summits of these waves come to the eye."

Leonardo then goes on to explain how, when the new moon rises in the west near the setting sun, we see between the cusps of the lunar crescent the entire surface of the moon in a kind of shadowy light. How can this be if the moon has no light of its own? The answer: The sun projects its light on the earth's waters, which in turn reflect it toward the moon.

"The moon has its days and nights as has the earth," Leonardo points out, "the night in the part which does not shine and the day in that which does. Here the night of the moon sees the light of the earth, that is to say, of its water. . . . " Consequently, our hemisphere only dimly illuminates the moon, but according to Leonardo's geological theories, this illumination was stronger when this hemisphere was covered with water.

Thus, the earth is a heavenly body, like the moon: nothing more, nothing less. Like other stars, although it emits no light of its own, the water covering it reflects sunlight. Leonardo goes so far as to note that stars seem tiny to us only because they are very far away and that "there are many which are a great many times larger than the star which is our earth." Furthermore, the largest of these stars are minute compared with the size of the universe. "If you look at the stars without their rays—as may be done by looking at them through a small hole made with the extreme point of a fine needle and placed so as almost to touch the eye—you will perceive these stars to be so small that nothing appears less; and in truth the great distance gives them a natural diminution, although there are many there which are a great many times larger then the star which is our earth together with the water. Think, then, what this star of ours would seem like at so great a distance, and then consider how many stars

might be set longitudinally and latitudinally amid these stars which are scattered throughout this dark expanse."

In this immense universe, the earth yields its onetime preeminence of the sun, and in Leonardo's notes we find a passage entitled "Praise of the Sun."

" . . . The reasons of its size and potency I shall reserve for the Fourth Book. But I marvel greatly that Socrates should have spoken with disparagement of that body, and that he should have said that it resembled a burning stone, and it is certain that whoever opposes him in such an error can scarcely do wrong. I could wish that I had such power of language as should avail me to censure those who would fain extol the worship of men above that of the sun, for I do not perceive in the whole universe a body greater and more powerful than this, and its light illumines all the celestial bodies which are distributed throughout the universe.

"All vital principle descends from it, since the heat there is in living creatures proceeds from this vital principle; and there is no other heat or light in the universe, as I shall show in the Fourth Book, and indeed those who have wished to worship men as gods, such as Jupiter, Saturn, Mars, and the like, have made a very grave error seeing that even if a man were as large as our earth he would seem like one of the least of the stars, which appears but a speck in the universe; and seeing also that these men are mortal and subject to decay and corruption in their tombs."

Leonardo likened the earth to other planets, but no doubt this was nothing more than an opinion. He did not back it up with proof based on experimentation. The telescope, which one day would provide evidence that the earth is indeed akin to other planets, had not yet been invented. People still had only a vague idea of how heavenly bodies moved in space. Orbits once thought to be circular would one day turn out to be elliptical. Uniform movement would give way to the notion that the speed of a heavenly body is inversely proportional to its distance from the sun. Nevertheless, Leonardo remains, as Félix Ravaisson put it, "the great trailblazer of modern thought." "In 1508," Pierre Duhem writes, "when Copernicus was only starting out on his twenty-three-year quest (1507–1530) to unravel the workings of the universe, Leonardo da Vinci had already rejected the geocentric theory and stated that the earth is neither at the center of the universe, nor even at the center of the sun's orbit. In 1508, he had already worked out well-defined principles concerning the origin of fossils, principles that were not to be set forth again until Bernard Palissy taught them in Paris in 1575."

Even if one concedes that Leonardo was a precursor who left no disciples, that what we find in his notes are not so much bona fide proofs as hunches, those notes continue to earn for him a reputation as the most extraordinary, original, and penetrating thinker of his day, if not of all time.

VIII GEOLOGIST

DURING his travels, the Greek poet Xenophanes of Colophon (sixth century B.C.) reported seeing fossil shells that were unquestionably the remains of living creatures. In the third century A.D., the theologian St. Hippolytus wrote, "Xenophanes believed that the earth and the sea were once mingled, and that time brought about their separation. His proofs are as follows: shells can be found both in the ground and in mountains; imprints of a fish and some seals turned up in the quarries of Syracuse; an imprint of an anchovy was found deep inside a rock on Paros, while on Malta were discovered the imprints of seals and all manner of sea creatures. The reason for this, he says, is that at one time everything was mud, and when this mud dried up the imprints were preserved."

The philosopher Avicenna suggested in the ninth century that mountains were formed either by earthquakes and subsequent thrusting up of the earth, or by "the effects of wind and flowing water which carve out valleys in soft rock and expose hard rock;

many hills were formed this way. Such changes must have taken a very long time, and at present mountains may be in the process of shrinking. That water was primarily responsible for these surface changes is proven by the occurrence of impressions of sea creatures and other forms of life in numerous rocks. The yellow earth covering mountain surfaces—unlike the ground just below—came from the breakdown of organic remains mixed with waterborne earth materials. No doubt this material was originally in the sea which at one time covered the entire earth."

Avicenna's theory gained currency in western Europe thanks to Albertus Magnus and Vincent de Beauvais, to name two of its leading proponents. The former stressed the conflict between erosion, which has a leveling effect on the earth's surface, and the heaving that occurs at the ocean floor.

What forces conspired to give the earth its present configuration? How did water fit into the overall geological picture? How was it that sea fossils

BIRD'S-EYE VIEW OF PART OF TUSCANY
Pen and ink and wash, 27.5 × 40.1 cm. Royal Collection, Windsor Castle.

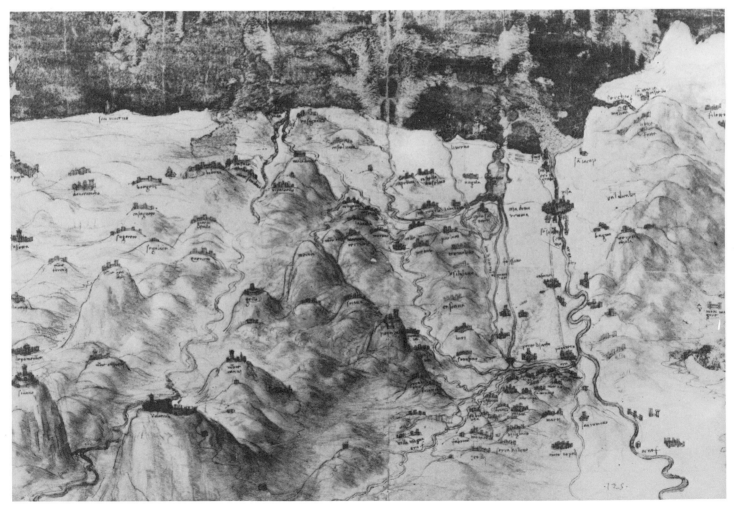

144

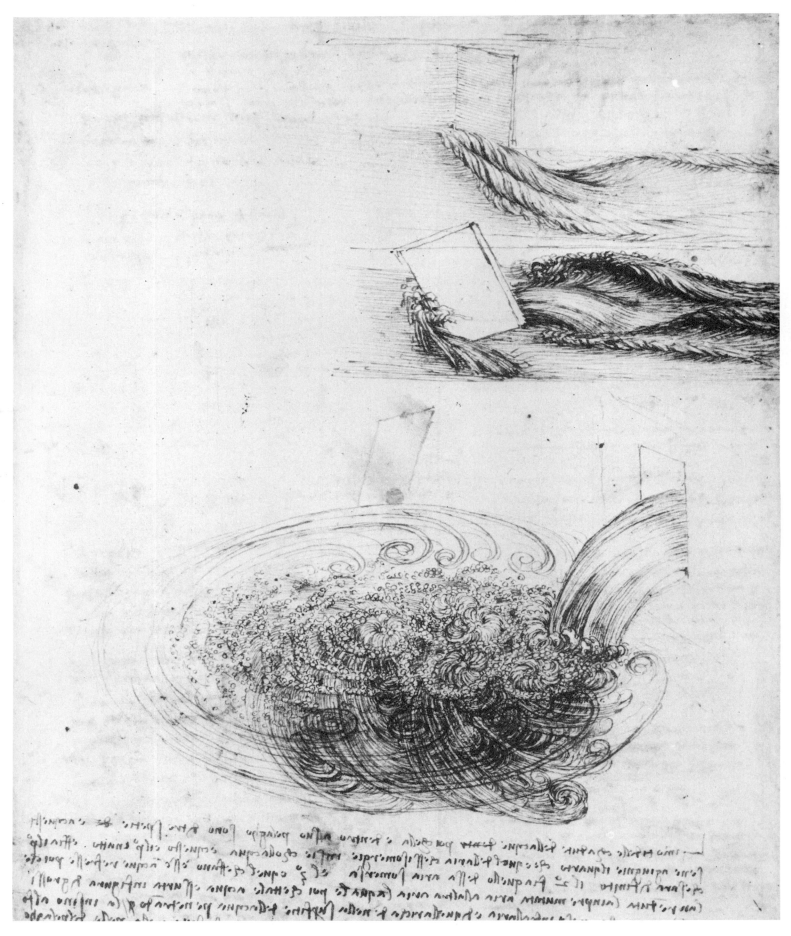

STUDIES OF WATER FORMATIONS
Pen and ink, 29 × 20.2 cm. (reproduced original size). Royal Collection, Windsor Castle.

Following page. STORM
Red chalk, 29 × 15 cm. (reproduced original size).
Royal Collection, Windsor Castle.

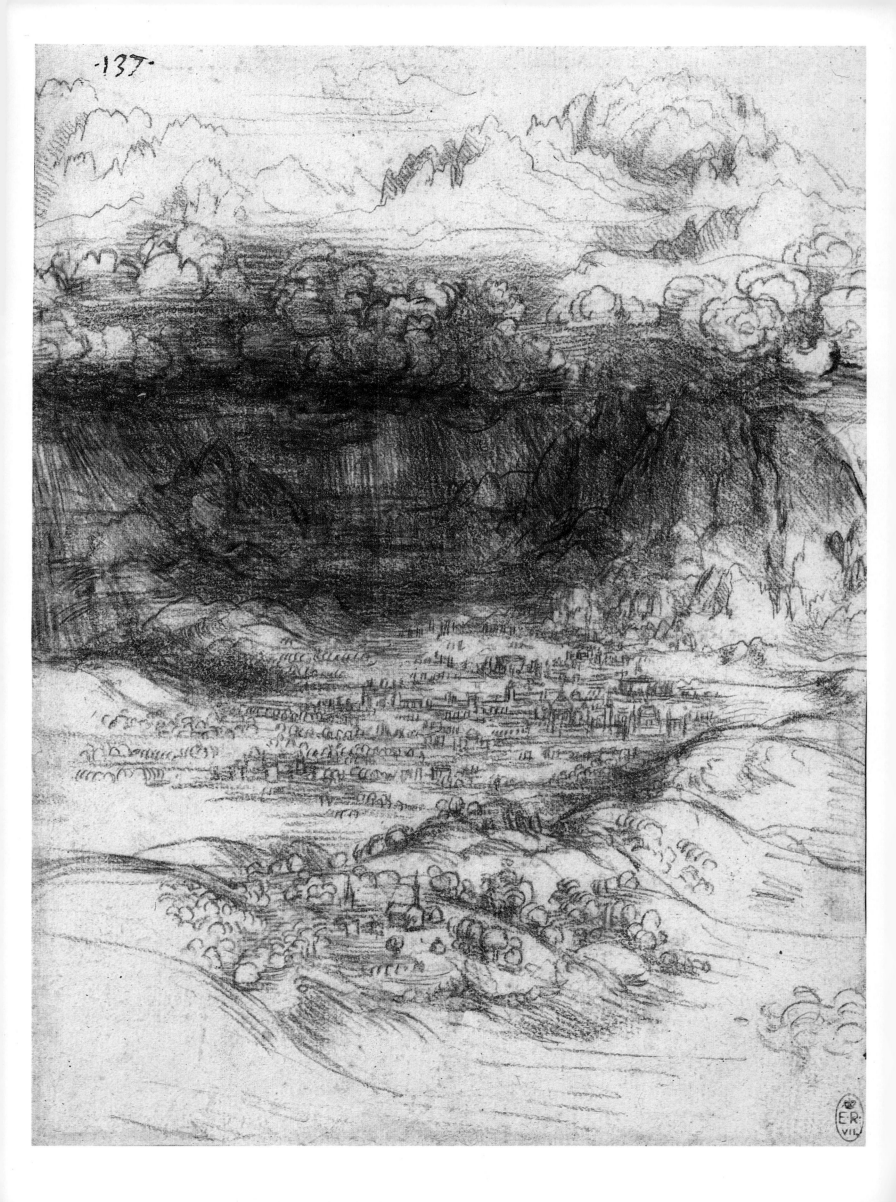

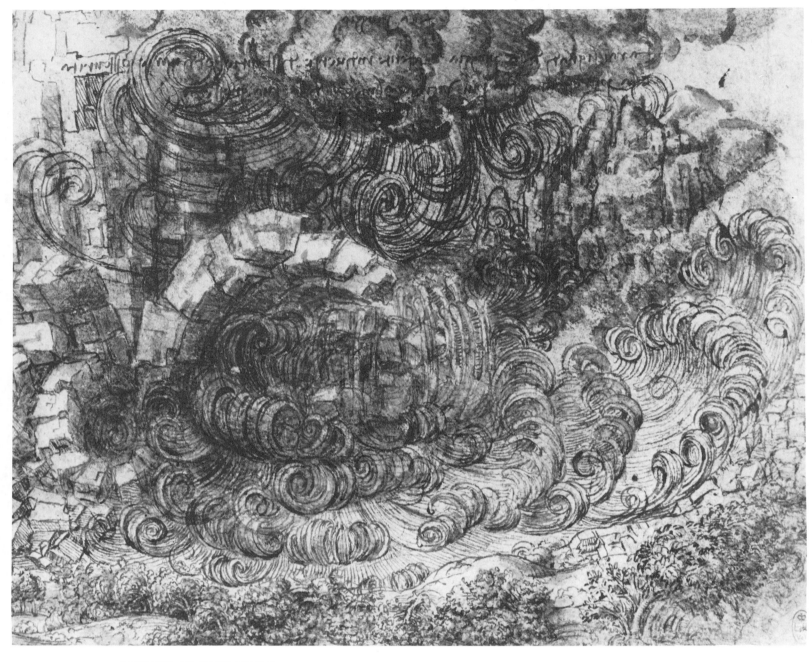

DELUGE OR EXPLOSION
Black chalk and brown ink, 15.8 × 21 cm. Royal Collection, Windsor Castle.

SNOW-COVERED MOUNTAINS
Red chalk on red prepared surface, heightened with white, 10 × 16 cm. (reproduced original size). Royal Collection, Windsor Castle.

could be found deep inside the earth as well as in the peaks of lofty mountains? These questions had been asked time and again for a great many years before Leonardo grappled with them; the ones that intrigued him most were the enigma of sea fossils and the part water played in shaping the earth.

One theory, borrowed from Aristotle, attributed such shells to the influence of the stars. This Leonardo found unacceptable. Arthur Birembaut sums up the theory as follows. "God in His wisdom had His reasons for putting the stars in the sky. They influence certain natural tendencies of both the body and the spirit. Since the stars are eternal, there arose a theory that a field of 'plastic force' brings about the formation of shells found in mountains and deep in mines. And since all things come from the earth, this plastic force is the sole shaper of forms; if the shells are not whole, it is because the plastic force has not had a long enough time to act."

Leonardo took this view head on. "And if you wish to say that the shells are produced by nature in these mountains by means of the influence of the stars, in what way will you show that this influence produces in the very same place shells of various sizes and varying in age, and of different kinds? And how will you explain to me the fact of the shingle being all stuck together and lying in layers at different altitudes upon the high mountains? For there there is to be found shingle from diverse parts carried from various countries to the same spot by the rivers in their course; and this shingle is nothing but pieces of stone which have lost their sharp edges from having been rolled over and over for a long time, and from the various blows and falls which they have met with during the passage of the waters which have brought them to this spot. And how will you account for the very great number of different kinds of leaves embedded in the high rocks of these mountains, and for the *aliga,* the seaweed, which is found lying intermingled with the shells and the sand? And in the same way you will see all kinds of petrified things together with ocean crabs, broken in pieces and separated and mixed with their shells."

Nor was Leonardo swayed by the explanation based on the Holy Scriptures: not only were fossils deposited during the Flood, but their existence constitutes in itself irrefutable proof that the Flood oc-

STUDY OF ROCK FORMATIONS
1510–1513. Pen and ink over black chalk, 18.5 × 26.8 cm. Royal Collection, Windsor Castle.

curred. "However," Leonardo argues, "granting this Flood to have risen seven cubits above the highest mountain," all shells "ought to be found lying on the mountain sides . . . and all at the same level, layer upon layer." Moreover, he goes on, "if the shells had been in the turbid water of a deluge they would be found mixed up and separated one from another, amid the mud, and not in regular rows in layers as we see them in our own times. . . . And how do we account for the tracks of earthworms which crawled between the various layers of stone when it was not yet dry? . . . These animals could not live without the power of movement in order to seek their food, and we cannot see that they are equipped with any instrument for penetrating the earth or stone in which they find themselves enclosed. But how could one find in the shell of a large snail fragments and bits of many other sorts of shells of different kinds unless they had been thrown into it by the waves of the sea as it lay dead upon the shore like the other light things which the sea casts up on the land?

"Why do we find so many fragments and whole shells between the different layers of the stone unless they had been upon the shore and had been covered over by earth newly thrown up by the sea which then became petrified? And if the above mentioned Deluge had carried them to these places from the sea, you would find the shells at the edge of one layer of rock only, not at the edge of many where may be counted the winters of the years during which the sea multiplied the layers of sand and mud brought down by the neighboring rivers, and spread them over its shores. And if you should wish to say that there must have been many deluges in order to produce these layers and the shells among them, it would then become necessary for you to affirm that such a deluge took place every year."

Fossil formation is a crucial part of the picture, for solving this riddle would go hand in hand with determining the reasons for geological shift and the part the sea plays in the process. Hydraulics engineers watch how water moves and maintains its equilibrium, and Leonardo was convinced that the surface of the sea, like that of the earth, was round. The earth is a star "not unlike the moon," and, allowing for surface irregularities, is spherical. One need only observe the curvature of the sea, and it becomes obvious that "the surface of the water is perfectly round." The reason? "Water does not of its own accord move unless it falls, and if it should move of itself it follows that it should fall." Now, Leonardo goes on, "no part of the sphere of the waters can move by itself because it is surrounded on all sides by water of the same height; thus it cannot rise higher on any side." Any point at the surface of the water is the same distance to the "center of the world" as any other point on the surface, and "if the earth were perfectly spherical, no part [of it] would be exposed by the surface of the water." (We should point out that Leonardo uses the word "world" in different ways depending on context. Here "center of the world" means the center of the planet Earth. Elsewhere, as in Leonardo's famous statement that "the earth is not in the center of the Sun's orbit nor at the center of the World but in the center of its companion elements and united with them," *world* clearly means *universe*.)

Leonardo goes on to explain why "heavy" bodies move or remain stable in terms of center of gravity. "Because the center of the natural gravity of the earth ought to be in the center of the World, the earth is always growing lighter in some part, and the part that becomes lighter pushes upward, and submerges as much of the opposite part as is necessary for it to join the center of its aforesaid gravity to the center of the World; and the sphere of the water keeps its surface steadily equidistant from the center of the World.

"Where the sun is straight above, the earth grows light; covered by the air, the waters and snows have been lacking to it, and on the opposite side the rains and snows have made the earth heavy again and drive it toward the center of the World, and thrust the parts that have become lightened to a greater distance from this center; so therefore the sphere of this water preserves an equality of distance from the center of its sphere but not of gravity."

The erosion caused by rainfall is part of the ceaseless action of gravity, a force that tends to wear away *terra firma*. "If the earth of the antipodes which sustains the ocean rose up and stood uncovered far out of this sea but being almost flat, how in process of time could mountains, valleys, and rocks with their different strata be created?

"The mud or sand from which the water drains off when they are left uncovered after the floods of the rivers supplies an answer to this question.

"The water which drained away from the land which the sea left, at the time when this earth raised itself up some distance above the sea, still remaining almost flat, commenced to make various channels through the lower parts of this plain, and beginning thus to hollow it out they would make a bed for the other waters round about; and in this way throughout the whole of their course they gained breadth and depth, their waters constantly increasing until all this water was drained away and these hollows became then the beds of torrents which take the floods

of the rains. And so they will go on wearing away the sides of these rivers until the intervening banks become precipitous crags; and after the water has thus been drained away these hills commence to dry and to form stone in layers more or less thick according to the depth of the mud which the rivers deposited in the sea in their floods."

Sedimentary rock and the fossils found within it bear out Leonardo's description of geological shifts.

"When nature is on the point of creating stones," he writes, "it produces a kind of sticky paste which, as it dries, forms itself into a solid mass together with whatever it has enclosed there, which, however, it does not change into stone but preserves within itself in the form in which it has found them. This is why leaves are found whole within the rocks which are formed at the bases of the mountains, together with a mixture of different kinds of things, just as they have been left there by the floods from the rivers which have occurred in the autumn seasons; and there the mud caused by the successive inundations has covered them over, and then this mud grows into one mass together with the aforesaid paste, and becomes changed into successive layers of stone which correspond with the layers of mud."

Leonardo then describes the formation of fossils, paying particular attention to "creatures which have their bones on the outside, like cockles, snails, oysters, scallops, *bouoli,* and the like. . . ." The fact that sea creatures, of which fossils are the remains, lived wherever their fossils are found attests to geological movement. In addition, "the center of the world is in itself immovable, but the place in which it is found is in continual movement toward different aspects. The center of the world changes its position continually, and of these changes some have a slower movement than others, for some changes occur every six hours and some take many thousands of years.

"But that of six hours proceeds from the ebb and flow of the sea, the other comes from the wearing away of the mountains through the movements of the water produced by the rains and continual course of the rivers. The site changes in its relation to the center of the world and not the center of the site, because this center is immovable and its site is continually moving in a rectilinear movement, and such movement will never be curvilinear."

Consequently, the sea "changes the weight of the earth" and "the shells of oysters and other similar creatures which are born in the mud of the sea testify to us of the change in the earth round the center of our elements. This is proved as follows. The

mighty rivers always flow turbid because of the earth stirred up in them through the friction of their waters upon their bed and against the banks; and this process of destruction uncovers the tops of the ridges formed by the layers of these shells, which are embedded in the mud of the sea where they were born when the salt waters covered them. And these same ridges were from time to time covered over by varying thicknesses of mud which had been brought down to the sea by the rivers in floods of varying magnitude; and in this way these shells remained walled up and dead beneath this mud, which became raised to such a height that the bed of the sea emerged into the air.

"And now these beds are of so great a height that they have become hills or lofty mountains, and the rivers which wear away the sides of these mountains lay bare the strata of the shells, and so

STUDY OF FLOWING WATER AND EDDIES
Pen and ink with red chalk, 29 × 20.2 cm. Royal Collection, Windsor Castle.

150

the light surface of the earth is continually raised, and the antipodes draw nearer to the center of the earth, and the ancient beds of the sea become chains of mountains."

According to Pierre Duhem, "Leonardo's geological creed may be his most complete and most enduring scientific discovery." He starts with fossils found inside lofty mountains and ends up musing on the unfathomable depths of time. How recent and tenuous is man's presence on earth, yet how great the human mind can be! "The knowledge of past time and of the position of the earth is the adornment and the food of human minds." Elsewhere, however, we read, "O Time, swift despoiler of created things! How many kings, how many peoples hast thou brought low! How many changes of state and circumstances have followed since the wondrous form of this fish died here in this hollow, winding recess? Now destroyed by Time, patiently it lies in this narrow space, and with its bones despoiled and bare, it has become armor and support to the mountain which lies above it."

This majestic concept of time, which led Leonardo to plumb the remote past of the earth, also prompted him to look ahead to the future and even visualize the end of the world. As he saw it—this may have been a legacy of the Middle Ages—the earth may be likened to a living thing, to the human body. "We may say that the earth has a spirit of growth, and that its flesh is the soil; its bones are the successive strata of the rocks which form the mountains; its cartilage is the tufa stone; its blood is the springs of its waters. The lake of blood that lies about the heart is the ocean. Its breathing is by the increase and decrease of the blood in its pulses, and even so in the earth is the ebb and flow of the sea. And the vital heat of the world is fire which is spread throughout the earth; and the dwelling place of its creative spirit is in the fires which in diverse parts of the earth are breathed out in baths and sulfur mines. . . ."

But the body of man possesses sinews, and this is what distinguishes it from the body of the earth. Leonardo planned to begin his *Treatise on Water* by listing the similarities between rocks and bones, the ocean and blood, breathing and the rise and fall of tides, followed by an attempt to show that "in this body of the earth there is lacking sinews, and these are absent because sinews are created for the purpose of movement, and as the world is perpetually stable within itself no movement ever takes place there, and in the absence of any movement the sinews are not necessary. But in all other things man and the world show a great resemblance."

Neither man nor the world lives forever. One day, humankind shall perish for lack of water and the earth shall meet a fiery death. "The watery element remaining pent up within the raised banks of the rivers and the shores of the sea, it will come to pass with the upheaval of the earth that as the encircling air has to bind and circumscribe the complicated structure of the earth, its mass which was between the water and the fiery element will be left straitly compassed about and deprived of the necessary supply of water.

"The rivers will remain without their waters; the fertile earth will put forth no more her budding branches; the fields will be decked no more with waving corn. All the animals will perish, failing to find fresh grass for fodder; and the ravening lions and wolves and other beasts which live by prey will lack sustenance; and it will come about after many desperate expedients that men will be forced to abandon their life and the human race will cease to be.

"And in this way the fertile, fruitful earth being deserted will be left arid and sterile, and through the pent-up moisture of the water enclosed within its womb and by the activity of its nature, it will follow in part its law of growth until having passed through the cold and rarified air it will be forced to end its course in the element of fire. Then the surface of it will remain burnt to a cinder, and this will be the end of all terrestrial nature."

IX BOTANIST

IN AN attempt to show that the painter is superior to the poet, Leonardo argues for the primacy of sight over the other senses and claims that it is sight alone that prompts men to seek the pleasures of the countryside. "What compels you, O man, to forsake your house in the city, leave your parents and friends behind, and go away, through hill and dale, to the country? What else but the natural beauty of the universe, something which, all things considered, only sight allows you to enjoy?"

With somewhat labored irony, Leonardo pictures a poet describing a lovely landscape while seated indoors in the cool of the evening, safe from sunstroke, weariness, and illness. The effect of the poet's description on a listener, he argues, cannot compare with the effect of the landscape itself, or of the painter's representation of the landscape. When poetry is the intermediary, "the soul cannot benefit from the eyes that are the windows of its abode, nor enjoy the sight of beautiful places, nor contemplate the shady valley scored by the windings of meandering rivers, the sundry flowers and their visual harmony of colors, and all the other things only the eye perceives." Conversely, "if in the cold, dismal season of winter the painter shows you these very landscapes and others in which you made merry; if you can see yourself again beside a fountain, wooing your lady love in the blossoming meadow and the soft shade of verdant trees, will you not take in this a different kind of pleasure than if you heard the effect described by a poet?"

Leonardo's reasoning, however, is far from airtight. He assumes that the person looking at the painting has previously seen the landscape before him (or one like it), and he seems to overlook the feelings experienced by someone listening to a poet as he paints a verbal picture of a landscape that has moved the listener in the past.

If nothing else, these few lines attest to Leonardo's firm belief that sight takes precedence over the other senses. True, he analyzes the world like a scientist, but above all he looks at it through a painter's eyes—something that is especially clear in his notes on botany. The sheer bulk of his sketches and notations bear witness to the passionate interest with which the painter observed nature. He recorded slight variations within families of trees and flowers, captured the rustling of plant life, and even laid the groundwork for a theory of landscape in the *Trattato della Pittura*. However, he was careful to add, "I shall not finish dealing with this question here because I am setting it aside for elsewhere and because it has no connection with painting." Leonardo's unerring eye led him to discover laws governing the form and growth of plants, but it also led him to the conclusion that nature is so prolific and ingenious, "among trees of the same species no two are alike. . . ."

Leonardo was keenly interested in translating landscapes into pictures, and he wanted it done as accurately and unambiguously as possible. The purpose of landscape *qua* work of art is not merely to decorate; it must correspond to something real and true. This is why he reproached Botticelli, who considered such study fruitless, "for if one but threw a sponge full of color at the wall it would leave a patch in which one might see a beautiful landscape." Leonardo, for his part, took a very dim view of this technique (although such writers as Victor Hugo and George Sand were to use it in the nineteenth century). Botticelli looked upon landscape as "a matter requiring only a brief and rudimentary study." Leonardo's conclusion? "That painter painted very sorry landscapes."

No doubt it is significant that Leonardo's first dated drawing (1473) is a landscape. The inscription on the sheet seems to indicate that the twenty-one-year-old artist was pleased with what he had just drawn. The structure on the left is probably the castle of Montelupo; the valley in the distance, that of the Arno. This view of the Arno valley reappears in several Florentine paintings (notably by Antonio Pollaiuolo), while the rocky formation at the right recalls the boulder in the background of Verrocchio's *Madonna and Child with Angels* in the National Gallery (London). Leonardo's treatment of trees—parallel lines or, when more distinct, round blots—is conventional, but already "he was noting the various ways foliage appears in different lights and at different distances."

Later on, Leonardo took this much further, as the following passage in the *Trattato della Pittura* attests. "Although those leaves which have a polished surface are to a great extent of the same color on the right side and on the reverse, it may happen that the side which is turned toward the atmosphere will have something of the color of the atmosphere; and it will seem to have more of this color of the atmosphere in proportion as the eye is nearer to it and sees it more foreshortened. And, without exception the shadows show as darker on the upper side than on the lower, from the contrast offered by the highlights which limit the shadows. The underside of the leaf, although its color may be in itself the same as that of the upper side, shows a still finer color—a color that is green verging on yellow—and this happens when the leaf is placed between the eye and the light which falls upon it from the opposite side.

TWO TREES ON A RIVERBANK
Pen and ink, 7 × 7.4 cm. Royal Collection, Windsor Castle.

LONG-STEMMED PLANT (COIX LACHRIMA)
Black chalk, 21.3 × 23 cm. Royal Collection, Windsor Castle.

"Therefore, O Painter, when you do trees close at hand, remember that if the eye is almost under the tree, you will see its leaves [some] on the upper and [some] on the under side, and the upper side will be bluer in proportion as they are seen more foreshortened, and the same leaf sometimes shows part of the right side and part of the under side, whence you must make it of two colors."

Leonardo's biographers, after arriving at approximate dates for his copious studies of plants, concluded that botany held a continuing fascination for him right from childhood (however murky his early years continue to be). By the age of twenty, they claim, Leonardo was drawing with great accuracy. "His first attempt," writes Antonio Baldacci,

STUDY OF A BIRCH GROVE
Red chalk, 19.1 × 15.3 cm. Royal Collection, Windsor Castle.

"was a minutely detailed rendering of the foliated stems of *Lilium candidum* in the *Venus* and the *Cupid* in the Uffizi. Even greater command may be seen in the blossoming stems of the same plant as rendered in the Windsor MS. and which reappear, albeit in a smaller version, in the Louvre and Uffizi *Annunciations*." In addition, this historian assumes that Leonardo's passion for plant life was such that he compiled a herbarium so that he might have a ready reference to those forms he found most interesting. During his stint in Rome, the artist is known to have spent long hours in the Vatican gardens.

Leonardo's truly all-embracing curiosity ought not to be confused with the kind we occasionally encounter today. City dwellers back than had not yet lost touch with the earth and rural life. The animals, plants, smells, and noises of the country were still very much in evidence in Florence, Milan, and even Rome itself. "We are hothouse people, but they were a 'hardy' variety," writes Lucien Febvre about the sixteenth century. "They were outdoors people who felt as well as saw—inhaling, listening, touching, breathing in nature through all their senses."

We are accustomed to scientific classification, and there is nothing to stop one from collecting all of Leonardo's writings on plants, systematically arranging them, and reorganizing them into theoretical and applied botany, the latter subdivided into medical, artistic, horticultural, and industrial botany. (The same could be done, for that matter, with his notes on geology, mechanics, astronomy, and so forth). Poring over Leonardo's papers led many historians to

BLOSSOMING RUSH (SPARGANIUM ERECTUM)
Red chalk on pink surface, 20.1 × 14.3 cm. (reproduced original size). Royal Collection, Windsor
Castle.

Facing page. LILY
Pen and ink and bister wash over black chalk, heightened with white, 31.4 × 17.7 cm.
(reproduced original size). Royal Collection, Windsor Castle.

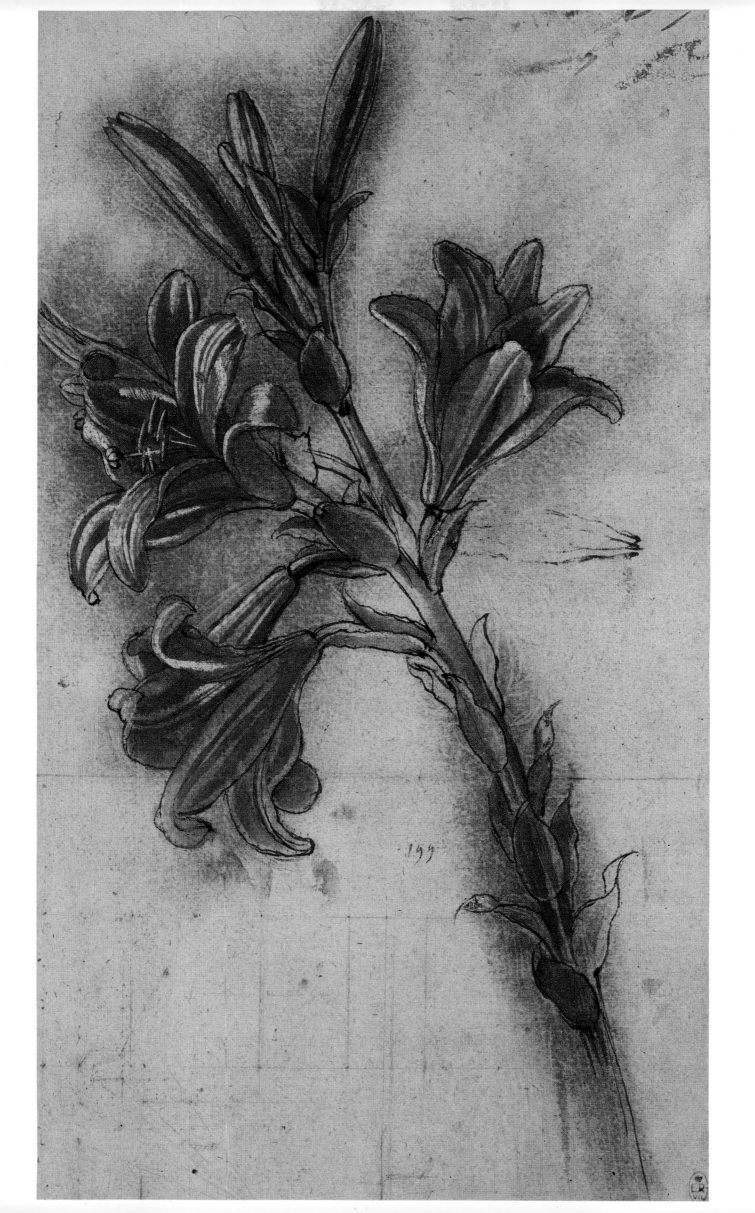

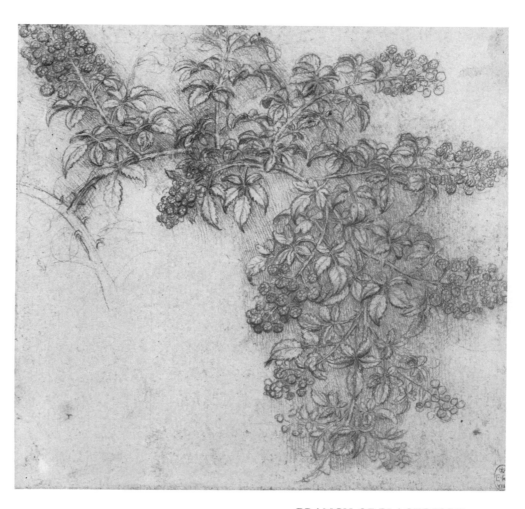

PYRUS TORMINALIS
Red chalk on pink prepared sur-
face, 14.4 × 14.3 cm. Royal
Collection, Windsor Castle.

BRANCH OF BLACKBERRY
BUSH
Red chalk on pink prepared sur-
face, 15.5 × 16.2 cm. Royal Col-
lection, Windsor Castle.

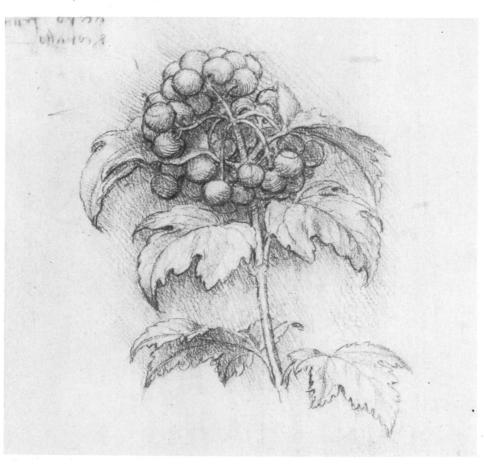

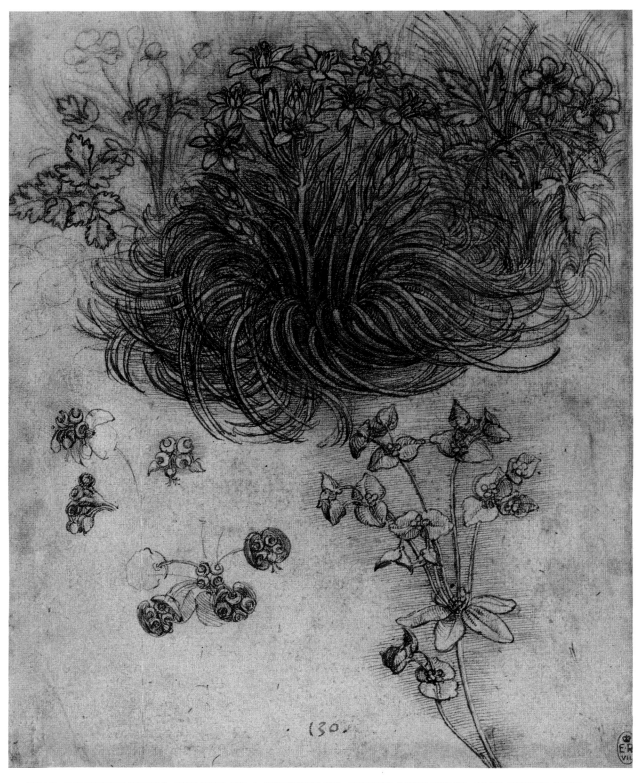

STAR-OF-BETHLEHEM, LEAVES OF A CROWFOOT, WOOD ANEMONE, AND SEEDS AND
BLOSSOMS OF A SPURGE
(Study for *Madonna of the Rocks*)
Red chalk and pen and ink, 19.8 × 16 cm. (reproduced original size). Royal Collection, Windsor Castle.

conclude that what they had before them was—allowing for repetition and discontinuity—if not the actual groundwork of an immense encyclopedia, then the fruit of an encyclopedic mind. But can it not also be said that Leonardo da Vinci was just the opposite of an encyclopedist? His writings do not constitute a summa of his era, nor even a summa of his own knowledge, but rather an accumulation of personal inquiries. However difficult it may be to conceive of someone preferring unending research to certainty, we must do so if ever we are to understand Leonardo's *oeuvre*.

So accurate are Leonardo's drawings of flowers and leaves that description is superfluous; they border on scientific interpretation. "The beginning of the ramifications of trees upon their principal branches is the same as the beginning of the leaves upon the shoots of the same year as the leaves. And these leaves have four ways of proceeding one higher than the other: the first and most usual is that the sixth on the upper side always is born above the sixth on the under side; the second is that the two thirds above are over the two thirds below; and the third way is that the third above is over the third below." The fourth mode of insertion is not spelled out here, but in a passage on the elder tree, Leo-

GROWTH OF PLANTS
Manuscript G. Institut de France, Paris.

nardo describes leaves which face each other in twos. The three modes discussed above may be visualized as follows. In the first, an imaginary spiral line meets five leaves as it winds around the branch once or twice; in the second, the leaves face each other, with pairs meeting at right angles and the third verticil lying in the same plane as the first; in the third (the elm, for example), the imaginary line meets two leaves as it goes around the branch once.

Naturally, Leonardo arrives at logical explanations for what he observes—explanations that are also a celebration of Creation. "Nature has arranged the leaves of the latest branches of many plants so that the sixth is always above the first, and so it follows in succession if the rule is not impeded. This serves two uses for the plants, the first being that as the branch or fruit springs in the following year from the bud or eye which is above it in contact with the attachment of the leaf, the water which wets this branch is able to descend to nourish the eye by the fact that the drops are caught in the axil where the leaf springs; and the second use is that when these branches grow in the succeeding year one will not cover the other, because the five branches come forth turned in five different directions and the sixth comes forth above the first but at a sufficient distance."

Having observed that, at a given height, the branches of a tree are as big taken together as the main branch from which they emerge, and that the lower shoots are larger than the upper shoots, Leonardo inferred that sap is divided between boughs and branches and that, having weight, sap runs down into the lower branches when the warmth of the sun no longer draws it toward the upper ones. "The lower branches, after they have formed the

Below left. LEAF DISTRIBUTION OF THE ELM
Manuscript G. Institut de France, Paris.

Below right. LEAF DISTRIBUTION OF THE ELDER
Manuscript G. Institut de France, Paris.

TARAXUM OFFICINALIS AND TREE
Pen and ink. Royal Collection, Windsor Castle.

over, "almost all the upright parts of trees are found to bend somewhat, turning their convex part toward the south. And the branches are longer, thicker, and more numerous toward the south than toward the north. This arises from the fact that the sun draws the sap toward that part of the surface of the tree which is nearest to it."

Leonardo noticed that the concentric rings of a cut tree trunk tend to be off center and concluded that rings tell a tree's age and the direction of its growth. "The southern parts of plants show greater youth and vigor than do the northern ones. The rings of cut tree branches indicate the number of years they have lived, while their greater or lesser width tell us which years were wetter or drier. The branches also tell us what direction they faced, for those facing south are larger than those facing north, and for this same reason the center of the tree is nearer its southern bark than its northern bark."

In 1581, a jeweler in Pisa was to bring this same phenomenon to the attention of Montaigne during the essayist's stay in the city. "I bought an Indian walking stick to support myself while walking," he writes. "This clever worker, known for his fine mathematical instruments, informed me that all trees have as many rings as they have lived years and showed me this in all those he had in his shop. And the part facing north is narrower and its rings closer together and more tightly packed than the part facing south."

"The sun gives spirit and life to plants and the earth nourishes them with moisture," notes Leonardo, who then describes an experiment "of leaving only one small root on a gourd, and this I kept nourished with water; and the gourd brought to perfection all the fruits it could produce, which were about sixty gourds of the long kind. I set my mind diligently to consider this vitality and perceived that the dews of night were what supplied it abundantly with moisture through the insertion of its large leaves and gave nourishment to the plant and its offspring, or the seeds which its offspring had to produce. . . . Every shoot and every fruit is produced above the insertion of its leaf which serves it as a mother, giving it water from the rain and moisture from the dew which falls at night from above. . . . "

angle of separation from their trunk, always bend down, so as not to press against the other branches which follow above them on the same trunk and to be better able to take the air [and sun] which nourish them." The upper branches form an acute angle of separation from the trunk, for the same reason. More-

X OBSERVER OF ANIMALS

TRITE though this observation may seem, it bears repeating here: the world in which Leonardo and his contemporaries lived was quite different from ours. Italian cities were still very much in touch with the countryside, which bore little resemblance to rural areas as we know them today. Animals were a vital component of city life, providing transportation for people and goods, energy for work, and food. The fields beyond city walls were filled not only with grazing herds, but game and the wolves and birds of prey that took their toll of livestock. Since animals were much more thoroughly integrated into human life, people back then had a special attitude toward animals both domestic and wild, four-legged animals in particular. A brief look at bestiaries of the Middle Ages will help put this attitude in clearer perspective.

In the medieval bestiary we find, often right next to one another, domestic animals, wild animals, and creatures we refer to nowadays as "monsters": the sciapod, the cynocephalus, the manticore, and the unicorn, to name only a few. Consider, for example, the levcrocotta, which had the feet of a horse, a head brandishing an enormous cleft horn, the body of an ass, the hindquarters of a stag, the breast of a lion, and something akin to a human voice; or the manticore, with its three rows of teeth, lion's body, and scorpion's tail. But these extraordinary creatures were not figments of the medieval imagination; they were waiting to be discovered in ancient texts. The Middle Ages accepted them not only because people took the writings of venerable authors on faith, but because Christ had come to save the world and it was not right that any part of Creation, however monstrous, should be spurned.

Nor did the Renaissance reject these fabulous beasts. They had adorned the capitals of medieval churches; now they decorated manuscripts and the first printed books and disported themselves in the work of countless painters. The surgeon Ambroise Paré wrote a *Discours de la Licorne,* and the unicorn was to grace many a splendid tapestry. A few individuals, to be sure, were growing a bit skeptical, but now that new worlds were being discovered people seemed prepared to credit stories about odder creatures still.

Vasari's anecdote about how young Leonardo painted a round shield for one of his father's peasants appears time and again in accounts of the artist's life. Leonardo, biographers tell us, made a collection of "lizards, crickets, serpents, butterflies, locusts, bats, and various strange creatures of this sort and assembled different parts to create a fearsome and horrible monster." This prompted Gabriel Séailles to com-

ment on Leonardo's brand of realism. "To create a monster he did not rely on his imagination," Séailles wrote in 1892. "That would have yielded nothing but a trivial and purely decorative creature. He wanted his monster to be—if I may venture to use the word—real, and to do this it had to be plausible, credible, made up of integrated, interconnected parts, like a living thing. So he turned to the natural world familiar to him. He observed grasshoppers, lizards, bats, snakes: the strange creatures that inspire instinctive fear in men. He imitated nature even as he devised a form that does not exist in nature, piecing together a monster from various components the way nature herself would. The terror it struck in people's hearts seemed natural, too; it was a terror that came from within. His was the realism of a great artist blessed with the kind of genius that turns a human mind into an extension of nature. This fanciful creature of Leonardo's youth reveals the guiding principle the artist was to follow in his maturity: study nature that one may duplicate her processes,

STUDY OF FOREQUARTERS AND HINDQUARTERS OF A DOG.
Red chalk, 18.7 × 12.2 cm. Royal Collection, Windsor Castle.

that one may complete nature through human intervention, be it a machine that fulfills a need or a work of art that arouses and enriches our emotions."

According to Marcel Brion, Leonardo dressed "a lizard with fish's fins and bat's wings to create a monster" and operated on living animals. "Better informed about biology than anyone else at the time, surely Leonardo could not have been satisfied with collages of this sort. He must have tried his hand at actual grafts or transplants, though how successful they were no one can say." Not to mention, of course, that experiments of this kind went hand in glove with anatomical research and that the creation of hybrid creatures reveals, as Brion puts it, "a side of Leonardo's personality there is no logical reason to overlook, for it is of paramount importance."

Our aim is not to cast doubt on psychological inferences of this sort, but it may be useful to mention an account Marco Polo wrote two centuries before Leonardo's experiments. After leaving the Chinese court of the Mongol emperor Kublai Khan, the Venetian traveler set sail for home. Along the way he stopped in the kingdom of Basman (Pasay) on Sumatra and there witnessed the making of a highly original export commodity: pygmies! "I also want you to know," he writes, "that the pygmies which certain travelers claim to have brought back from India are nothing but lies and deception. Allow me to tell you that these creatures they call men are made on this island. No doubt you know that this island is home to a species of tiny monkey with a human face. They take these monkeys and apply ointments to remove all of their hair save for around the genitals. They then simulate a beard by implanting long hairs in the chin, after which they are allowed to dry. Once the skin has dried, the holes into which the hairs have been set close up, making it look as though they grow there naturally. Then, since the feet, hands, and other members are not identical to those of men, they adjust and mold them to look human. They dry the creatures and model them, coating them with camphor or other substances until they look like men. But it is a monumental hoax, because they are all made exactly as I have described, for apparently men as tiny as these have never been seen in India or, for that matter, any other more primitive land."

Marco Polo did not share the realism of the inhabitants of Sumatra—"blessed with the kind of genius that turns the human mind into an extension of nature"—no more than he understood how creativity such as this offered a glimpse into their psyche.

A deft and resourceful engineer, Leonardo built numerous "robots" for a great many court entertainments in Italy and France. They often took the shape of fabulous creatures. Witness, for example, the dragon he drew about the time of the *Battle of Anghiari* (probably for a masquerade), or the mechanical lion he devised for the festivities in Pavia to honor Francis I of France. The lion took a few steps forward, stopped just short of the king, then opened to reveal a bank of lilies. Leonardo also indulged his fancy for contraptions of this sort at Amboise, and he designed another flower-filled lion for a celebration at Argentan (Normandy) in honor of Francis I's visit to his sister, Marguerite de Valois, and new brother-in-law, Charles, duke of Alençon. Other animated figures appeared the following year when the king's niece, Madeleine de la Tour d'Auvergne, married Lorenzo de' Medici. Leonardo was a past master of mechanical toys, and Marcel Brion wonders if Leonardo, "hungry for knowledge so that one day he might rival the creations of nature," did not yearn to "fashion an artificial man." Tempting though it may be for science fiction buffs, this hypothesis—which challenges those who advocate Leonardo the "sound" and "sensible" engineer—is clearly unfounded and probably gratuitous.

Leonardo displayed his engineering skill by making ingenious "robots" and intricate machinery for entertainments, as did his fellow engineers. And like his fellow painters, Leonardo drew a number of animals from the traditional bestiary of fantastic beasts. If there were no monsters anywhere in his *oeuvre,* no dragons or griffins or unicorns, it would be more than cause for astonishment; it would be well nigh unbelievable. The fact that we come across so few of them is in itself remarkable.

Traditionally, a unicorn was shown as an onager (wild ass) with a white body, a purple head, deep blue eyes, and protruding from its forehead, a long horn, white at the base, black in the middle, and scarlet at the tip. It was said to be so swift-footed that no other animal could catch up with it. Hunters were believed to resort to unusual methods to capture this merciless beast. They would place in its path a virgin whose "odor" the unicorn found attractive. It would draw near and place its head in the girl's lap, at which time the hunters could safely kill the animal and make off with its horn. However, if the maiden was "sullied and not a virgin," the unicorn unfailingly tore her to pieces. The horn of this fabulous creature was thought to have the power to safeguard against plague and poison, and its reputed capacity to heal many illnesses made it a costly commodity. Any liquid it touched was instantly purified, and a drawing by Leonardo (Ashmolean Museum, Oxford) shows a unicorn purifying a pool of

water with its horn. The unicorn and maiden are the subjects of two other drawings, one on the reverse of two studies for the *Madonna and Child with a Cat* (British Museum, London), the other in the Ashmolean Museum.

Another allegorical drawing by Leonardo (graphite heightened with ink, Louvre) shows fighting animals and a man holding a burning mirror. One of the animals is a unicorn, its head lowered as it charges its adversaries.

Another sketch in the Ashmolean Museum, a silverpoint on pinkish buff prepared surface, shows a horseman and a griffin locked in combat. The lines of the rearing horse are forceful and sure; the griffin is sketched in only a few lines. Could this be a preliminary drawing for a *St. George and the Dragon,* even though the "dragon" in this case has the eagle's beak usually associated with the griffin? England is now home to several other drawings of dragons. In the Royal Collection at Windsor Castle there are three silverpoints on white prepared surface with touches of ink, all of which show dragons at various stages of completion. The same collection boasts a sheet with studies of horses, a cat, and a St. George and the Dragon in various poses (all pen and ink over black chalk); a sheet with studies of cats and a dragon (pen and ink and wash over black chalk); another with an unfinished drawing of a dragon (black chalk with some ink); and a pen and ink drawing of two heads of monsters, one of which resembles a human face, while the other looks somewhat like a poodle.

On still another sheet we find an architectural sketch and, mounted on a faintly outlined horse, a rider with an elephant's head who seems to be playing music with its trunk. This curious appendage ends in a trumpet bell, and the horseman appears to be stopping holes in the instrument with his fingers. Probably this was a costume design for a masquerade.

Strange, monstrous creatures also appear in Leonardo's drawings of various allegorical subjects. The allegory of political adroitness (Christ Church, Oxford) is a two-headed Prudence that is half man, half woman. Two allegories of Envy, also at Oxford, show a figure with two bodies; for Pleasure, Pain, and Envy Leonardo devised a naked man with four arms and two heads. However, strictly speaking, allegorical "monsters" such as these do not belong in a bestiary. On the other hand, Leonardo's notebooks abound with observations on fauna (often borrowed from Pliny and other ancient authors) that would not be at all out of place in a compendium of fantastic creatures. Here is the sampling offered by J.

Péladan in his anthology, *Léonard de Vinci: Textes choisis.*

"Swallow. This by means of celandine opens the eyes of its little ones when blind."

"Fidelity or loyalty. The cranes are so faithful and loyal to their king that at night when he is asleep some pace up and down the meadow to keep guard over him from a distance; others stand near at hand, and each holds a stone in his foot. . . ."

"Correction. If the wolf while prowling warily round some cattle stall should chance to set his foot in a trap so that he makes a noise, he bites his foot off in order to punish himself for his mistake."

"Temperance. The camel is the most lustful animal that there is, and it will follow a female a thousand miles, but if it lived continually with its mother or sister it would never touch them, so well does it know how to control itself."

"Peace. Of the beaver one reads that when it is pursued, knowing this to be on account of the virtue of its testicles for medicinal uses, not being able to flee any farther it stops, and in order to be at peace with its pursuers bites off its testicles with its sharp teeth and leaves them to its enemies."

"Serpents. The serpent, a very large animal, when it sees a bird in the air inhales its breath with such vigor as to draw the birds into its mouth."

"Crocodile—Hypocrisy. This animal seizes a man and instantly kills him; and after he is dead it mourns for him with a piteous voice and many tears, and having ended its lament it cruelly devours him. It is thus with the hypocrite, whose face is bathed with tears over every slight thing, showing himself thus to have the heart of a tiger; he rejoices in his heart over another's misfortunes with a face bedewed with tears."

In Péladan's anthology the following passage appears in the section entitled "Fables":

"The hawk, being unable to endure with patience the way in which the duck was hidden from him when she fled before him and dived beneath the water, desired also to follow in pursuit beneath the water; and getting its wings wetted it remained in the water; and the duck raised herself in the air and mocked at the hawk as it drowned."

We could probably trace these sundry observations to earlier authors, but the oddest part of all is Péladan himself, who states that of the thousands of sheets Leonardo wrote, he, Péladan, selected only those revealing "decisive features of [Leonardo's] physiognomy," those characterized by "unalloyed conscientiousness" and "unyielding logic."

All of Leonardo's biographers mention the story about how he would buy birds from fowlers only to

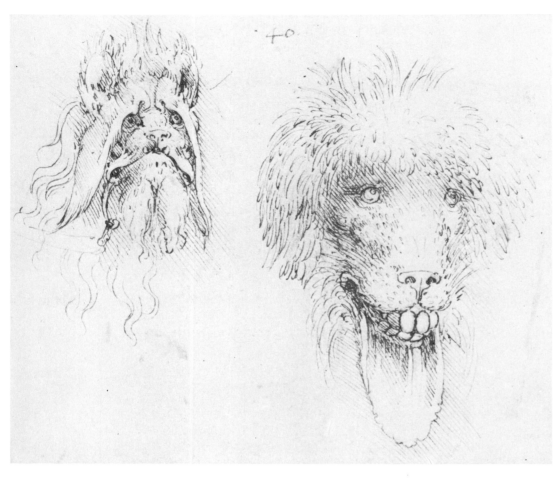

TWO MONSTER HEADS
Pen and ink, 14 × 17.3 cm. Royal Collection,
Windsor Castle.

DRAGON
Pen and ink over black chalk,
21 × 27 cm.
Royal Collection, Windsor Castle.

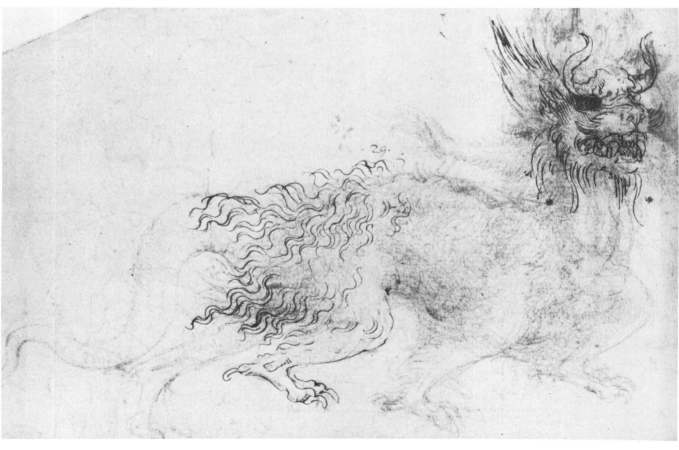

Following left-hand page. STUDIES OF CATS AND A DRAGON
Pen and ink and wash over black chalk, 27 × 21 cm. (reproduced original size). Royal Collection, Windsor Castle.

Following right-hand page. STUDIES: HORSES, A CAT, AND ST. GEORGE AND THE DRAGON
Pen and ink, 28.9 × 21.2 cm. Royal Collection, Windsor Castle.

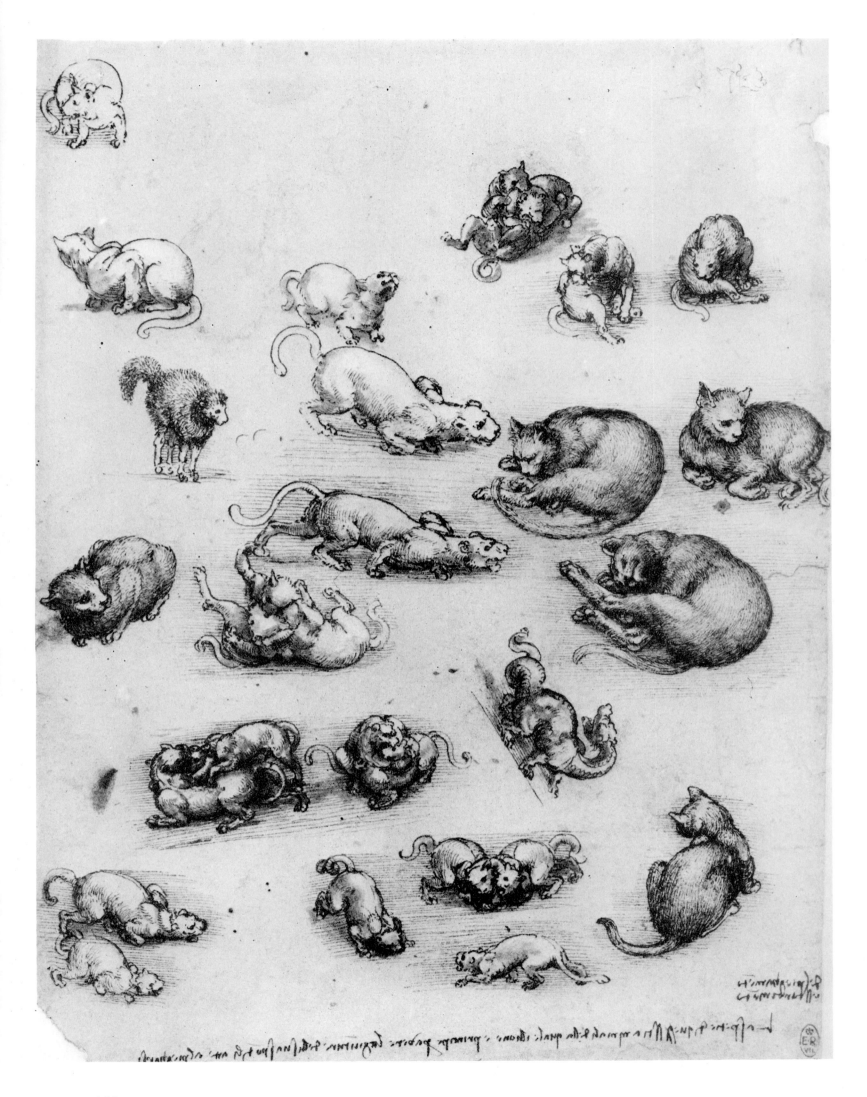

164

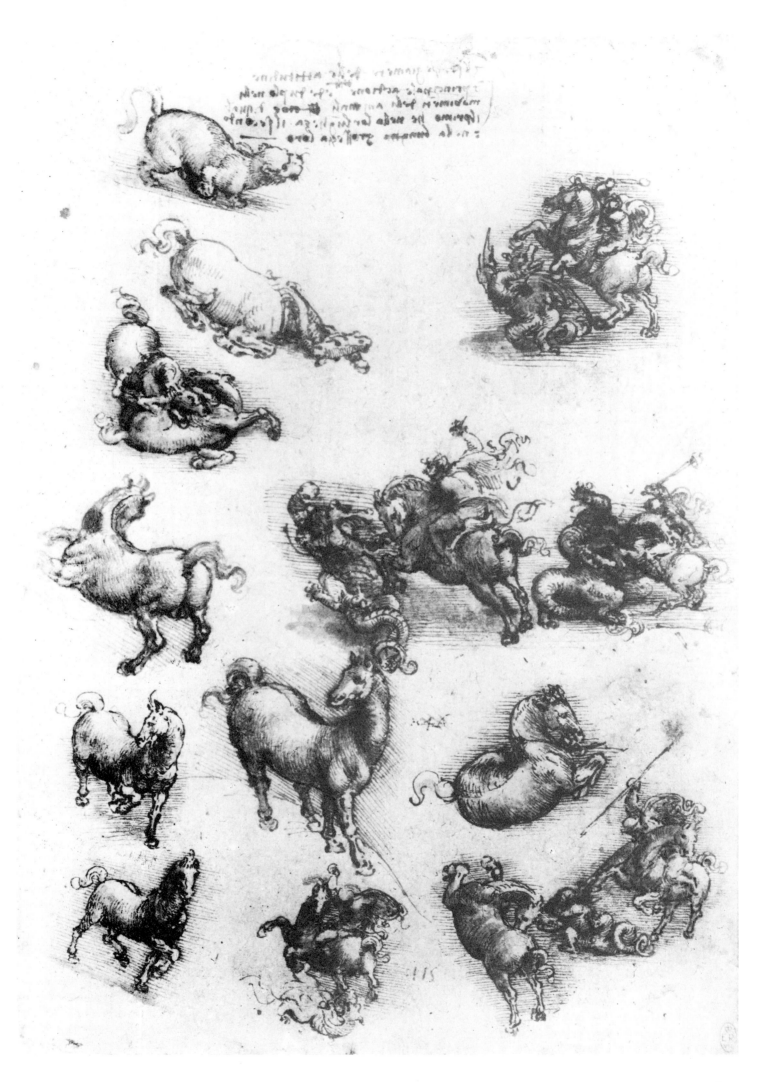

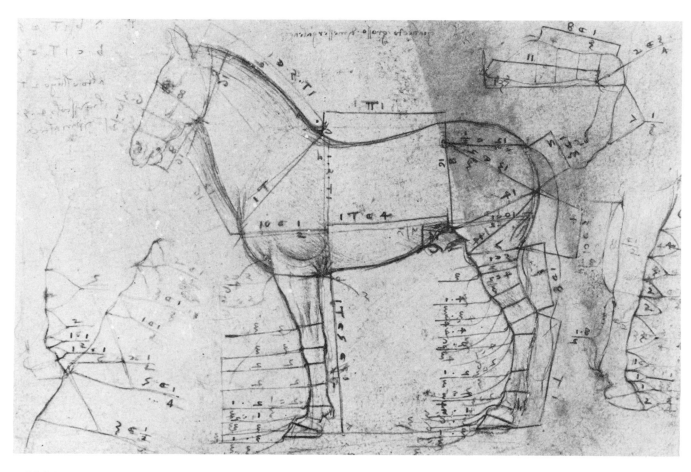

PROFILE OF HORSE WITH MEASUREMENTS
Silverpoint. Royal Collection, Windsor Castle.

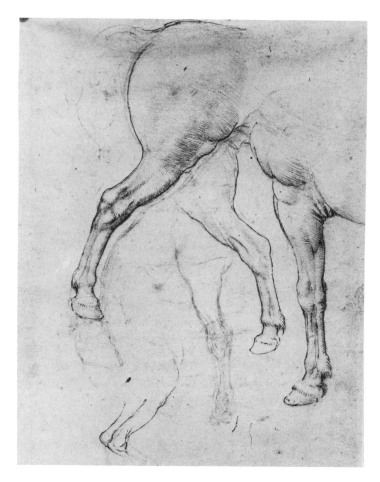

STUDY OF A HORSE'S LEGS
Pen and ink over black chalk. Royal Collection, Windsor
Castle.

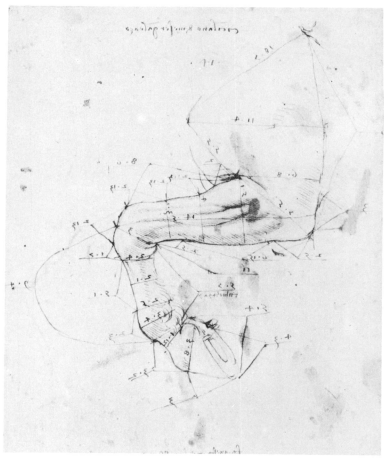

**STUDY OF THE LEFT FORELEG OF A HORSE, WITH
MEASUREMENTS**
Pen and ink, 25 × 18.7 cm. Royal Collection, Windsor Castle.

set them free, and even his contemporaries were familiar with his love for animals. "Between Goa and Rasigut there is a land called Cambaia where the Indus flows into the sea," the Florentine traveler Andrea Corsali wrote in 1515 to Giuliano de' Medici. "It is inhabited by pagans called Guzzarates, and they are superb merchants. . . . They do not feed on anything that has blood, nor will they allow anyone to hurt any living thing, like our Leonardo da Vinci."

Of the animal drawings that survive, we should note the pen and ink over metalpoint sketch of the camel in the foreground of the composition study for the *Adoration of the Magi* (Uffizi, Florence). In A. E. Popham's *The Drawings of Leonardo da Vinci* (1946) we find: a bear's head (metalpoint on pinkish buff prepared surface) in the collection of Capt. Norman Colville, London; a study of a bear (same medium and support) in the collection of Ludwig Rosenthal of Canada; and, also in the Colville collection, four metalpoint studies of dog and wolf paws with three additional studies of the same subject on the verso of the sheet.

In the Royal Collection at Windsor Castle there is a sheet with sketches of oxen and asses, probably for a future Nativity scene; the medium is silverpoint (or graphite) with some pen and ink highlights.

Leonardo's earliest known sketch of animals (British Museum) shows a dog and two cats, and the artist's *oeuvre* abounds in studies of cats, notably for the *Madonna and Child with a Cat*. Yet, the number of cats Leonardo observed is minute compared with his countless drawings of horses. As Marcel Brion points out, "As soon as he drew horses Leonardo seemed to be possessed by an uncanny lyricism, as though transported into another world." Horses hold a special—one could even say disproportionate—place in Leonardo's work. During one phase of his career, the artist was working simultaneously on the *Adoration of the Magi* and the equestrian monument of Francesco Sforza, both of which feature horses.

The *Adoration* in the Uffizi fairly teems with horses. "Here," writes A. E. Popham, "are to be found horses standing, walking, curvetting, prancing, rearing, seen from the front, the back and the side. It might almost be regarded as an illustrated treatise on the movements of the horse. The horses of the *Adoration* are far from being realistic animals, nor are they the animals of Roman sculpture. They seem nearest to the horse of Donatello's Gattamelata monument. They are distinguished from Leonardo's later horses by the smallness of their heads; they have very wide foreheads which narrow down to

STUDIES OF ASSES AND AN OX
Silverpoint, 16.4 × 17.7 cm. Royal Collection, Windsor Castle.

where the nostrils begin; the muzzles are wide and almost circular in shape. These horses behave in a wild, romantic way, in contrast to the stereotyped action of classical sculpture. . . ."

As for the monument that was supposed to have been erected to the glory of Ludovico il Moro's father, Leonardo gave little thought to Francesco Sforza. The sculptor's sole concern was the horse on which he lavished his skill. The rider would come later. The colossal clay model of the horse was preceded by many preliminary drawings: several are in the Royal Collection at Windsor, others are in the Musée Bonnat, the Biblioteca Reale in Turin, and the Biblioteca Ambrosiana in Milan. Marvelous though these leaping, quivering specimens may have appeared on paper, unfortunately they must have been unfeasible as sculpture. In his preface to *De Divina Proportione*, Luca Pacioli mentions that the planned horse would measure twelve *braccia* (over seven meters) from hoof to the top of the head, while the bronze needed for casting was estimated at 200,000 pounds (or nearly seven metric tons, the Milanese pound of the sixteenth century being roughly equivalent to a third of a kilogram).

The horse once again took center stage when it came time for Leonardo to work out his plan for the *Battle of Anghiari,* a struggle between horses in which cavalrymen are only secondary characters. When Leonardo began painting the scene in 1505, he used a drying technique that ruined the work as

soon as it was finished. All that survives are small sketches in the Accademia in Venice and the Royal Collection at Windsor Castle. A number of Leonardo's disciples (and later on, Rubens) left copies of larger drawings, perhaps even of the cartoon itself. One pen and bister on white paper in the Gabinetto dei Disegni e Stampe of the Uffizi shows a group of seven warriors after the *Battle of Anghiari*. Another old copy from the Gabach collection and formerly the Cabinet du Roi (the verso bears the initials of Robert de Cotte and A. Coypel) is now in the Cabinet des Dessins of the Louvre.

About 1508 Leonardo's in-depth knowledge of the horse was once again pressed into service for the funerary monument to Gian Giacomo Trivulzio, the general who in 1499 defeated Ludovico il Moro. His assignment was to make a bronze steed and rider set on a marble base with eight columns and eight carved figures. The supine figure of the deceased was to be surrounded by six harpies with candelabra. Only a few sketches survive.

Leonardo's concept of the animal world was at times truly oversimplistic, as the following passage from the *Trattato della Pittura* attests. "It is an easy matter to men to acquire universality, for all terrestrial animals resemble each other as to their limbs, that is in their muscles, sinews and bones; and they do not vary excepting in length or thickness, as will be shown under Anatomy. But then there are aquatic animals which are of great variety; I will not try to convince the painter that there is any rule for them for they are of infinite variety, and so is the insect tribe."

Leonardo the engineer had a lifelong interest in how water moves and intended to study how living things—men as well as fish—behave in an aquatic environment. Part of his outline reads as follows. "Of the manner of swimming of fishes; of the way in which they leap out of the water as may be seen with dolphins, for it seems a marvelous thing to make a leap upon something which does not stand firm but slips away. Of the manner of swimming of animals of long shape such as eels and the like. . . . Of the way in which fishes swim when they are round in shape. . . . In what way a man ought to learn to swim. Of the way in which a man should rest upon the water. How a man ought to defend himself against the whirlpools or eddies of the waters which suck him down to the bottom. How a man when sucked down to the bottom has to seek the reflex current which will cast him out of the depths."

XI ANATOMIST

SPURRED by a passion for knowledge, Leonardo apparently pressed his lone search as if convinced that omniscience was an attainable goal. In this respect he remained a man of the Middle Ages. In a created, finite world in which man is a microcosm, a person who delves deeply enough into a particular area of study necessarily ends up studying it in its entirety. He would come to know all of it, the underlying assumption being that knowledge, like Creation, is one, finite, and all-embracing.

Leonardo's ambition may have known no limits and his mind may have been open to everything, but he worked from concrete facts instead of abstractions, from deliberately constructed theories rooted in experience and his unending quest for usefulness and efficiency. He had, if you will, a "philosophy," that is, a certain concept of the world, man, and life, but he was neither a true metaphysician nor a true philosopher. He was interested in how the earth was formed, how water circulates, how things fall, the stars; yet he was neither a geologist nor a physicist nor an astronomer. He was an engineer. Intrigued though he was by human and animal anatomy, however much he tried to fathom the workings of physiology and how each organ fits into the overall picture, we must bear in mind that he was a painter, not a physician.

Leonardo never tired of taking notes. He would repeat the same observations, with only slight changes, at different points of his life. He recorded things that seemed important to him, not to a prospective reader, and did so on the spur of the moment, limiting his thoughts to a few lines and only very rarely writing as much as an entire page. Leonardo's vade mecum of notes was in fact a hodgepodge of calculations, original thoughts, material copied from various books, and, almost invariably, sketches.

It hardly comes as a surprise that Leonardo usually considered sketches the core of his anatomical research. "With what words, O Writer, will you describe with like perfection the entire configuration which the drawing here does?" he asks in a marginal note of an anatomical study. "And do not meddle in things appertaining to the eyes by making them enter through the ears, for you will be far surpassed by the work of the painter."

Leonardo da Vinci planned to write a *Treatise on Anatomy,* and the project figured prominently in his life. The first mention of it appears on sheets dating as far back as 1489. More than twenty years later he wrote, "In this winter of 1510 I hope to complete all this anatomy." Tradition has it that Leonardo enlisted Marcantonio della Torre, a doctor and anatomist at the University of Pavia, to help him reach his goal. We do know for certain that in 1505 (the year he painted the *Mona Lisa*) Leonardo dissected two bodies, one of a two-year-old child and one of an old man, at the hospital of Santa Maria Nuova in Florence.

Leonardo worked out more than just an outline of his planned treatise and amassed a considerable number of notes for it. However, reading the notes that survive—and there are still quite a few—leads to a curious observation. Some begin with instructions to the reader or, more precisely, to himself, as though Leonardo were drawing up an agenda for future anatomical research: "You will describe the limbs . . ." or "Give the measurement of . . ." or "Show . . ." Others begin, "I dissected . . ." or "These things which I did . . ." as if reminding himself of what he had observed and probably intended to use when it came time actually to write the treatise. Yet, texts one could describe as purely instructive or prescriptive— "The human body is thus . . ." or "Now we turn to such and such a detail . . ." or "Here is how this organ works . . ."—such core material is almost nowhere to be found.

In his paintings Leonardo preferred curving, well-proportioned lines to prominent muscles, not that that prevented him from probing superficial anatomical features as well as the anatomy and physiology of the viscera. Leonardo's anatomical plates are by and large a record of his own experiments, and he is believed to have used methods of his own devising and special preparations to enhance form, structure, and organ function and to prolong the useful life of preserved organs.

From the earliest anatomical studies, argues Dr. Arturo Castiglioni, Leonardo did not set much store by the work of his predecessors, in particular that of the Italian anatomist Mondino (13th–14th century) and Galen, and turned a deaf ear to the scholastic tradition. More recently, Dr. Charles Lichtenthaeler, while acknowledging the uncommon beauty, originality, and in some cases continued relevance of Leonardo's anatomical studies, notes that they "also include errors, and what is more significant, errors that can be traced back to the writings of Galen and to the Galenic tradition." There are two possible explanations for this. Either Leonardo drew sketches to understand better the anatomy manual he was reading, or else he himself thought he saw what ancient authors claimed to see. For example, ever since the Hippocratic collection, the liver was considered the organ of "yellow bile," the spleen the organ of "black bile." Each was thought to be drained by special ducts. Leonardo drew these sup-

posed splenetic canals a number of times. In accordance with what Galen has written—not with what an autopsy would reveal—Leonardo shows the venous system branching out from the liver, reduces the size of the liver, and increases that of the spleen in order to maintain the liver-spleen balance taught by Galenic tradition. However, Dr. Lichtenthaeler adds that "Leonardo's own research often led him to rectify such errors. In the most recent drawings, for instance, the major blood vessels branch out from the heart instead of the liver."

This development in Leonardo's research leads to two observations. On the one hand, his capacity to place greater trust in his eyes than in the authority of ancient authors strikes us as curiously modern, especially when we stop to think that as late as 1804 Laënnec wrote his thesis on the importance of Hippocratic doctrine for practical medicine. On the other hand, we should bear in mind that, of the roughly eight hundred treatises printed before 1501—a period of intense activity in Leonardo's career—only eight were by Hippocrates, seven by Galen, and four by Celsus in Latin (plus one printing in Italian), whereas treatises by Arab authors abounded. Not until the first half of the sixteenth century was there to be a rise in the number of Greek and Latin editions of Hippocrates and Galen.

In the book he was planning to write, Leonardo intended to proceed "in the same order as was adopted before me by Ptolemy in his Cosmography." "Here will be shown to you in fifteen figures the cosmography of the Microcosmos. . . . I shall divide each member as he divided the whole into provinces, and then I shall describe the use of parts from every aspect, placing before your eyes a knowledge of the entire form and habit of man, insofar as it has local motion by means of its parts. And might it so please our Creator that I be able to demonstrate the nature of man and his customs in the way that I describe his figure."

This concept reappears in MS. A in the library of the Institut de France. "Man has been called by the ancients a lesser world, and indeed the term is well applied, seeing that a man is composed of air, earth, water, and fire, and this body of earth is similar. While man has within himself bones as a stay and framework for the flesh, the world has stones which are the support of the earth. While man has within him a pool of blood wherein the lungs as he breathes expand and contract, so the body of the earth has its ocean, which also rises and falls every six hours with the breathing of the world; as from the said pool of blood proceed the veins which spread their branches through the human body, so the ocean fills the body

of the earth with an infinite number of veins of water. . . ."

Two things Leonardo was sure of, and rightly so: his anatomical drawings were of excellent quality, and dissection was a tool without which there could be no true understanding of the human body. But he subscribed to two seemingly conflicting points of view. Only through repeated dissection can one understand the body, but dissection presents almost insurmountable difficulties for anyone who has a weak stomach, who is susceptible to "the fear of living in the night hours in the company of corpses quartered and flayed and horrible to see," and who is not blessed with superb draftsmanship, knowledge of perspective, the speed and patience of a good surgeon, an eye for detail, and the requisite financial resources. Only through drawings can we distinguish among the various parts that make up the body—veins, arteries, nerves, tendons, muscles, bones—yet they are all "marred by staining with blood," others nearly invisible "owing to their minuteness," and still others unavoidably ruined during anatomy lessons.

Consequently, the planned book in which Leonardo intended to show the human body "just as though you had a real man before you" remained just that: a plan. It was supposed to reveal "the parts of an anatomized man . . . from different aspects, from below, from above, and from the sides, turning the subject around and investigating the origin of each member." To obtain this information Leonardo had to overcome tremendous odds due to the "very great confusion which results from the combination of membranes intermingled with veins, arteries, nerves, cords, muscles, bones, and the blood, which of itself stains every part the same color. The vessels which discharge this blood are not perceptible owing to their minuteness. The continuity of the membranes is inevitably destroyed in searching for those parts enclosed within them and as their transparency is marred by staining with blood, this prevents recognition of the parts covered by them, owing to the similarity of their sanguineous color. You can have no knowledge of one without confusing and destroying the other. Therefore it is necessary to make further anatomies, three of which you will need to acquire a complete knowledge of the veins and arteries, destroying everything else with the utmost care; three others to acquire a knowledge of the membranes; three for the cords, muscles, and ligaments; three for the bones which must be sawn through to demonstrate which are hollow and which are not, which are medullary, which are spongy, which are thick from without inward, which are thin. And some are extremely thin in one part and

Facing page. PROPORTIONS OF THE HUMAN FIGURE ACCORDING TO VITRUVIUS
Pen and ink, 34.4 × 24.5 cm. Accademia, Venice.

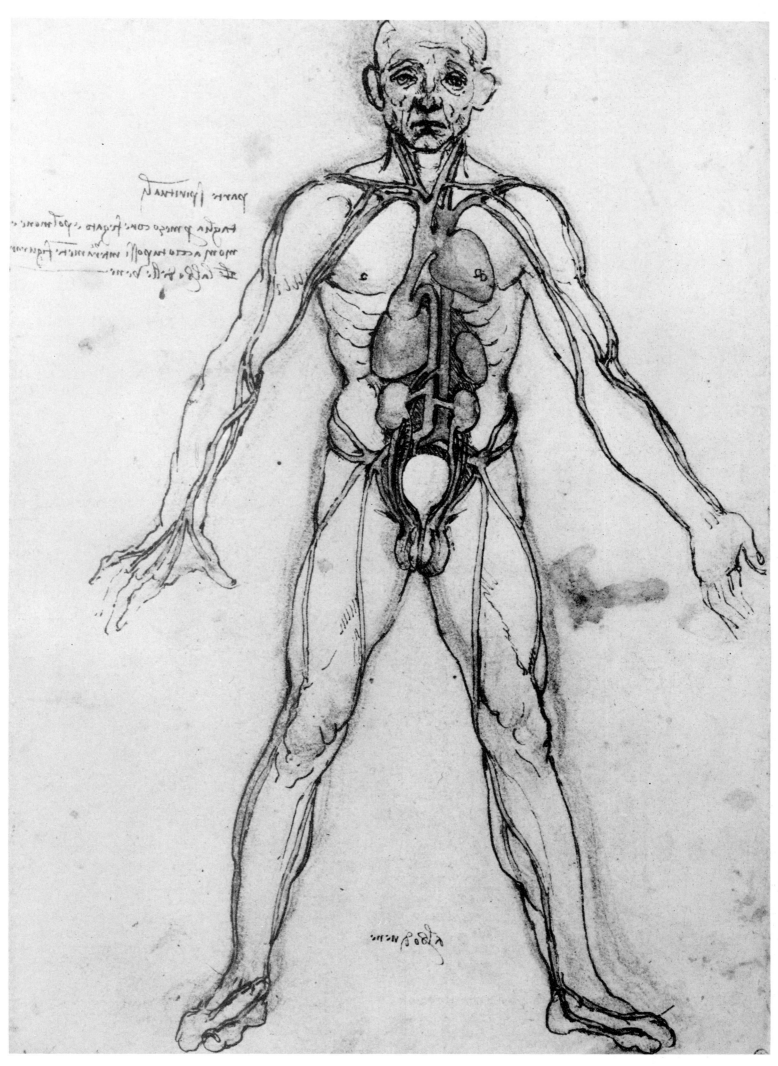

ANATOMICAL STUDY: THE HEART, VITAL ORGANS, AND MAIN ARTERIES
28.2 × 19.9 cm. (reproduced original size). Royal Collection, Windsor Castle.

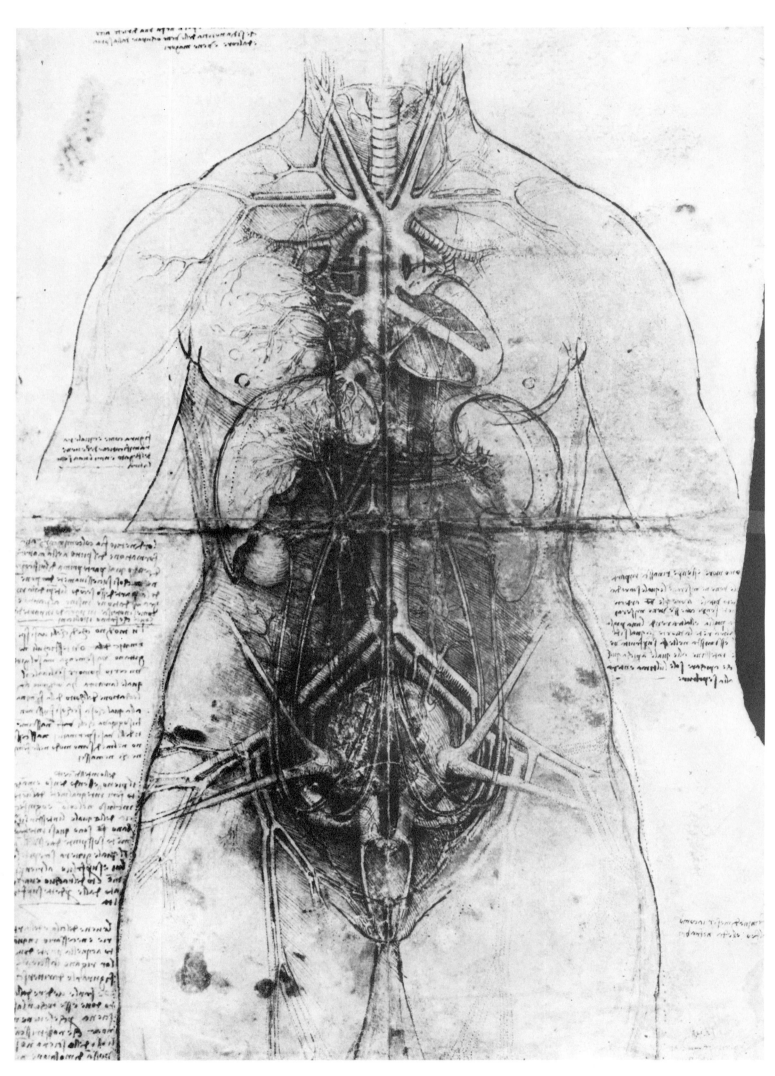

ANATOMICAL STUDY: PRINCIPAL FEMALE ORGANS
Pen and ink and wash over black chalk, 47 × 32.8 cm. Royal Collection, Windsor Castle.

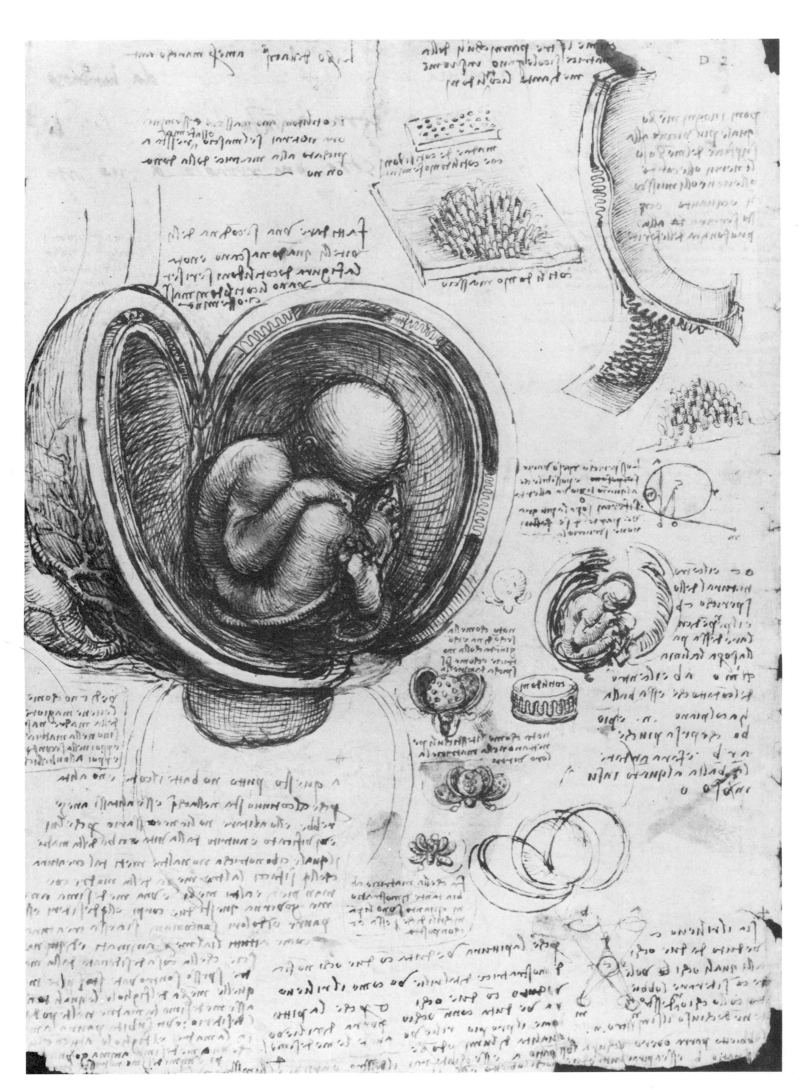

EMBRYO IN THE WOMB
Pen and ink, 30.1 × 21.4 cm. Royal Collection, Windsor Castle.

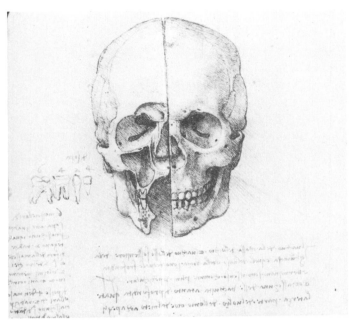

HUMAN SKULL (LEFT HALF IN CROSS SECTION)
Pen and ink, 18.3 × 13 cm. Royal Collection, Windsor Castle.

more than ten human bodies, destroying all the other members, and removing the very minutest particles of flesh by which these veins are surrounded, without causing them to bleed, excepting the insensible bleeding of the capillary veins; and as one single body would not last so long, since it was necessary to proceed with several bodies by degrees until I came to an end and had a complete knowledge; and this I repeated twice, to learn the differences.

"And if you should have a love for such things you might be prevented by loathing, and if that did not prevent you, you might be deterred by the fear of living in the night hours in the company of those corpses, quartered and flayed and horrible to see. And if this did not prevent you, perhaps you might not be able to draw so well as is necessary for such a demonstration; or, if you had the skill in drawing, it might not be combined with knowledge of perspective; and if it were so, you might not understand the methods of geometrical demonstration and the method of the calculation of forces and of the strength of muscles; patience also may be wanting, so that you lack perseverance. As to whether all

thick in another, and in other parts hollow or full of bone or of marrow or are spongy. Thus it may be that all these conditions will sometimes be found in one and the same bone and there may be a bone which has none of them. . . .

"Through my plan"—Leonardo's projected *Treatise on Anatomy*—"every part and every whole will be made known to you by means of a demonstration of each part from three different aspects; for when you have seen any member from the front with what nerves, cords, or vessels which arise from the opposite side, the same member will be shown to you turned to the side or from behind, just as if you had the same member in your hand and went on turning it gradually until you had a complete understanding of what you wish to know. And so, similarly there will be put before you in three or four demonstrations of each member from different aspects, in such a way that you will be left with a true and full understanding of all you wish to know of the human figure."

Leonardo then turns to those who believe anatomy lessons with corpses more profitable, warning them of the problems they face should they wish to probe beneath the surface. "And you who say that it would be better to watch an anatomist at work than to see these drawings, you would be right, if it were possible to observe all the things which are demonstrated in such drawings in a single figure, in which you, with all your cleverness, will not see nor obtain knowledge of more than a few veins, to obtain a true and perfect knowledge of which I have dissected

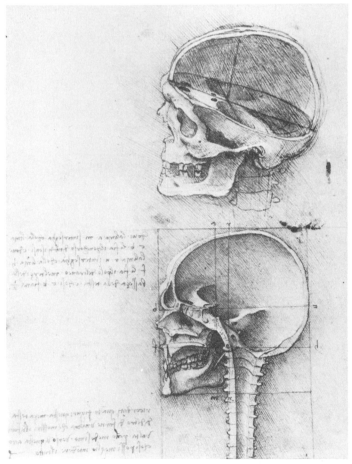

TWO PROFILE STUDIES OF A SKULL FACING LEFT
Pen and ink, 18.1 × 12.9 cm. Royal Collection, Windsor Castle.

175

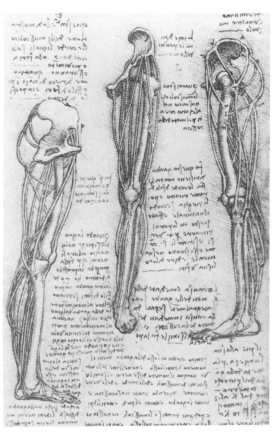

LEFT LEG SHOWING BONES AND TENDONS
Pen and ink, 21.5 × 11 cm. Royal Collection, Windsor Castle.

REAR VIEW OF SKELETON SHOWING NECK TENDONS
Pen and ink, 27.4 × 20.4 cm. Royal Collection, Windsor Castle.

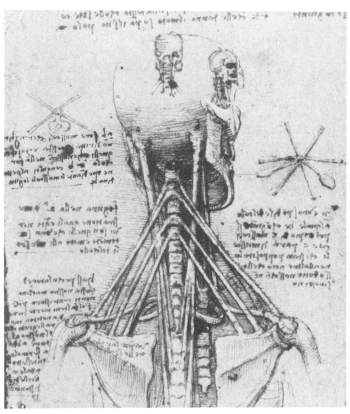

these things were found in me or not, the hundred and twenty books [drawings?] composed by me will give verdict Yes or No. In these I have been hindered neither by avarice nor negligence, but simply by want of time. Farewell."

"O speculator on this machine of ours," he advises the anatomist, "let it not distress you that you give knowledge of it through another's death, but rejoice that our Creator has placed the intellect on such a superb instrument."

Mechanistic terminology notwithstanding, Leonardo's blueprint seems inspired by a wish to express human life accurately through painting. He will begin with human birth and proceed with discussions of the bones, muscles, and nerves as they function dynamically in a living man. "This work should begin with the conception of man and describe the nature of the womb, and how the child lives in it, and up to what stage it dwells there, and the manner of its quickening and feeding . . . and what drives it forth from the body of the mother. . . ."

In the Windsor MS., which dates from the second Milanese period, Leonardo outlines the dissection "schedule" he plans to follow, including "three of the female body in which there is a great mystery owing to the womb and its foetus." Nevertheless, the chapter devoted to the female genitalia is, as Dr. Jean Mathé sees it, one of Leonardo's least satisfying. "Obviously this subject held little interest for him," Dr. Mathé points out. "He considered the sex act 'repulsive' and likened the uterus and penis to two animals that have given human will the slip. His drawing of the vulva is wretched, slipshod, with no indication of the labia majora or minora. The uterus is round and patently bovine, the supporting ligaments are attached by a bifid insertion, and the ovary is curiously suspended sideways alongside the uterine wall."

To his credit, Leonardo was the first to draw the uterine artery and the vascular system of the cervix and vagina, as well as a single-chambered uterus at a time when the uterus was still thought to comprise several compartments (a way of accounting for twin pregnancies and animal litters). He was also the first to describe a fetus in utero correctly, tethered by an umbilical cord, surrounded by the three fetal membranes, the chorion, amnion, and allantois. This is all the more remarkable in that Leonardo never actually saw it and must have relied on a cow embryo. He showed the importance of the fetal liver with its enlarged left lobe, and noted the fact that "placental circulation functions independently from that of the mother, a revolutionary concept several centuries

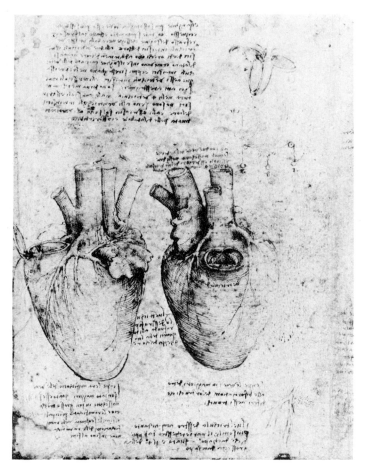

TWO DRAWINGS OF THE HEART
Pen and ink, 41 × 28 cm. Royal Collection, Windsor Castle.

Leonardo's drawings of the skeleton are accurate. Drawn in cross section and perspective, his skulls correctly show the "hitherto unknown" frontal and maxillary sinuses as well as the meninges, the pia mater and the dura mater. "The only thing missing is the arachnoid membrane." However, the cervical spine is drawn without vertebral ligaments, and his drawings of zygapophysis and the vertebral foramens are inaccurate. On the other hand, the bones of the upper and lower extremities are rendered in painstaking detail; the curvature of the spine is flawless. "His minor errors," Dr. Mathé points out, "include incorrect insertions of the trapezius muscle in too large a scapula, and of the oblique muscle in the vertebrae. . . . The sternum, too long, is divided into seven segments, but the ribs are accurately drawn. . . ."

Leonardo paid particular attention to studying and drawing muscles. "Make the rule and give the measurement of each muscle," he writes, "and give the reasons of all their functions, and in which way they work and what makes them work." To quote Dr. Mathé: "Leonardo's minutely detailed, accurate, and comprehensive study of facial muscles was revolutionary for its time. Every muscle is analyzed not only in terms of morphology and insertion, but in

ahead of its time" (Dr. Jean Mathé). In his description of the male genitalia, Leonardo leaves out the epididymus but draws the penis with two meatuses and two passages: a lower canal (urethra) for urine and sperm and a supposed upper canal for "animal spirit." Apparently he knew nothing about the prostate.

After birth come the various stages of human growth. "Then describe which are the members which grew more than the others after the child is born, and give the measurements of a child of one year. Next describe a grown male and female, and their measurements, and the nature of their complexions, color, and physiognomy."

"And again," he advises the artist in the *Trattato della Pittura,* "remember to be very careful in giving your figures limbs that they must appear to agree with the size of the body and likewise to the age. Thus a youth has limbs that are not very muscular, not strongly veined, and the surface is delicate and round, and tender in color. In man the limbs are sinewy and muscular, while in old men the surface is wrinkled, rugged, and knotty, and the sinews are very prominent."

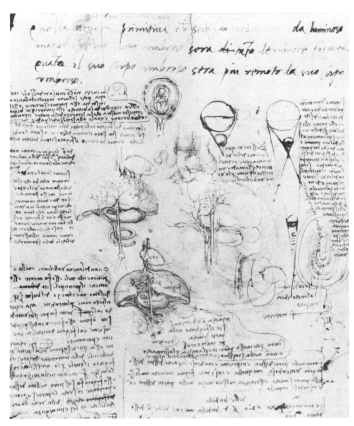

ORGANS OF THE THORAX
Pen and ink. Royal Collection, Windsor Castle.

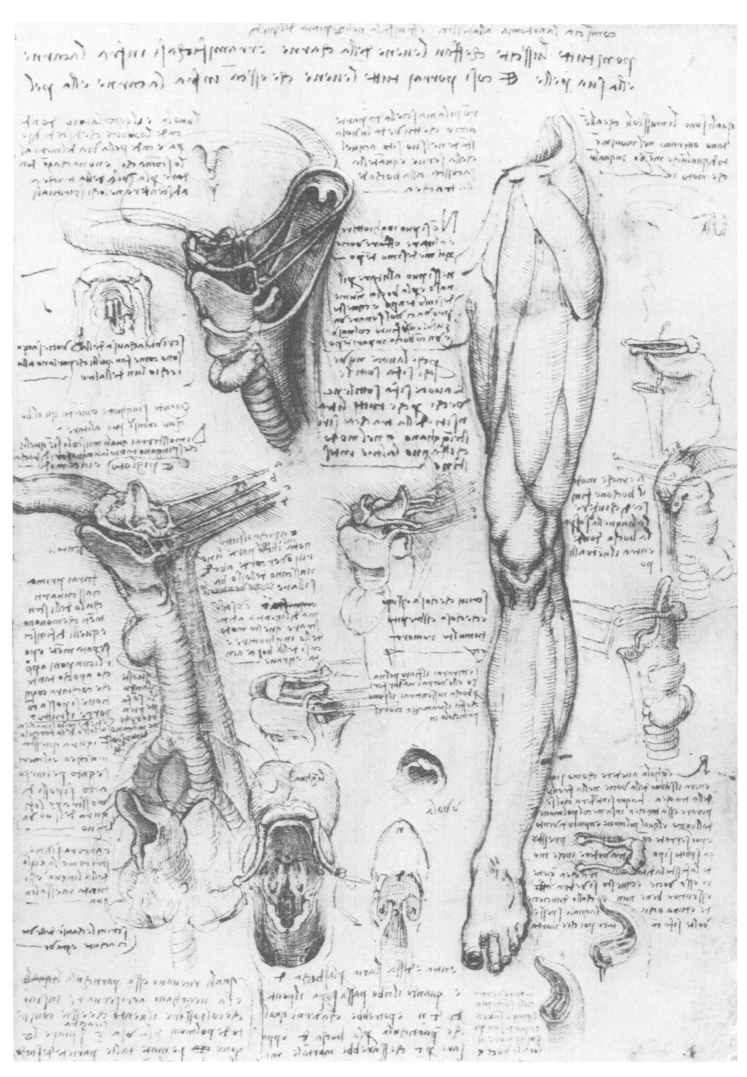

TRACHEA, ESOPHAGUS, AND SOUND-PRODUCING ORGANS; LEG AND ARTERY
Pen and ink. Royal Collection, Windsor Castle.

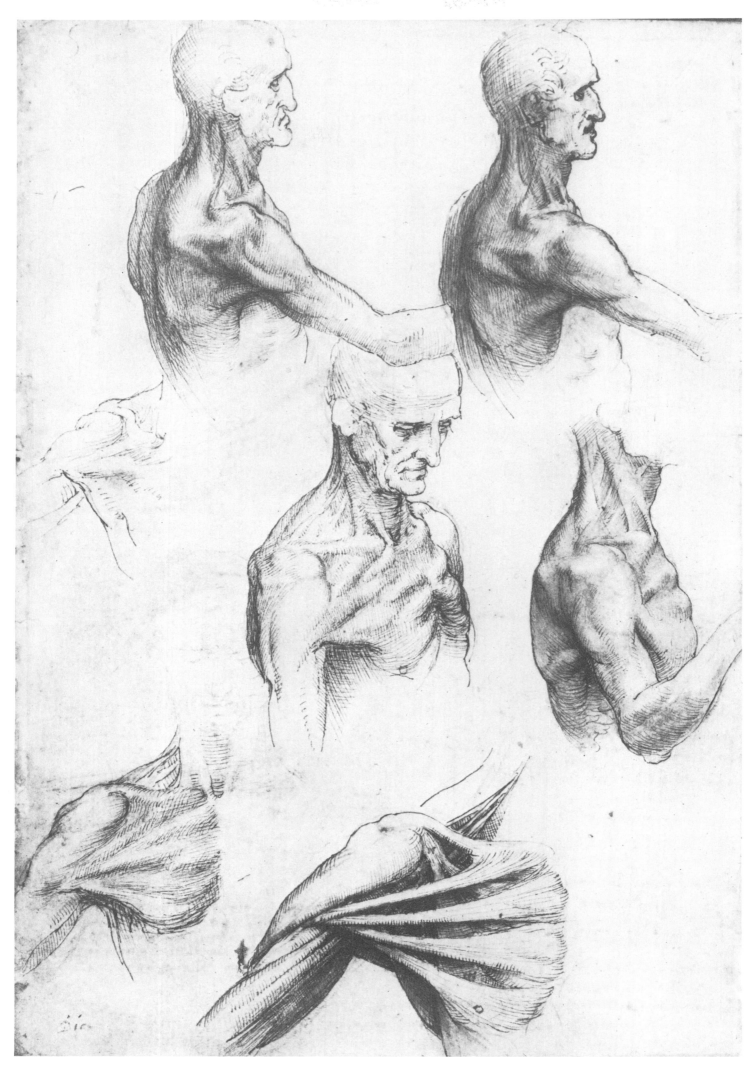

MUSCULATURE OF THE HEAD AND SHOULDERS
Pen and ink, 28.4 × 19.7 cm. (reproduced original size). Royal Collection, Windsor Castle.

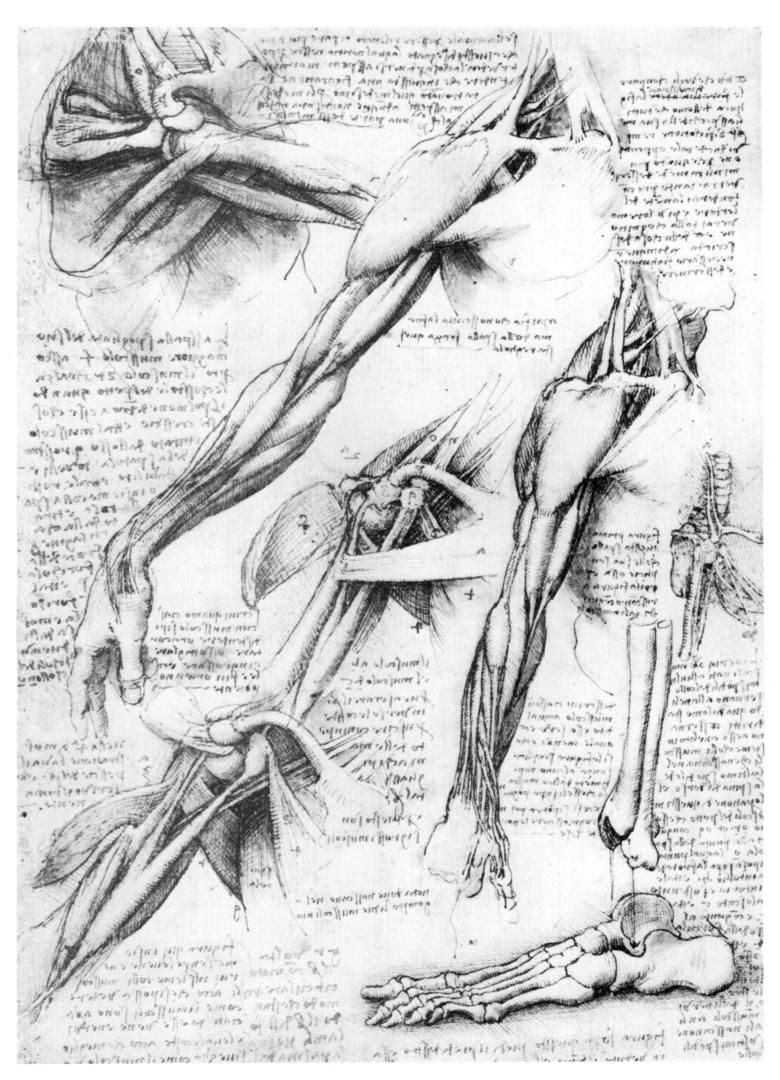

ANATOMICAL STUDIES: SHOULDER, ARM, AND FOOT
Pen and ink, 28.5 × 19.7 cm. (reproduced original size). Royal Collection, Windsor Castle.

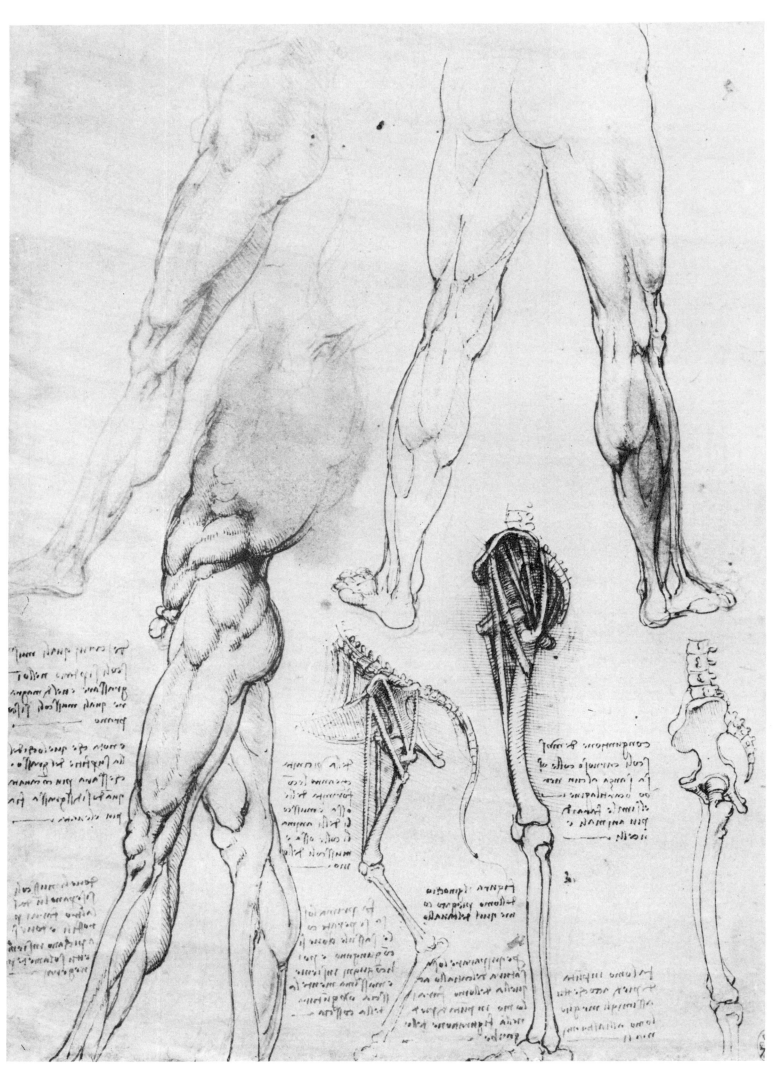

COMPARATIVE ANATOMY OF A HUMAN LEG AND THE LEG OF A DOG
Ink over red chalk, 28.5 × 20.5 cm. (reproduced original size). Royal Collection, Windsor Castle.

terms of function and how feelings are translated into expressions. This physiognomy of sorts was part of an attempt to make facial expression the basis of a science of moods."

Leonardo often depicted the muscles of the neck and cervical walls as ropelike structures in order to show how their insertions and play of "antagonistic muscles" hold the head upright. His descriptions of how muscle courses through the extremities are both anatomically correct (insertions, for example) and artistically flawless (shading). Cross sections detail the interaction of muscles as well as the relationship between muscles and vasculo-nervous pedicles. Dr. Mathé continues: "Especially worth mentioning is the superb draftsmanship in the ropelike tendons of the hand, from which [Leonardo] derived a machine enabling a clarinet player to manipulate stops at a distance. Above all, the impeccable, astounding description of how the sinews of the arm course into the hand and fingers—a description that has stood the test of time ever since. . . . The various positions of the body Leonardo explained in terms of 'antagonistic' groups of muscles. He saw bone as a lever, muscle a rope, and the brain (of which nerves were but an extension) a motor. He was convinced that feelings and emotions determine and condition the positions a body assumes."

"Remember," Leonardo admonishes, "that to be certain of the point of origin of any muscle, you must pull the sinew from which the muscle springs in such a way as to see that muscle move, and where it is attached to the ligaments of the bones.

"You will never get anything but confusion in demonstrating the muscles and their positions, origin, and termination, unless you first make a demonstration of thin muscles after the manner of linen threads; and thus you can represent them, one over another as nature has placed them; and thus, too, you can name them according to the limb they serve."

In the Windsor MS. Leonardo offered a figurative description of bodily movement. "The nerves with their muscles serve the tendons even as soldiers serve their leaders, and the tendons serve the common sense as the leaders their captain, and this common sense serves the soul as the captain serves his lord. So therefore the articulation of the bones obey the nerve, and the nerve the muscle, and the muscle the tendon, and the tendon the common sense, and the common sense is the seat of the soul, and the memory is its monitor, and its faculty of receiving impressions serves as its standard of reference."

Leonardo described the circulatory system in lavish detail, especially the heart of man and the higher mammals. While in Tuscany he observed the rhythmic oscillation of goads that butchers thrust into the thoracic wall and heart of living pigs. Dr. Mathé notes that between the first and last drawings of the heart—there are more than fifty in all—Leonardo came remarkably close to the truth. His earliest hearts consist of two ventricles; in his last we see four chambers in minute detail. "He was the first to recognize that the contraction of cardiac muscle is the result of an automatic neurological mechanism; he called the left pneumogastric nerve 'the heart nerve.' He was the first to take a close look at the tricuspid and mitral valves, never tiring of drawing them over and over to more clearly define their machinelike precision. Moreover, he discovered, studied, and flawlessly drew the ligaments, folds, and other anatomical features of the cavities of the heart, explaining how so-called vital spirit is created by the friction of blood against parietal corrugations."

Harvey's demonstration that blood circulates was without question a watershed in physiology. Because of this, people sometimes mistakenly believe that, before Harvey, blood was thought to be motionless. Galen, for instance, distinguished between red blood, which moved from the heart to the lungs, and black blood, which moved from the liver and spread throughout the body. We find in Leonardo's notes such phrases as *l'impeto del sanguine* or *la revolutione del sanguine nel antiporta del cuore.* Elsewhere we read, "The auricles of the heart are outer doors which receive blood escaping from the ventricle during a full contraction, for if such blood did not escape in part, the heart could not contract." Or: "The blood of animals . . . is always moving from the sea of the heart and flows to the top of their heads." Or: "The blood that returns when the heart reopens is not that which closes the doors of the heart." But in making these statements, Leonardo did not prefigure Harvey; he simply repeated Galen. True, Leonardo pointed out that blood vessels expand and contract; he also described pathological impairment. But he did not grasp the connection between the driving action of the heart and the circulation of blood because he reasoned by analogy. For him, the circulation of waters in the "body" of the earth, the flow of sap in plants, and the movement of blood in animals were comparable processes.

Leonardo drew the lungs, studied changes in their diameter during respiration, and isolated the bronchial vessels that feed the pulmonary vessels. However, his work on the respiratory system reveals an especially keen interest in the vocal apparatus. The lungs, he believed, act as a "bellows," and

variations of tone are produced by changes in the length and width of tracheal rings and perhaps also by the constrictors of the larynx. As for the breathing mechanism proper, "The substance of the lung is dilatable and extensible. It lies between the ramifications of the trachea [i.e., bronchi] in order that those ramifications may not be displaced from their position, and this substance is interposed between these ramifications and the ribs of the chest to act as a soft covering."

We have seen that Leonardo bowed to tradition when he subscribed to the theory of "vital spirit." Nevertheless, we should also note that some of his observations hint at an intuitive understanding of the analogy between respiration and combustion. "The element of fire," he writes, "continually consumes the air which in part feeds it, and it would remain in a void if new air did not rush in to fill it." Elsewhere we read, "Wherever air is not suited to receive fire, no fire can live, nor any animal of the earth or sky. . . . Where no fire lives, no breathing thing lives."

Leonardo sums up the digestive tract in a vivid desciption. "Man and animals are really the passage and the conduit of food, the sepulcher of animals and resting place of the dead, one causing the death of the other, making themselves the covering for the corruption of other dead [bodies]." His drawings of the stomach and the intestines—"provided we do not quibble over minor problems concerning position of loops or length" (Dr. Mathé)—are accurate, but Leonardo "failed to understand how digestion works chemically through endocrine and exocrine secretion, nor did he even grasp the parietal musculature responsible for peristalsis. As he saw it, the intestine was emptied by mechanical surfeit of food and by weight, abetted by muscular contraction of the lining and the diaphragm."

Historians agree that Leonardo studied about thirty corpses. Anatomists at the time were known to have worked under trying conditions. When we stop to think that Leonardo's painstaking and passionate interest began in Milan in 1489 at the latest and lasted until his stint in Rome (1515), thirty human bodies of both sexes and all ages—an average of two a year—seem a modest source indeed when measured against the admirable results they yielded. (A footnote: In 1515 Pope Leo X suddenly denied Leonardo access to the morgue of the Hospital of the Holy Spirit.)

However, we should also take into account the fact that ever since Herophilus and, of course, Galen, anatomists usually studied animal anatomy, then reasoned by analogy. A painter who was al-

ready intrigued by the forms and positions of animals, especially of the horse—witness the *Battle of Anghiari* and the equestrian monument of Francesco Sforza—Leonardo must have relied heavily on animal dissection. We know from numerous accounts that drawings and explanatory notes concerning these dissections once existed, but only a few survive. In his *Treatise on Painting* (1584), Lomazzo studied the horse, "whose limbs are supremely handsome, delicate, and agile," and attempts to describe "their true and correct proportion, copying Leonardo da Vinci, a unique and matchless sculptor and painter of horses, as can be seen in his anatomy." In his account of the Sforza monument, Vasari mentions the loss of "a little wax model which was held to be perfect, together with a reference book which Leonardo composed on the anatomy of horses."

Aside from some drawings that have survived, several notes attest to Leonardo's interest in comparative anatomy. "Here I make a note to demonstrate the difference there is between man and the horse and in the same way with other animals. And first I will begin with the bones, and then will go on to all the muscles which spring from the bones without tendons and end in them in the same way, and then go on to those which start with a single tendon at one end."

Physiology and anatomy always go hand in hand in Leonardo's work, and he was especially intrigued by the question of life. He was astonished, and rightly so, that "the frog retains life when deprived of its head, heart, and all its intestines. And if you suddenly prick the said nerve [spinal medulla] it suddenly twitches and dies. . . . The frog immediately dies when its spinal medulla is perforated. And previously it lived without head, without heart or any entrails or intestines, or skin. It thus seems that here [cerebro-spinal axis] lies the foundation of motion and life." Leonardo used such expressions as "instrumental usefulness of the limbs" and such words as "serve," "assist," "use," "value," and "benefit" to underscore the inextricable link between anatomy and physiology.

If Leonardo was so meticulous an observer of comparative and human anatomy, it was always to hone his skill as a painter. "Every being is composed of veins, tendons, muscles, and bones," he writes in his outline of the *Treatise on Anatomy*. "This you should do at the end of the book. Then represent in four histories four universal conditions of mankind, namely, joy, with various modes of laughing, and represent the cause of laughter; weeping, the various ways with their cause; strife with various move-

ments expressive of slaughterings, flights, fear, acts of ferocity, daring, homicide, and all the things which connect with cases such as these. Then make a figure to represent labor, in the act of dragging, pushing, carrying, restraining, supporting and conditions such as these." Elsewhere he notes that "a figure is not worthy of praise if it does not express the passion of its soul" and, conversely, "that figure is most admirable which by its actions best expresses the passion that animates it."

Leonardo observed with an anatomist's eye, but he also showed muscles in action and respected the proportions of the body as a whole and of each of its parts. His drawings of organs are accurate, his interpretation of them prophetic. In 1538 the anatomist Vesalius had one of Titian's pupils, Jan von Calcar, draw the human skeleton. Five years later, these *Tabulae anatomicae sex* were followed by *De humani corporis fabrica,* surely the most celebrated of all treatises on anatomy. Calcar's three skeletons actually do something: one leans on a spade, another bends over a tomb, another joins his hands at the forehead as though overcome or burdened. The illustrations for the second book were attributed to another of Titian's pupils, Domenico Campagnola. They, too, are "action" drawings that show a strange people moving amid delightful landscapes. Leonardo's anatomical drawings are free of this affectation; they are working scientific diagrams that were intended for no one's eyes but his. Vesalius went on to teach anatomy. Fifty years earlier, Leonardo carried out research that could be called self-centered since he never finished his *Treatise on Anatomy.* But he was neither a surgeon nor a physician; he was a painter. Although his erudition left much to be desired, have we not seen that on several occasions it was respect for the authors of antiquity—in other words, erudition—that led him to make mistakes?

XII INVENTOR

As THE twentieth century draws to a close, Leonardo da Vinci remains all the more baffling in that many experts, each in his field of expertise, have taken the "legend" of Leonardo to task. Unless verification of some kind can be provided, they refuse to acknowledge the assertions previously made about this "universal man": inspired painter, sculptor, architect, city planner, anatomist, physiologist, botanist, geologist, astronomer, and mathematician, not to mention engineer capable of outstripping all of his contemporaries in such diverse technical areas as weaponry, fortification, hydraulics, and applied mechanics.

Was Leonardo in fact this unrivaled prophet whose manuscripts reveal a man ahead of his time in every branch of science then known? Was he a clairvoyant who, centuries ahead of his time, formed an accurate picture of what the twentieth-century city would look like and anticipated such things as textile manufacturing, the harnessing of waterways and steam, and modern warfare complete with machine guns, assault tanks, submarines, and flying machines? The publication of some of Leonardo's notes seemed to lend weight to these hypotheses, and models built according to his specifications bolstered the conviction of those who saw in Leonardo not just a precursor, but the most inspired precursor of all time. How could one help feeling awestruck as one examined his plans for a shooting machine, a steam cannon, a spring-driven carriage, a paddleboat, multiple-gear drive, a helicopter, and a parachute? To think that all of these things, so familiar to us, were unknown back then and that he had had the genius to devise them!

Because he was both a famous painter and an engineer, Leonardo da Vinci was the subject of many books, usually by art historians, occasionally by philosophers, rarely by historians of science, and more often than not by people specializing in scientific research of the late Middle Ages. Admiration for Leonardo the artist, coupled with a dearth of information about the predecessors and contemporaries of Leonardo the engineer, cleared the way for unconditional glorification.

It was only logical and natural that Joséphin Péladan—or "Sâr," as he styled himself—should be keenly interested in this superman who "devoted himself to omniscience, unbeknownst to his era," to this "unbounded intellect." In his introduction to *Textes choisis* (1907), Péladan quotes an exceptionally congenial letter from the duchess of Mantua to Leonardo, dated May 24, 1504. "However courteous this charming woman—the model of a high-minded, well-read lady—may have been, she would not have written to any other artist in so deferential and coaxing a tone, no more than Francis I would have addressed a Titian or an Andrea del Sarto as *mon père.*" But should we not at least mention the fact that Leonardo was the king's senior by forty-two years, whereas Andrea del Sarto was only eight years older than Francis I, Titian only four?

The astounding variety of Leonardo's notes, his interest in a wide range of scientific and technical problems, the exceptional quality of the sketches he drew to elucidate and solve those problems—all this, coupled with continuing ignorance about what scientists and engineers accomplished before and during his lifetime, turned Leonardo into the most astonishing precursor and most prolific inventor of all time. Pierre Duhem's three-volume inquiry (1906–1909 and 1913) into "those [Leonardo] read and those who read him," while giving Leonardo's genius its due, showed that new ideas did not spring spontaneously and gratuitously from his mind, but rather took shape in a milieu already rich in other ideas "implanted by the lessons of teachers Leonardo had heard and especially by writings he had pondered." In *Les Ingénieurs de la Renaissance* (1964), Bertrand Gille approaches Leonardo's engineering research from a similar perspective and draws much the same conclusions: Leonardo read a great deal; he took copious notes; it would be a mistake to "treat the notebooks as though they were a definitive book." The notebooks, Gille argues, reveal nothing but the successive phases of his thinking at those moments when his imagination merged with whatever he had gleaned from other authors.

As he tried to determine the direction of Leonardo's research, Gille detected a susceptibility to certain forms and a penchant for designing machines: "His inquiries into eddies and waterfalls are striking, and no less striking are a few sketches which, at first glance, seem to be purely technical in nature." In certain areas, Leonardo tried to work out concrete demonstrations of theories he wished to adopt, and in so doing linked theory and practice. "His work with pure technology—what we today would call applied science—was perhaps Leonardo da Vinci's most significant contribution."

Leonardo used models for his hydraulics projects and even studied and drew workers as they labored at construction sites. But was he an inventor? Maybe so, says Bertrand Gille, "but there is quite a distance between creative imagination and practical, concrete application, and that is our criterion for gauging how little Leonardo was a man of action. His inventions, if you can call them that, are potential, as is the case in the work of some of his predecessors.

Following page. STUDIES OF LABORERS DIGGING
Manuscript B. Institut de France, Paris.

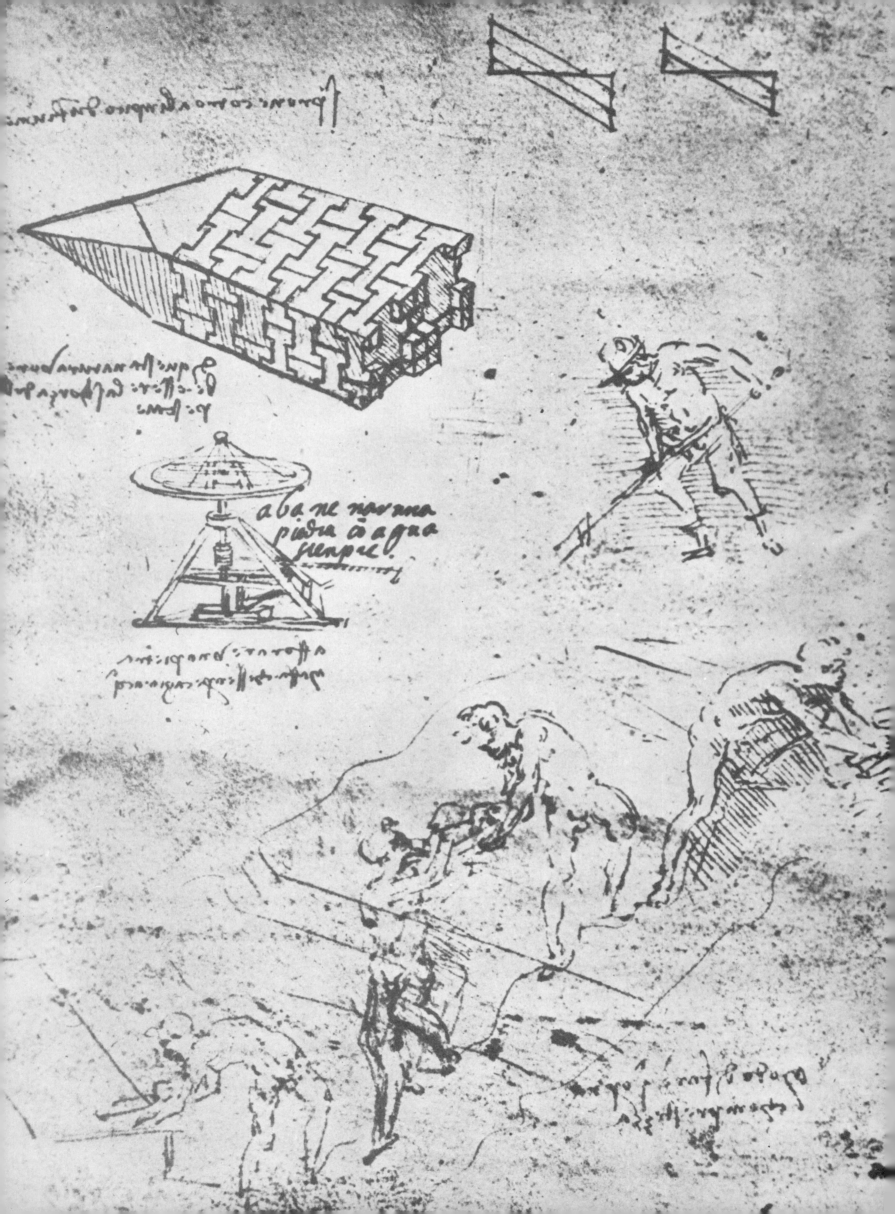

This is apparent in his draftsmanship, which yielded something more akin to sketches than blueprints." The thing that most intrigues Gille seems to be Leonardo's aspirations for technical progress and a more complete mastery over nature, the feeling—"albeit not peculiar to Leonardo"—that an age of mechanization was in the making.

The research done by Europeans later referred to as scholars, humanists, and scientists from the last quarter of the fifteenth century to about 1520 was not so much a creed as an extraordinary receptiveness to new knowledge and a willingness to put it to the test. These open-minded, exhilarated souls moved along a number of different paths. In the field of applied engineering, Leonardo was apparently spurred by concerns shared by other engineers of his day.

When confronted with specific problems, Leonardo the engineer fell back on standard approaches that could be put to immediate use and let experience be his guide. Then and only then did reasoning come into play. Granted, a great many hastily written notes survive, pointing to Leonardo's presumed

intention to compile a coherent book later on. However, all he could have been planning was an engineering abstract, not a scientific treatise. Oddly enough, he seemed to be in no hurry whatever to begin writing the book itself, and he was no more captivated by the unprecedented potential of printing than were most of his contemporaries.

Consider the case of another scientist—Copernicus, twenty-one years Leonardo's junior. He formulated a new theory of the universe, kept up a voluminous correspondence with many mathematicians and astronomers, and—apparently confident his ideas would not incur the wrath of the Church—even let certain disciples herald his system. Is it not astounding that he should wait until 1543, only a few months before his death, to publish in Nuremberg *De revolutionibus orbium caelestium*? "I wondered whether it might not be better to follow the example of the Pythagoreans," he wrote, "who were wont to transmit the mysteries of their philosophy to no one but friends and close relatives, orally, not in writing . . . so that that beautiful things which eminent men so

ROLLING MILL
Codex Atlanticus.

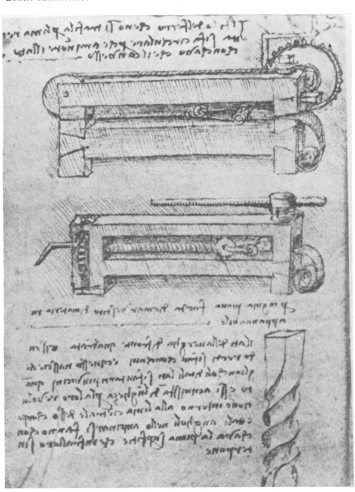

ROLLING MILL
Codex Atlanticus.

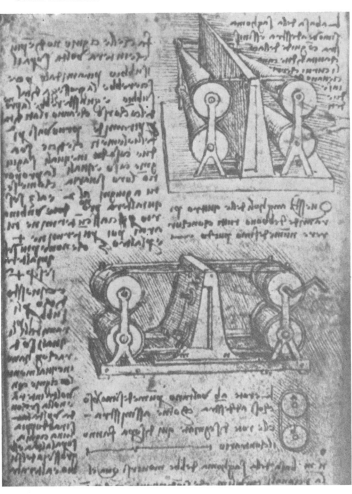

diligently study should not be scorned by imbeciles and ignoramuses."

Leonardo da Vinci had no intention of working for imbeciles and ignoramuses, either. His intelligence and self-reliance set him apart from other men. Skeptical and unperturbed, he remained aloof and, as Romain Rolland once pointed out, "was so cut off from homeland, religion, the whole world, that he found himself in the company of tyrants, who shared his self-reliance. Leonardo had been trained as an artist—a comprehensive, in-depth program of study engineers-to-be usually pursued—and perhaps this is why he seemed so intent on showing what he could accomplish as an engineer per se. In his letter of self-recommendation to Ludovico Sforza, his talents as sculptor and painter are added at the end as though an afterthought. He is, he writes, an engineer anxious to ply his trade. Perhaps we should look upon some of his "ahead-of-their-time" schemes as *exercices de style,* a way of making good on the claims trumpeted in his letter, of pleasing and surprising his employer. Probably there is not as wide a gap as we think between, on the one hand, his weaponry, fortifications, hydraulic equipment, and mechanical tools and, on the other, ideas aimed solely at entertaining a select audience (hydraulic and pneumatic robots, mechanical birds, musical contraptions, etc.).

For many reasons Leonardo was unable to ply his trade on a grand scale in warfare, civil engineering, city planning, or shipbuilding. Consequently, he channeled his powers of imagination into entertainments, the drawings for which, unfortunately, do not survive. The rolling mills, dredges, looms, and countless other machines he designed were, as far as admirers like Péladan are concerned, a waste of time, a squandering of "genius of the highest order." "There are always people to see to such drudgery in every era," he argues, "but no hand ever drew like the one that grew cold and stiff in the manor house of Cloux, near Amboise, on May 2, 1519. Even for a genius there are only twenty-four hours in a day, and the forces of diligence, however impassioned, have their limits."

These so-called minor projects may have served a purpose in that they prompted Leonardo to fill in gaps in his knowledge of theory, helping him to achieve a certain perfection he deemed indispensable. To be sure, he did not shape a comprehensive scientific corpus; efficiency remained his key objective; and he was continually on the lookout for ways to increase man's control over the material world. Just the same, who else but someone captivated by science could have written that "mechanics is the paradise of the mathematical sciences"?

188

DREDGER ON PONTOONS
Manuscript E. Institut de France, Paris.

LIFE PRESERVER
Codex Atlanticus.

DIVING EQUIPMENT WITH BREATHING APPARATUS
Codex Atlanticus.

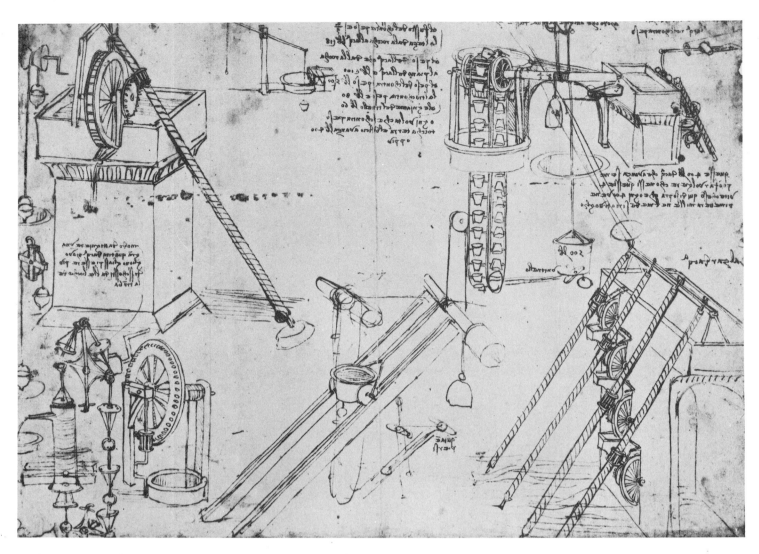

CHAIN-DRIVEN PUMP AND SCREWS FOR RAISING WATER
Codex Atlanticus.

STUDIES OF PULLEYS
Codex Atlanticus.

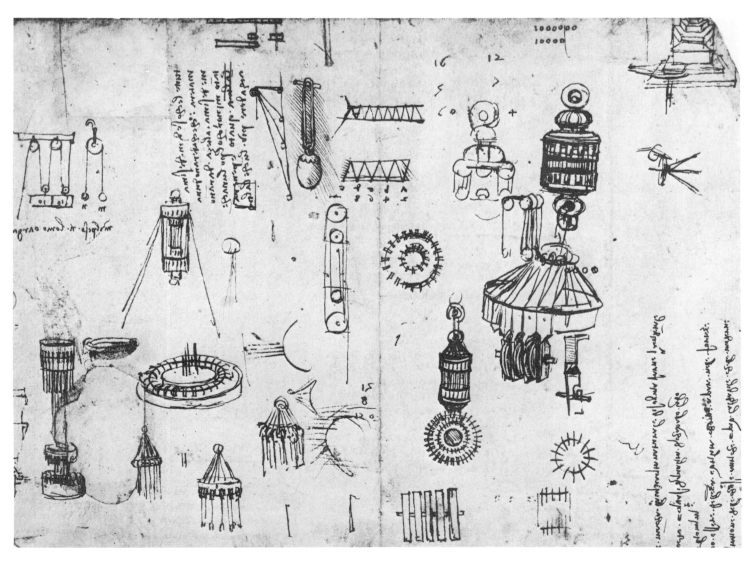

Intending to write a treatise on the subject, Leonardo took copious notes on water, especially in 1505 and 1506. Lord Leicester culled pertinent notes from Leonardo's engineering observations in the *Codex* that bears his name and ended up with no fewer than 903 concrete instances of feasible water management schemes. Surely they would have enabled him to compile a comprehensive treatise on practical hydraulics, but his provisional chapter headings imply that discussions would have been limited to specific problems, not theory or systematic analysis.

Be that as it may, he reasoned more than his predecessors or contemporaries did, especially more than Francesco di Giorgio, an engineer from whom Leonardo borrowed quite heavily. Bertrand Gille quotes a passage that shows how Leonardo could summon his knowledge of theory to buttress his arguments. The problem: What steps should be taken to save his house, located on a riverbank that threatened to cave in? "I have a house upon the bank of the river, and the water is carrying off the soil beneath it and is about to make it fall in ruin; consequently I wish to act in such a way that the river may fill up again the cavity it has already made, and strengthen the said house for me.

"In a case such as this we are governed by the fourth of the second, which proves that 'the impetus of every movable thing pursues its course by the line along which it was created'; for which reason we shall make a barrier at the slant *n m,* but it would be better to take it higher up at *o p,* so that all the material from your side of the hump might be deposited in the hollow where your house is; and the material from the hump *k* would then do the same, so that it would serve the need in winter.

"But if the river were great and powerful the said barrier would have to be made in three or four attempts, the first of which, made in the direction that the water is approaching, ought to project beyond its bank a fourth part of the width of the river; then, below this, you should make another, distant as far as the summit of the leap that the water makes when it falls from the first barrier,—for in this summit of its leap the water leaves the summit of the mound made by the shingle which was hollowed out by the first percussion, made by the water when it fell from the first barrier upon its bed. And this second dam extends halfway across the breadth of the river. The third should follow below this, starting from the same bank, and at the same fixed distance from the second as the second was from the first; and it follows in length as far as three-quarters of the width of the river. And so you will proceed with the fourth dam which will close the whole river across.

"And from these four dams or barriers there will result much greater power than if all this material had been formed into one barrier, which in uniform thickness would have closed the whole width of the stream. And this happens by the fifth of the second, where it is proved that the material of one single support, if it be quadrupled in length, will not support the fourth of that which it used formerly to support, but much less."

Leonardo again used his powers of reasoning when he challenged solutions put forward by those who came before him. Witness his discussion of the problem of calculating the speed of a ship. "To know how far a ship travels in an hour. The ancients have employed different methods in order to discover what distance a ship traverses in each hour. Among them is Vitruvius, who expounds one in his work on architecture, but his method is fallacious like the others. It consists of a wheel from a mill touching the ocean waves at its extremities, and by means of its complete revolutions describing a straight line which represents the line of the circumference of this wheel reduced to a condition of straightness. But this device is only of value on the smooth, still surface of lakes; should the water move at the same time as the ship with an equal movement the wheel remains motionless; and if the movement of the water be either more or less swift than that of the ship, then the wheel will not have a movement equal to that of the ship, so that such an invention has but little value.

"Another method may be tested by experiment over a known distance from one island to another, and this is by the use of a light board which is struck by the wind, and which comes to slant to a greater or less degree as the wind that strikes it is swifter or less swift, and this is in Battista Alberti.

"As regards the method of Battista Alberti, which is founded upon an experiment over a known distance from one island to another, such an invention will work successfully only with a ship similar to that with which the experiment has been tried, and it is necessary that it should be carried out with the same freight and the same extent of sail, and with the sail in the same position, and the waves of the same size. But my method serves with every kind of ship, whether it be with oars or sail; and whether it be small or large, narrow or long, high or low, it always serves."

Unfortunately, Leonardo gives no details about his method. All we find is the following sentence in

Facing page. FLYING MACHINE WITH UNDERCARRIAGE AND LANDING GEAR
Manuscript D. Institut de France, Paris.

in his recipe for stinkbombs. "If you would create a stench, take human excrement and urine, or else some cabbage . . . place them in a tightly sealed jar and store it under a dunghill for a month. Then break it wherever a stench is desired. You may use eels and urine, or shrimps, following the same procedure with a jar buried in a dunghill. Break where desired."

Did Leonardo really believe himself to be the foremost military engineer of his day? The answer would appear to be yes, judging by his letter to Ludovico Sforza. Until recently, Leonardo specialists were convinced of his preeminence in this field. However, a better understanding of fifteenth-century military equipment and of planned or actual improvements being made at the time seems to cast serious doubts on Leonardo's ingenuity, at least as far as weaponry is concerned. We do know, however, that, notwithstanding his impressive agenda and self-assurance, Leonardo did not secure from Ludovico

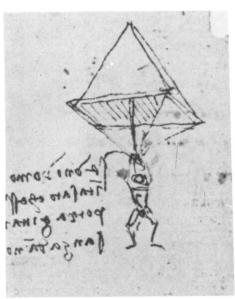

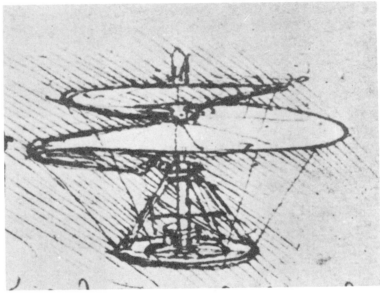

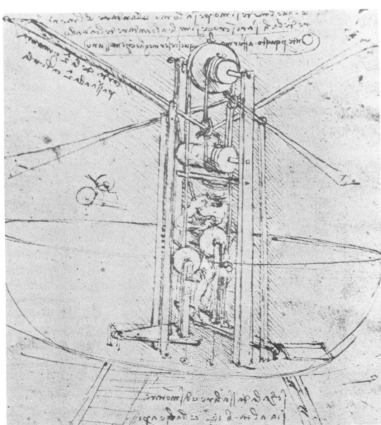

Above left. PARACHUTE
"If a man have a tent made of linen of which the apertures have all been stopped up, and it be twelve braccia across and twelve in depth, he will be able to throw himself down from any great height without sustaining any injury." *Codex Atlanticus.*

Above right. DESIGN FOR A HELICAL AIRSCREW OR HELICOPTER
Manuscript B. Institut de France, Paris.

FOUR-WINGED FLYING MACHINE DRIVEN BY A MAN STANDING INSIDE
Manuscript B. Institut de France, Paris.

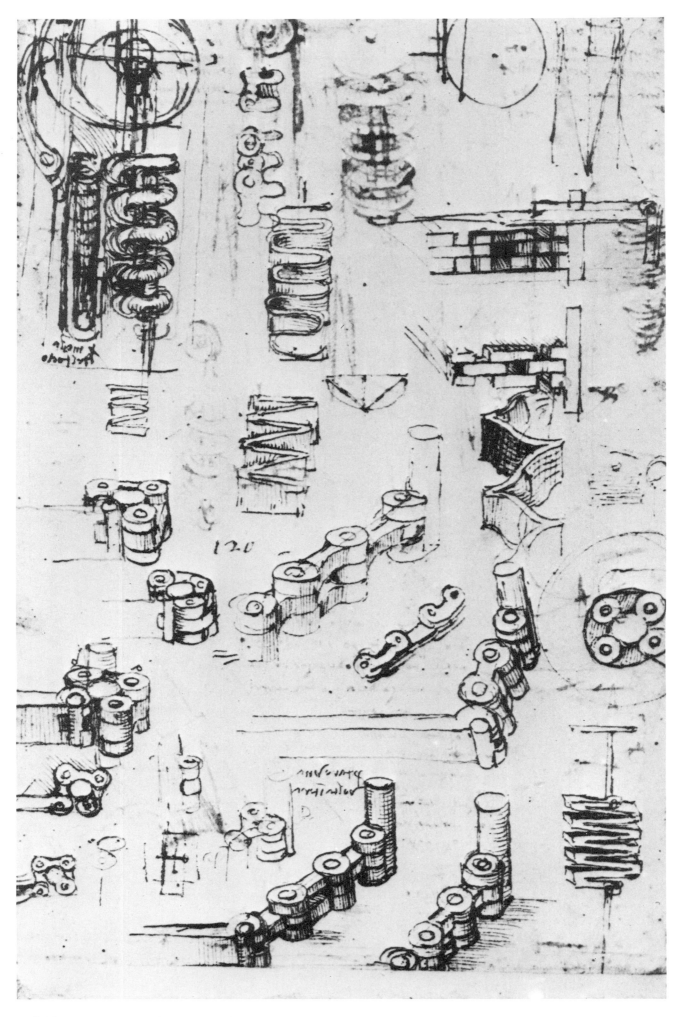

CHAIN LINKS AND CYLINDRICAL SPRINGS
Codex Atlanticus.

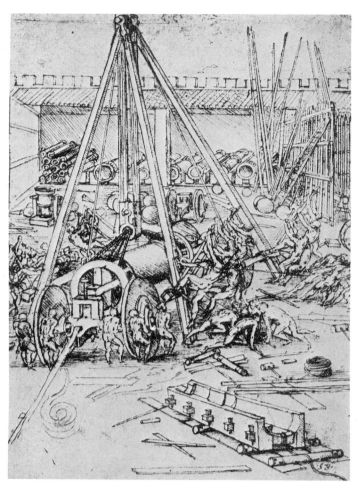

CANON FOUNDRY
Royal Collection, Windsor Castle.

the coveted title of military engineer and instead had to channel much of his energy into staging entertainments for the Milanese court. Not until the beginning of the sixteenth century was he appointed Cesare Borgia's *ingegnere generale,* and although named inspector of Borgia's castles and fortresses, he served in this capacity for only a year.

Lomazzo tells us that Leonardo did drawings for Gentile dei Borri, Ludovico's armorer, showing "how soldiers on horseback and on foot might defend themselves." He probably also submitted designs for intricately decorated halberds and other ceremonial weapons for the Duke's guard. If we credit the account of early authors, he drew weapons used by various nations throughout the ages, going back to very ancient times, and sought ways of improving bows, slings, colossal crossbows, scythe-wielding tanks, and other weapons still popular at the time. He studied cannon making and drew multiple-barrel, stationary, and rotary models (like Kyeser before him), various kinds of sights (adjustable, dial, screw), and designed assault tanks (as did Kyeser, Taccola, and Guy de Vigevano). However, as

Sir Kenneth Clark points out, "Leonardo's knowledge of military engineering was not in advance of his time."

Leonardo's *architonitro*—a weapon he traced back to Archimedes—used steam to propel shot. A copper cannon is placed a third of the way down into live coals. When the metal is white hot, a valve is opened, releasing water from a storage tank above. On hitting the superheated part of the cannon, the water turns into a copious "smoke" (that is, steam), which hurls the projectile forward with tremendous power and noise. Leonardo reckoned the machine capable of shooting a projectile weighing a talent about half a mile. For sea battles he devised poison shells filled with choking fumes and ballistas designed to hurl blazing arrows.

Several pages of Leonardo's notebooks are devoted to cannon founding, but they read more like standard formulas than sections of an original treatise. His information remained fragmentary. Compared with the notebooks of the bronzesmith Lorenzo Ghiberti (1378–1455), "there was probably little in the way of appreciable innovation here, either" (Bertrand Gille).

Leonardo's notebooks are filled with plans for military architecture. Unfortunately, one is hard put to point to even a single structure that can be positively attributed to him. Ignazio Calvi, author of *L'ingegneria militare di Leonardo* (1953), believed that one day the necessary evidence would turn up, perhaps in the form of documents from archives in Milan. Whatever on-site supervision Leonardo provided must have been aimed primarily at repairing existing fortifications.

The wealth of this engineer's imagination is obvious in his countless drawings of machines, and often details prove more innovative and intriguing than do his general schemes. It would be impossible to enumerate them all here. One of his earliest was a device for cutting out files. A weight-driven die hammer advances each piece a fixed distance so that with every stroke of the punching mechanism the next length of metal is automatically fed to a point just beneath the die.

His machine for the die-stamping of gold featured six work "stations" driven by a watermill or a draft animal. Other inventions include a pedal-driven grain mill; a boring machine that alternated between upward and rotary movement; a rolling mill for producing thin sheets of tin; a wire drawing device for making copper strips; a drill to bore tree trunks and turn them into waterpipes; a shearing machine for wool cloth; and a number of different hoisting devices.

LIST OF REPRODUCTIONS

MANUSCRIPTS

Ms A	43 sheets	21.2 × 14.6 cm.
Ms B	84 sheets	23.5 × 17.6 cm.
Ms C	30 sheets	22 × 21 cm.
Ms D	10 sheets	16 × 22.2 cm.
Ms E	80 sheets	15 × 10 cm.
Ms F	96 sheets	14.5 × 10 cm.
Ms G	93 sheets	14 × 9.5 cm.
Ms H	142 sheets	10.4 × 7.4 cm.
Ms I	140 sheets	10.2 × 7.4 cm.
Ms K	128 sheets	9.8 × 6.5 cm.
Ms L	90 sheets	10.1 × 7.5 cm.
Ms M	94 sheets	9.8 × 7 cm.

(Institut de France, Paris)

Ashburnham Ms. 34 sheets 24 × 21 cm.
(Bibliothèque Nationale, Paris)

Codex Arundel 283 sheets 22 × 15 cm.
(British Museum, London)

Codex Atlanticus 403 sheets 60 × 45 cm.
(Biblioteca Ambrosiana, Milan)

Codex Forster 1000 sheets (approx.)
(Victoria and Albert Museum, London)

Anatomy notebooks
(Royal Collection, Windsor Castle)

Codex Leicester 36 sheets 29.5 × 21.8 cm.
Madrid Codex
(Biblioteca Nacional, Madrid)

Codex on the Flight of Birds 18 sheets
(Biblioteca Reale, Turin)

Codex Trivulzio 51 sheets 19.8 × 13.7 cm.
(Castello Sforzesco, Milan)

CONCISE BIBLIOGRAPHY

Arata, G. U. *Leonardo architetto e urbanista*. Milan, 1953.

Atti del Convegno di studi vinciani, Firenze, Pisa e Siena, gennaio 1953. Florence, 1953.

Bayer, Raymond. *Une Esthétique de la Grâce, Léonard de Vinci*. Paris, 1953.

Bec, Christian. *Le Siècle des Médicis*. Paris, 1977.

Belt, E. and Steinitz, K. T. *The Manuscripts of Leonardo da Vinci: Their History, with a Description of the Manuscript Editions in Facsimile*. Los Angeles, 1948.

Beltrami, Luca. *Documenti memorie riguardante la vita e le opere di Leonardo da Vinci*. Milan, 1919.

Bérence, Fred. *Léonard de Vinci, ouvrier de l'intelligence*. Paris, 1938.

Berenson, Bernhard. "Leonardo da Vinci, an Attempt at a Revaluation," *The Study and Criticism of Italian Art*. London, 1916.

————*The Drawings of the Florentine Painters, Classified, Criticized and Studied as Documents in the History and Appreciation of Tuscan Art*. New York, 1903.

Blunt, Anthony. *La Théorie des arts en Italie de 1450 à 1600*. Paris, 1962.

Bodmer, Heinrich. *Leonardo: des Meisters Gemälde und Zeichnungen*. Stuttgart and Berlin, 1945

Bonaparte, Marie, (trans.) *Un Souvenir d'enfance de Léonard de Vinci, par Sigmund Freud*. Paris, 1927.

Brion, Marcel. *Leonard de Vinci*. Paris, 1952.

Bulletin de l'association Léonardo de Vinci. Amboise, since 1960.

Burckhardt, J. *The Civilization of the Renaissance in Italy (1860)*. Oxford and London, 1945.

Calvi, I. *L'ingegneria militare di Leonardo*. Milan, 1953.

Cassirer, E. *Individuum und Kosmos in der Philosophie der Renaissance*. Leipzig and Berlin, 1927.

Chastel, André. *Léonard de Vinci: Traité de la peinture, traduit et reconstruit pour la première fois à partir de tous les manuscrits*. Paris, 1960.

————. *Art et Humanisme à Florence au temps de Laurent le Magnifique*. Paris, 1959 and 1961.

————. *Léonard de Vinci par lui-même. Textes choisis, traduits et présentés par . . . précédés de la vie de Léonard par Vasari*. Paris, 1952.

Clark, Kenneth. *Leonardo da Vinci: An Account of his Development as an Artist*. Baltimore, 1967.

————. *A Catalogue of the Drawings of Leonardo da Vinci in the Collection of His Majesty the King at Windsor Castle*. Cambridge, 1935.

Coleman, Marguerite. *Amboise et Léonard de Vinci*. Tours, 1932.

Corbeau, André. *Les Manuscrits de Léonard de Vinci*. Amboise, 1968.

Cox-Rearick. Janet. . . . *Musée du Louvre, La Collection de François I^{er}, catalogue* . . . Paris, 1972.

Delumeau, J. *La Civilisation de la Renaissance*. Paris, 1967.

Duhem, Pierre. *Etudes sur Léonard de Vinci . . . ceux qu'ils a lus et ceux qui l'ont lu*. Paris, 1906–1909.

————. *Etudes sur Léonard de Vinci, Third Series: Les Précurseurs parisiens de Galilée*. Paris, 1913.

————. Chapter VIII: "La Statique au Moyen Age et Léonard de Vinci, in Revue des Questions scientifiques," *Les Origines de la Statique*, Third Series. 1904.

Eissler, Kurt R. *Leonardo da Vinci: Psychoanalytic Notes on the Engima*. International Universities Press, 1961.

Ferrero, Leo. *Léonard de Vinci ou l'oeuvre d'art, précédé d'une étude: Léonard et les philosophes de Paul Valéry*. Paris, 1929.

Freud, Sigmund. *Eine Kindheitserinnerung des Leonardo da Vinci*. Vienna, 1910.

Friedenthal, Richard. *Léonard de Vinci, texte français de Anne Gaston*. Paris, 1965.

Gautier, Théophile. *Les Dieux et les demi-dieux de la peinture, par Théophile Gautier, Arsène Houssaye et Paul de Saint-Victor* . . . Paris, 1864.

Gille, Bertrand. *Les Ingénieurs de la Renaissance*. Paris, 1964.

Gilles, René. *Le Symbolisme dans l'art religieux. Architecture—Couleurs—Costumes—Peinture—Naissance de l'Allégorie*. Paris, 1942.

Gourmont, Remy de. *Promenades philosophiques, II^e série: La science de Léonard de Vinci*. Paris, 1925.

Goldscheider, Ludwig. *Leonardo da Vinci: Landscapes and Plants*. Phaidon, 1952.

————. *Leonardo da Vinci*. Phaidon, 1964.

Hevesy, André de. *Pèlerinage avec Léonard de Vinci*. Paris, 1939.

Hildebrandt, E. *Leonardo da Vinci der Künstler und sein Werk*. Berlin, 1927.

Hours, Madeleine. "La Peinture de Léonard vue au Laboratoire," in *Connaissance de Léonard de Vinci*. Paris, n.d.

Huard, P. *Léonard de Vinci, dessins anatomiques*. Paris, 1968.

Huard, P. and Grmek, M. *Dessins scientifiques et techniques de Léonard de Vinci*. Paris, 1962.

Huyghe, René. "La Pensée dè Léonard appartient-elle à la Renaissance?," in *Connaissance de Léonard de Vinci*. Paris, n.d.

————. *La Joconde, Musée du Louvre*. Freiburg, 1974.

Jacquot, J. *Les Fêtes de la Renaissance*. Paris, 1956.

Larivaille, Paul. *Le XVI^e siècle italien, de l'apogée de la Renaissance è l'aube de l'âge Baroque*. Paris, 1971.

La Tourette, Gilles de. *Léonard de Vinci*. Paris, 1935.

Le Comte, D. *Léonard de Vinci, dessins*. Paris, 1942.

Lenoble, Robert. "Origines de la pensée scientifique moderne," in *Histoire de la science (Encyclopédie de la Pléiade)*. Paris, 1957.

Léonard da Vinci et l'expérience scientifique au seizième siècle. (Colloques internationaux du Centre national de la Recherche scientifique, Paris, 1952.) Paris, 1953.

Leonardo da Vinci. (Printed in Italy) Cercle du Bibliphile, 1958.

Lomazzo, G. Paolo. *Trattato dell'arte della pittura*. Milan, 1584.

MacCurdy, Edward. *The Notebooks of Leonardo da Vinci*. London, 1938.

MacMahon, Ph. *Leonardo da Vinci: Treatise on Painting*. Princeton, 1957.

Mairot-Dromard, M.-T. *Les grands heures du Clos-Lucé*. Tours, 1959.

Mandrou, Robert. *Des Humanistes aux hommes de Science, XVI^e et XVII^e siècles*. Paris, 1973.

Mathé, Jean. *Léonard de Vinci, dessins anatomiques*. Freiburg, 1978.

Merejkowski, Dmitri. *The Romance of Leonardo da Vinci*. New York, 1930.

Milanesi, G. *Documenti inediti (Anonimo Gaddiano)*. Florence, 1872.

Müntz, Eugene. *Léonard de Vinci*. Paris, 1899.

Nebbia, Ugo. *Léonard de Vinci, artiste et ingénieur*. Paris, 1952.

Nicodemi, Giorgio. "Les Dessins de Léonard," in catalogue of 1956 exhibition at the Musée Jacquemart-André: *Dessins et Manuscrits de Léonard de Vinci*. Paris, 1956.

Nulli. *Ludovic le More*. Paris, n.d.

Ottino della Chiesa, Angela. *Tout l'oeuvre peint de Léonard de Vinci*. Paris, 1968.

Panofsky, Erwin.

Pater, Walter. *The Renaissance*. London, 1893.

Péladan, J. *Léonard de Vinci: Textes choisis*. Paris, 1907.

———. *Les Manuscrits de Léonard de Vinci: Les 14 manuscrits de l'Institut de France*. Paris, 1910.

———. *Traité de la peinture; Traité du paysage*. Paris, 1910.

Popham, A. E. *The Drawings of Leonardo da Vinci*. New York, 1945.

Raccolta Vinciana. Milan, 1905–1964.

Reti, Ladislas. *Léonard de Vinci, l'humaniste, l'artiste, l'inventeur*. Paris, 1974.

———. "Leonardo da Vinci nella storia della macchina a vapore" in *Rivista di Ingegneria*. 1956–1957.

Richter, Jean Paul (ed.). *The Literary Works of Leonardo da Vinci* (2 vols). London, 1939.

Rinaldis, Aldo de. *Storia dell'opera pittorica de Leonardo da Vinci*. Bologna, 1926.

Rosci, Marco. *Léonard da Vinci*. Paris, 1978.

Rosenberg, Adolf. *Leonardo da Vinci*. Bielefeld and Leipzig, 1898.

Sartoris, Alberto. *Léonard architecte*. Paris, 1952.

Schneider, René. *La peinture italienne des origines au XVI^e siècle*. Brussels, 1929.

Schuhl, Pierre-Maxime. *Machinisme et philosophie*. Paris, 1947.

Schuré, Edouard. *Les Prophètes de la Renaissance*. Paris, 1920.

Séailles, Gabriel. *Léonard de Vinci, l'artist et le savant*. Paris, 1892.

Segnaire, Julien. *Tout l'oeuvre peint de Léonard de Vinci*. Paris, 1950.

Servicen, Louise (trans.). *Les carnets de Léonard de Vinci*. Paris, 1942 and 1953.

Siren, O. *Leonardo de Vinci*. Paris and Brussels, 1928.

Solmi, Edmundo. *Le fonti dei manoscritti di Leonardo da Vinci*. Turin, 1908.

———. *Leonardo da Vinci*. Florence, 1900.

Steinitz, K. *Catalogue of the Elmer Belt Library of Vinciana*. Los Angeles, 1946 and 1955.

Strobino, G. *Leonardo da Vinci e la meccanica tessile*. Milan, 1957.

Taton, R. *Histoire générale des sciences*. Paris, 1957–1958.

Terrasse, Charles. *Léonard de Vinci*. Paris, 1952.

Tursini, L. *Le Armi di Leonardo da Vinci*. Milan, 1953.

Valéry, Paul. *Léonard et les philosophes* (study preceding Ferrero's *Léonard de Vinci ou l'oeuvre d'art*). Paris, 1929.

Valentin, Antonina. *Léonard de Vinci*. Paris, 1950.

Vasari, Giorgio. *Le Vite dei piu eccelenti architetti, pittori e scultori*. Milan, 1945–1949.

Venturi, Adolfo. *Léonard de Vinci et son école*. 1948.

Venturi, Leonello. *La critica e l'arte di Leonardo*. Bologna, 1919.

Verga, E. *Bibliografia vinciana* (20 vols.). Bologna, 1931.

Vulliaud, Paul. *La pensée ésotérique de Léonard de Vinci*. Paris, 1910.

Wallace, Robert et al. *The World of Leonardo, 1452–1519*. Time Incorporated, 1966.

Wölfflin, Heinrich. *Die klassische Kunst, eine Einführung in die italienische Renaissance*. Munich, 1899.

———. *Classic Art: An Introduction to the Italian Renaissance*. Phaidon, 1948.

PHOTOGRAPH CREDITS